PIERO DELLA FRANCESCA

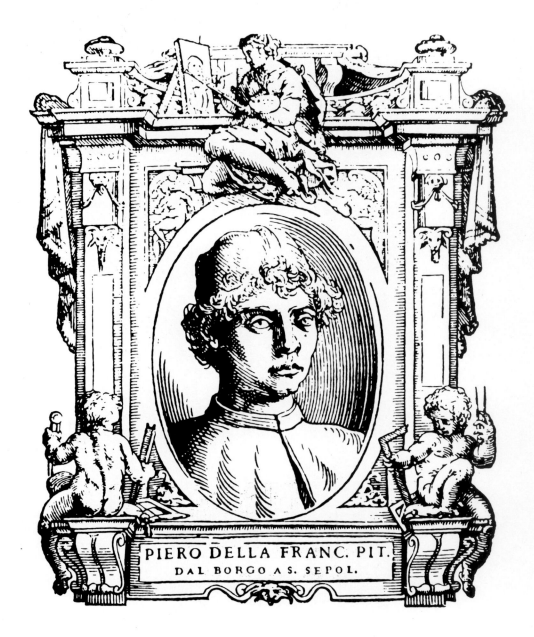

PIERO DELLA FRANC. PIT.
DAL BORGO A S. SEPOL.

PIERO DELLA FRANCESCA

MARILYN ARONBERG LAVIN

HARRY N. ABRAMS, INC., PUBLISHERS, NEW YORK

Editor: Mark Greenberg
Designer: Ellen Nygaard Ford
Photo Research: Jennifer Bright

Frontispiece: Presumed portrait of Piero della Francesca in
a woodcut published by Vasari in the second edition (1568)
of his *Lives*.

Library of Congress Cataloging-in-Publication Data

Lavin, Marilyn Aronberg.
 Piero della Francesca / Marilyn Aronberg Lavin.
 p. cm.
 "Masters of art" —
 Includes bibliographical references.
 ISBN 0-8109-3210-5
 1. Piero, della Francesca, 1416?–1492—Criticism and
interpretation. I. Title.
ND623.P548L38 1992
759.5—dc20 92-1321
 CIP

Text copyright © 1992 Marilyn Aronberg Lavin
Illustrations copyright © 1992 Harry N. Abrams, Inc.

Published in 1992 by Harry N. Abrams, Incorporated, New York
A Times Mirror Company
Printed and bound in Japan

CONTENTS

OPVS PETRI DEBVRGO SCI SEPVLCRI

PIERO DELLA FRANCESCA

PIERO AND MODERNISM. People more often name Piero della Francesca as their favorite than any other artist of the fifteenth century. Contemporary painters claim him as an aesthetic kinsman (Philip Guston, for example, carried a Piero postcard in his pocket). Students with no more than a survey course in the history of art smile with pleasure at the very mention of his name. Travelers to Italy, the intellectually enlightened and the ordinary tourist, describe their "Piero pilgrimage" with pride, taking pains to track down the few remaining works in Tuscany, Umbria, and the Marches. Trained by the Bauhaus, challenged by the post-Impressionists and Cubists, bombarded by the Abstract Expressionists, jolted by post-Modernism and deconstruction, our "modernist" eyes readily absorb Piero's soothing sense of seriousness. We see his plain and haughty figures as somehow better than normal; his open spaces and colors washed in light, as perfect as can be. We understand his clear and readable subjects as both paradigmatic of human experience and yet deeply moving and strangely portentous. His paintings are like acts of charity, and more: they contribute to the general good, yet they are really enjoyable.

In response to the mass adulation of Piero, already apparent in the 1930s, the critic Bernard Berenson expressed shock. His contemporaries, he insisted, were merely "culture-snobs" who did not understand the true universality of Piero's wordless poems. They were merely seeking justification from the past for their own worship of Cézanne. Berenson, of course, was referring to the many ties that seem to bring these two artists together: suppression of emotion, emphasis on geometric shapes, and an overriding concern for the flatness of the picture plane. Visually, Piero and Cézanne were seen as soul mates, although since Cézanne never went to Italy, no one tried to link them historically. But Piero was taken as the one Renaissance painter who, centuries earlier, had forecast the values of post-Impressionist art and thereby proved its validity. This polemical attitude, Berenson said, explained the twentieth-century love for Piero della Francesca.

Our continuing attraction to Piero, however, is a bit more complex than that. It can be shown, in fact, that his rise to prominence began not with the avant-garde but from within the heart of the academy.

It may come as something of a surprise that in the centuries after his death, Piero was remembered less as a painter than as a mathematician. From the sixteenth to the early nineteenth century, his fame rested almost exclusively on his authorship of three theoretical treatises: The *Trattato del abaco* on arithmetic; the *Libellus de quinque corporibus regularibus* on solid geometry; and the *De prospectiva pingendi,* on the theory of perspective for use in

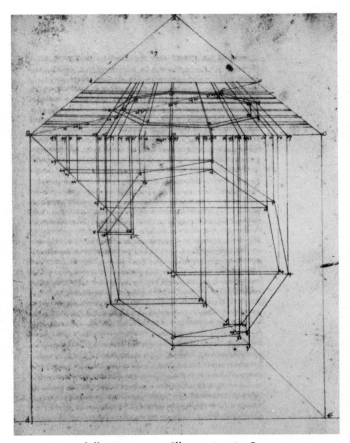

1. Piero della Francesca. Illustration in *De prospectiva pingendi.* Pen and ink. Biblioteca Palatina, Parma

painting (fig. 1). When these texts were finally published in modern times, historians of science confirmed their importance. Piero is now ranked among the greatest mathematicians of his day, on a par with Toscanelli, whom he most probably knew. His treatise on perspective, after being passed to his colleague Fra Luca Pacioli, and then on to Leonardo da Vinci and Albrecht Dürer, guided the representation of three dimensions on two-dimensional surfaces right up to the time of Impressionism. The Impressionists' mid-nineteenth-century break with tradition, based on their apparent rejection of geometric structure in pictorial space, seemed a serious threat to the hegemony of academic art. And it was precisely the fear of losing power that then led, quite directly, to the rediscovery of Piero as an artist and brought him to world attention.

One method of combating what was considered laxity in the structure of painting was introduced in 1872 by Charles Blanc, the newly elected director of the Ecole des

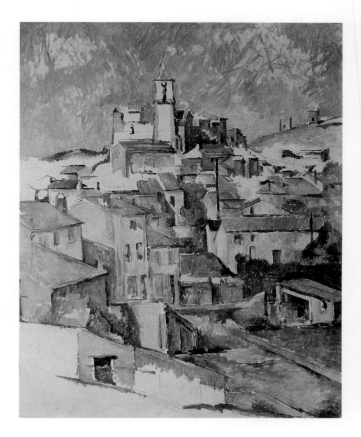

2. Paul Cézanne. *Gardanne.* c. 1886. Oil on canvas, 80 × 64.1 cm. The Metropolitan Museum of Art, New York. Gift of Dr. and Mrs. Franz H. Hirschland, 1957

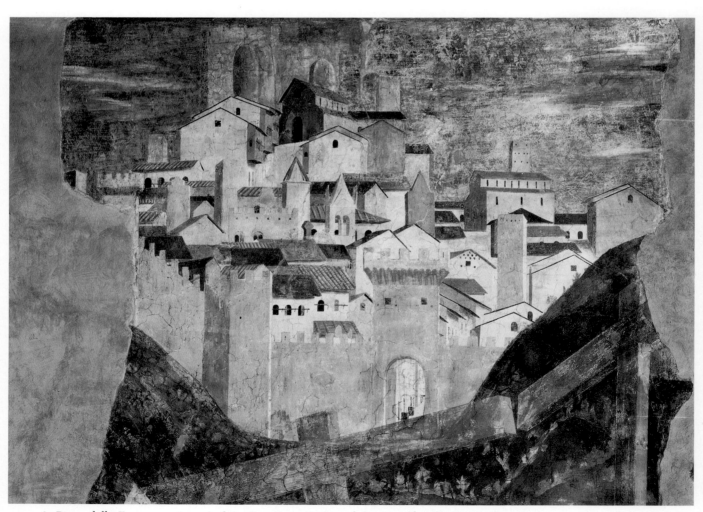

3. Piero della Francesca. *Legend of the True Cross: Finding of the Cross* (detail). Fresco. San Francesco, chancel, Arezzo

Beaux-Arts in Paris. Blanc determined that young artists would be trained more strictly than in recent decades. To ensure the return to traditional values, he reintroduced copying as a method of teaching, not just from casts after classical and Renaissance sculpture but also from copies of famous historical paintings. Blanc commissioned 157 replicas of Italian Old Masters to be used as study tools for this purpose and also to form part of a planned Musée des Copies. These commissions included easel paintings by Botticelli, Raphael, and Titian, a reduced replica of the whole of Michelangelo's *Last Judgment,* and full-scale copies of two tiers of Piero's Arezzo fresco cycle, *The Finding and Proving of the Cross* and the *Battle of Heraclius.* The Piero replicas were made by a little-known painter named Charles Loyeux, who was sent to Arezzo to carry out the work. Meanwhile, the idea of a copy museum met with disapproval from members of the committee of the Ecole, and the controversial Blanc was dismissed from his post. By December 1873, when a new director was in place, the part of the copy museum already formed was dismantled. When Loyeux's Piero copies arrived in Paris the following year, they displeased the committee greatly. The paintings were not destroyed only because the enterprise had been quite expensive (and Loyeux had become a public hero in Arezzo). Instead, they were installed, along with a number of the other replicas, high on the walls of the school chapel where they can still be seen, with some difficulty, behind the plaster casts and above temporary installations of exhibitions now held there.

Despite these internal controversies, both Blanc and the school librarian, Eugène Müntz, went on to write eloquently about the early Italian School and Piero in particular. Müntz had photographs and drawings of other Piero works brought from Italy to serve as further models. While these copies may have fulfilled their intended purpose well, among many of the younger generation, rather than averting the danger of an antiacademic art, they started a new revolution of their own.

Cézanne studied art in Aix-en-Provence, not Paris, and he never went to Italy. Therefore, despite the parallels that have been drawn between his art and Piero's, until now no direct link has been sought. But, in fact, Cézanne participated in the first Impressionist exhibition in Paris in 1874 and was in and out of the city all that year and the following. It is possible, therefore, that he saw Loyeux's copies soon after they went on view. They clearly made a strong impression, since, a few years later, Cézanne repeated a motif from one of the frescoes almost verbatim. In his *View of Gardanne* (fig. 2) he gave the townscape the same rising arrangement of geometric solids that make up Piero's view of Arezzo in the background of the *Finding of the Cross* (fig. 3). The particular bridge to modern art found here is unusually strong, since this very composition by Cézanne, as has been often recognized, inspired the first true Cubist landscapes of Braque, Picasso, and Derain in 1908–09.

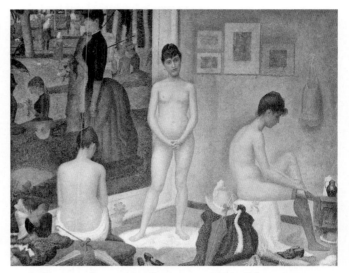

4. Georges Seurat. *Les Poseuses.* c. 1864. Oil on canvas. The Barnes Foundation, Merion, Pennsylvania

5. Piero della Francesca. *Legend of the True Cross: Story of Adam* (detail). Fresco. San Francesco, chancel, Arezzo

Another link in the chain from Piero through the academy to modernism was forged by the young Seurat. As a student at the Ecole des Beaux-Arts (he entered in 1878), he had access to both the Piero replicas and the photographs collected by Müntz. Clearly, he studied them quite closely, and as has been pointed out more than once, many of Piero's motifs reappear in some of Seurat's most familiar paintings. The stance of the central figure in his *Poseuses* (fig. 4), for example, is similar to the figure in animal skin in the Adam fresco (fig. 5), while the one on the right sits in St. Joseph's pose in the London *Adoration* (Colorplates 39, 40). The seated boy on the left of *Une*

6. Georges Seurat. *Une Baignade, Asnières* (detail). 1883–84. Oil on canvas, 221.9 × 321 cm. National Gallery, London. Reproduced by courtesy of the Trustees

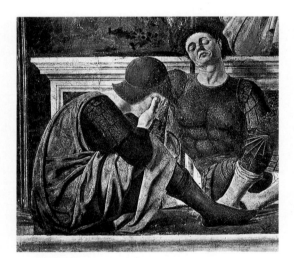

7. Piero della Francesca. *Resurrection of Christ* (detail). 1463–65. Fresco. Palazzo dei Priori, Sansepolcro

Baignade, Asnières (fig. 6) recalls a guard in Piero's *Resurrection* (fig. 7). The compositional structure of *La Parade* (fig. 8) is close to that of the *Proving of the Cross* (fig. 9), one of the scenes in the fresco replicas. Thus, far from being the result of rebelliousness, many of the most progressive steps toward the founding of an abstract art were stimulated, ironically enough, by examples offered within the walls of the academy.

After initial evaluations of mediocrity (Jacob Burckhardt had called his work "naive"), by the beginning of the twentieth century Piero was firmly identified with the formalist trends then in vogue, and his artistic status among critics began its rise. Aldous Huxley called his paintings "strange and startlingly successful . . . experiments in composition.". Roberto Longhi, who wrote the first monograph in 1927, eulogized his spatial intervals,

poetic tonal organization, lack of emotion, and the archaic quality of his classicism. Edging ever closer to the language of modernism, in 1929 the painter/critic André Lhote called Piero the "first cubist," and his fate was sealed. He became the contemporary painters' historical alter ego, validating the notion of art for art's sake and offering secular viewers "church painting" unencumbered by religious sentiment. In the 1920s and 30s this point of view was espoused mainly by cultured writers and connoisseurs like Huxley, Roger Fry, and Adrian Stokes. After World War II, and particularly after 1951 when Kenneth Clark published the first major monograph in English, praise for Piero was widely disseminated in classrooms. Even greater familiarity with his works came after an important restoration of the Arezzo frescoes was carried out in the early 1960s and new color prints became available. In the next decade, the predisposition to see Piero's style in terms of abstraction caught the interest of new-wave literary theoreticians, who found his visual symmetry irresistible. His works then became the focus of repeated analyses by the structuralists, and still today they are the subject of semiological analyses.

A striking anomaly will have become apparent from this historiographical sketch. While more and more studies show that the surfaces of most of Piero's paintings are coordinated by geometrical schemes closely reflecting his own mathematical theories and confirming a level of abstract value, at the time Piero was alive there was no such thing as "abstract art." Indeed, there was no art at all that was not commissioned by a paying patron, and in fifteenth-century Italy those commissions, both private and institutional, were for religious subjects, serving specific religious functions. As a result, we must bear in mind that the austere beauty of Piero's paintings could not have been understood by his contemporaries on aesthetic grounds only. Rather, to the fifteenth-century viewer the crystalline world of mathematical purity present in all his works would have been inseparable from the subject represented and mystical function it served. In the text

8. Georges Seurat. *La Parade*. 1887–88. Oil on canvas, 99.7 × 149.9 cm. The Metropolitan Museum of Art, New York. Bequest of Stephen C. Clark, 1960

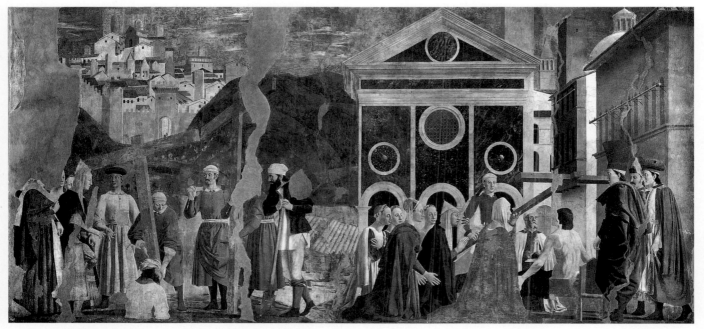

9. Piero della Francesca. *Legend of the True Cross: Finding and Proving of the True Cross.* Fresco. San Francesco, chancel, Arezzo

that follows, I will focus on the relationship between Piero's abstract form and the religious significance of the content in a number of his paintings. I will try to show how the very qualities that make his works so attractive to the twentieth-century sensibility contributed to their meaning and value in their own time. To understand Piero in this way, far from diminishing our emotional confrontation with his unique contributions, makes possible a more accurate assessment of his originality and an even deeper admiration and appreciation of his art.

LIFE. One reason Piero remains so intriguing is that contemporary documents give up very few of his secrets. There are no direct descriptions of his activities, and in the hundreds of pages of his own writings, there is not one remark of a personal nature. We know he was a native of the town of Sansepolcro [formerly Borgo San Sepolcro] (about 150 kilometers southeast of Florence), the son of Benedetto dei Franceschi, an apothecary, and Romana di Perino from Monterchi, but there is no record of his birth. We can only guess it took place between 1410 and 1420 because he was supposed to have been nearly eighty when he died in 1492. He had two brothers, Marco and Antonio, who, along with his father, often acted as his agents, receiving payments and signing receipts for him.

At least by 1436 Piero was studying painting with a provincial master, Antonio d'Anghiari, and absorbing all he could from the great artistic traditions in Assisi, Siena, and Florence, where, in fact, he is documented in 1439, working alongside Domenico Veneziano. Around 1450, he fulfilled commissions outside his native territory, traveling to Ferrara and Rimini and possibly north to Venice as well. He returned to work at home and in nearby Arezzo for several years, which were interrupted by a stay in Rome (1458–59) that came to an end when his mother

died. He then made his base Sansepolcro until 1468, when the town was threatened by the plague and he retired to Bastia, a small village in the nearby hills. His only documented visit to Urbino was in 1469, although he must have been there both before and after that date.

Piero held various public offices in Sansepolcro throughout his life, including Consigliere Popolare in 1442, 1467, and 1477, and from 1480 to 1482 as Capo dei Priori of the Confraternity of San Bartolomeo, the most important religious lay organization in Sansepolcro. At the end of this office, he again journeyed to Rimini where he rented a country villa from an aristocratic woman. He probably spent his time there completing his *Libellus de quinque corporibus regularibus,* which he dedicated to Guidobaldo, then the reigning duke of Urbino. Piero made his will in 1487, stating he was of sound mind and body, so if he lost his sight in old age, as Vasari reports, it must have been after that date. Having never married, he left most of his property to his brothers and their heirs. He gave instructions for his own burial, which was to be in the family tomb in the tower of Sansepolcro's Camaldolite Abbey Church (later the cathedral). When this area was excavated in 1956, a skeleton 180 cm in length (over 6 feet) was found. One likes to think it might be Piero's, as he is said to have been "very tall." The notice of his death on 12 October 1492 is one of the very few specific dates in Piero's biography; the quincentenary of this event is commemorated by the present publication.

CAREER. The brief period Piero spent in Florence working in Sant'Egidio with Domenico Veneziano was important for his career. He could have been a student-helper or, just as well, a young colleague and equal, but not yet a maestro. Although relatively young himself in 1439, Domenico was already preoccupied with perspective

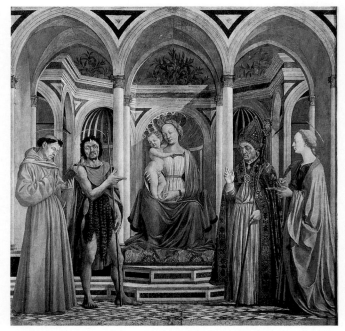

10. Domenico Veneziano. *St. Lucy Altarpiece* (main panel). c. 1440. Tempera on panel. Galleria degli Uffizi, Florence

construction, solidity of form, and sparkling coloristic effects (fig. 10). And in the following decades it was these very elements that were to remain among the most prominent in Piero's world of visual experience.

Piero, however, surpassed Domenico and most of his contemporaries in idealizing forms. In fact, his theoretical turn of mind carried him so far beyond detailed appearances that his figures often take on the quality of types. In their frequently repeating poses, even whole compositions, his works seem to remain uniform, apparently lacking in the usual stylistic development. With a model of perfection in his mind, Piero bent his efforts toward elevating the simple people he portrayed to the realm of theoretical and formal ideals.

Piero's presence in Florence in 1439 coincided with a great historical event. Under the ever-present threat of Turkish conquest, a council had been convened between the Eastern and Western branches of the Catholic Church. The streets were full of crowds of pompous council members from both sides of the table. John Palaeologus, the reigning Byzantine emperor, along with many Eastern Church officials and their attendants, could be inspected at close range in all their grand regalia. Costume sketches made at meetings and processions left deep marks on the Italian sartorial imagination for many generations to come. Along with other artists like Pisanello, Piero must have made notes of their extraordinary appearance, for later in his career some of his most compelling figures wear the colored coats, with extended sleeves, and exotic hats and scarves of the Eastern visitors.

Unlike many of his contemporaries—Veneziano, Fra Angelico, Paolo Uccello, Andrea Castagno—Piero did not remain in Florence. His patrons were never the Medici or other wealthy Florentine merchants. Instead, they were monasteries, confraternities, and citizens of his home territory, including as well a few of the courtly lords in nearby Umbria, Emilia, and the Marches. When he executed the cycle of the *True Cross* in Arezzo, a quite well-to-do family of bankers named Bacci were the sponsors, but the Franciscan friars who ran the church had the final say.

Piero's absence from the large urban centers may not have been due solely to his provincial nature; rather, it may indicate a different, ordinarily overlooked, aspect of his personal life. His artistic and literary remains show that he divided his attention among several activities, most of which kept him at home. In Vasari's brief biography in his famous *Lives of the Most Eminent Painters,* Piero's powers as a mathematician are emphasized almost above his painting talent. In the early fifteenth century, painting was still considered a craft, since it was done with the hands. Boys were apprenticed out (living with their masters) sometimes before they reached their teens, and they were taught to grind colors, draw, and finally to compose. Advanced learning from books was for them quite rare. Piero, on the other hand, studied Latin. He surely knew the classics, and the work of Euclid in particular. Modern scholarship has shown, in fact, that Piero not only knew all the texts available concerning Euclidian theory but knew the principles so well he could carry them to new conclusions of his own. He reinvented two Euclidian theorems, the manuscripts of which were not discovered until the sixteenth century, many years after his death.

With this kind of education, it is unlikely that the young Piero could have spent all his time on artistic training. Moreover, during the years of his maturity, his artistic output was relatively small. It may have been that he was a remarkably slow worker; the *Misericordia Altarpiece,* for example, took him more than fifteen years to complete (commissioned in 1445, delivered in 1462). But judging from the depth and concentration of his product, rather than dawdling, he was otherwise occupied. The logical conclusion is that painting was not his full-time occupation. As we have already seen, by 1442 he had been elected to one of the governing bodies of Sansepolcro. We shall see (in the discussion of the *Resurrection*) that, when the city fathers needed an image in the town hall to characterize the city, they called on him. Considering his own relatively large literary output, one begins to suspect he was not a lowly craftsman but a member of the upper class, moving in circles where thought, learning, and elevated forms of expression were the essence of daily life. The intellectual, theological, and philosophical problems that filled his mind were the same that occupied the humanistic despots, d'Este, Malatesta, and Montefeltro, who were currently creating a new world of mundane culture. Nothing would explain more directly the powerful intellectual grip that holds our attention in Piero's every painted work.

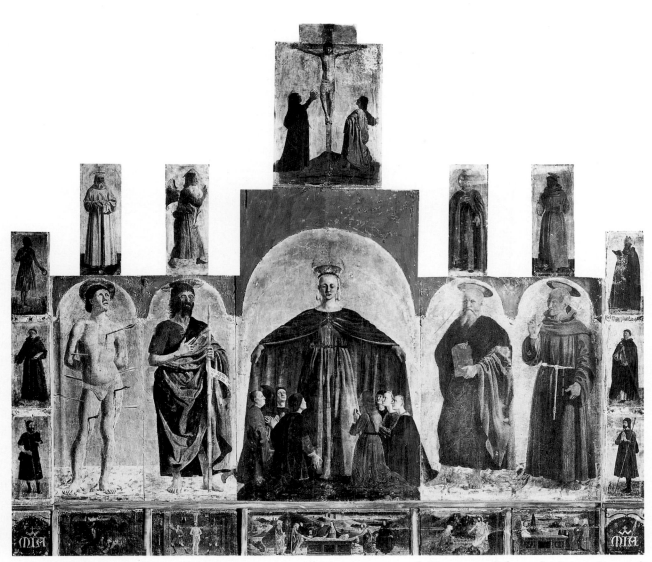

11. Piero della Francesca. *Misericordia Altarpiece.* 1445–c.60. Tempera on panel. Pinacoteca, Palazzo dei Priori, Sansepolcro

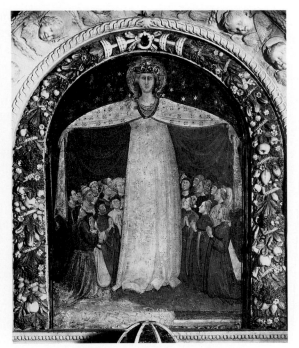

12. Parri Spinelli. *Madonna della Misericordia.* 1427. Fresco.
Santa Maria degli Angeli, Arezzo

MISERICORDIA ALTARPIECE. Piero's theoretical turn of mind is already evident in the commission for an old-fashioned form, the *Misericordia Altarpiece,* a polyptych with more than twenty separate gold-ground panels (fig. 11). Perhaps his earliest remaining work, begun in 1445, it was destined for the altar of the meeting hall of the Confraternity of Mercy, a local charitable organization in Sansepolcro. The central image shows Mary standing with her arms spread wide to open her cloak and give shelter to a number of kneeling devotees. Her garment is closed at the neck by a gem similar to a bishop's morse, expressing her liturgical power of ministration to the flock. The composition is quite faithful to a tradition of Aretine Misericordia altarpieces, as seen in Parri Spinelli's 1428 version (fig. 12), where a large-scale frontal figure of the Virgin holds out her cloak to protect figures kneeling under her garment. In both cases, her oversize scale and tentlike robe refer to the medieval symbolism of Maria Ecclesia, that is, Mary as the Church in its institutional capacity to protect its people. While the kneeling figures most probably represent individual members of the confraternity, they also stand for mankind in general.

13

Despite these similarities, Piero's version introduces an important new element. Mary's cloak is not just an extended drape; it has the spatial quality of a circular architectural structure. In fact, the confraternity members do not just huddle in the folds, as in Parri's image, but form a ring, always facing the Virgin, some turning their backs to the picture plane. The trajectory of Mary's downward glance completes the circle. Thus, through the vigor of his modeling and in spite of the flatness of the gold background, Piero carves a spatial niche out of the panel and gives his figures room to move and breathe.

The same sense of spatial reality envelops the standing saints flanking the central image. They are represented on variegated stone plinths that meet the gold background at 90-degree angles and form sliced-off sills at the picture plane. More than seventeen years passed before this altarpiece was complete (the final payment to Piero's brother Marco was made in 1462), and a stylistic progression in these figures moves from the buoyant crudity of St. Sebastian on the left to the grooved stability of San Bernardino of Siena at the far right. Yet all the saints show Piero's volumetric firmness. All are thinking human beings, rapt in meditation. As such, they are intercessory paradigms of devotion for the worshiper to contemplate. They are deliberately contrasted to the scenes of human experience introduced in the narrative cycle that brackets the altarpiece below and above.

Between the predella and the pinnacle, six scenes recount Christ's death and resurrection in a down-up-down pattern. The sequence begins at the lower left (members of Piero's shop probably assisted in painting the predella), with the first two scenes of the Passion set in structured vistas. The next episode moves to the unusually large pinnacle where, by contrast, the Crucifixion is represented in a field of gold. The contradiction of abstraction and reality here is very strong, as Piero expresses more emotion than he was to portray ever again in his career. Under the deeply modeled figure of her dead son, Mary is a heavily draped, middle-aged woman who flings up her oversize hands in despair. Nothing could be farther from Mary's youthful serenity in the main panel just below. The last three episodes of the cycle return to the predella and end at the right with the three Marys who discover Christ's empty tomb. Thus, already in his inaugural effort, Piero has taken a traditional form and infused it with new ideas. By plotting the narrative sequence from below to the top and down again, he interlaces narrative cycle and cult image and shows events forecast in Mary's virginal pregnancy. Fixed before us in a gesture of coredemption, she is visually identified as both cause and effect.

SIGISMONDO MALATESTA BEFORE ST. SIGISMUND. Piero's second major commission to survive was for another votive painting, this time for a private individual and in the fresco medium on a monumental scale (257 × 345 cm). Signed and dated 1451, the painting (figs. 13, 14) was commissioned by Sigismondo Pandolfo Malatesta, lord of Rimini, a city on the Adriatic coast, capital of one of the many petty states of Renaissance Italy. Sigismondo was a soldier by profession, and following one of his most important military victories, he began to think of his

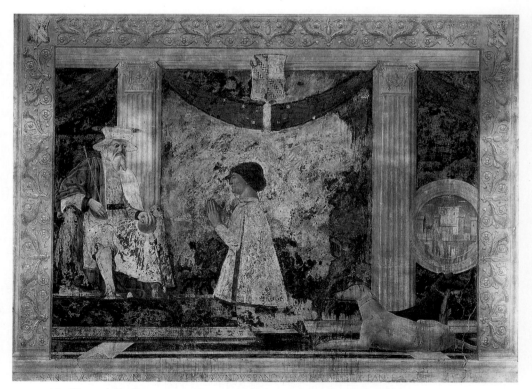

13. Piero della Francesco. *Sigismondo Malatesta before St. Sigismund.* 1451. Fresco. Tempio Malatestiano, Rimini

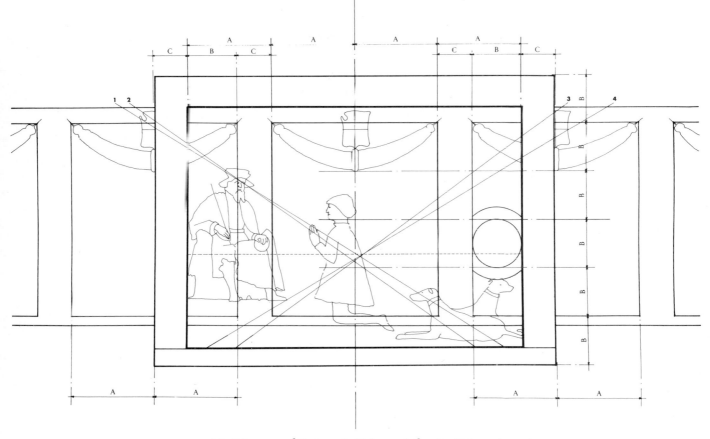

14. Diagram of *Sigismondo Malatesta before St. Sigismund*
by James Guthrie and Peter Schmitt

eternal glory by planning for his own tomb monument. He initiated a partial rebuilding of the fourteenth-century church of San Francesco, which for generations had been the burial place of the Malatesta family. He chose the first of three new chapels built into the right side wall as his tomb site and dedicated the space to his personal patron, St. Sigismund of Burgundy (fig. 15). The third chapel became the burial chamber of his beloved mistress, Isotta. The chapel in between, uniquely closed off from the nave by a wall, held Piero's fresco, on the interior of the entrance wall above the door.

Although the fresco immediately strikes us as astonishing in a number of ways, the commission seems to have been for a thank-offering of the usual sort: that is, the figure of a donor kneeling in strict profile, praying for the intercession of his patron saint. The traditional arrangement of this kind of image can be seen in a fresco, of about 1320, attributed to Giotto, in the Lower Church of San Francesco in Assisi: in a narrow vertical field, a diminutive devotee, Bishop Teobaldo Pontano, kneels for protection to a monumental figure of St. Mary Magdalene (fig. 16). Once more discrepancy in scale makes it evident that the interaction is between beings from different realms, one superior to the other. What is unusual in Piero's painting, therefore, is that his figures are the same size. With his head surmounted by a golden halo, the figure on the left is

15. Chapel of St. Sigismund, Tempio Malatestiano, Rimini

15

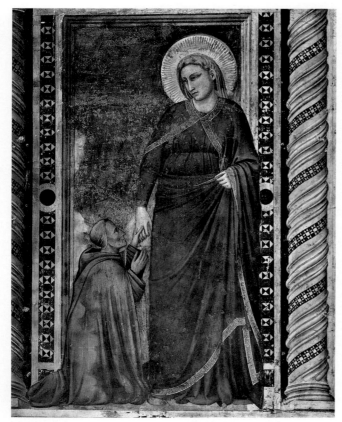

16. Giotto Bondone (?). *Bishop Pontano before the Magdalene*. c. 1315–20. Fresco. San Francesco, Lower Church, Magdalene Chapel, Assisi

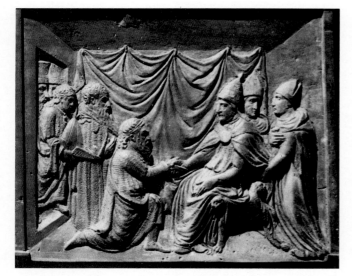

17. Antonio Filarete. *Coronation of Emperor Sigismund* (detail). c. 1443. Bronze relief. Doors of St. Peter's. Vatican City

from a narrow vertical to a broad horizontal, and with this widened form a second theme is introduced. Starting in the lower right, the composition moves in a diagonal laterally, from a pair of dogs reclining on the floor, to Malatesta on the lower step of a dais, to St. Sigismund seated on a throne atop the platform. This type of composition relates the image to scenes of secular ceremonies or special historical events. An example of the type can be seen on Filarete's bronze doors of St. Peter's, set in place just two years earlier (1449), where the kneeling propitiate and his retinue approach the pope enthroned to one side (fig. 17). The little relief depicts an event that took place in 1433, when King Sigismund of Hungary was crowned Holy Roman Emperor by Pope Eugenius IV. We shall see in a moment that this event had particular resonance for Sigismondo.

It was pointed out by scholars long ago that the representation of St. Sigismund in Piero's fresco (fig. 18) bears a striking resemblance to the popular Hungarian emperor also named Sigismund. The emperor's physiognomy was widely known from images such as a painted portrait on vellum attributed to Pisanello (fig. 19). According to hagiographic tradition, the saint was a soldier-king—the first Christian king of the Gauls—and since he died as a relatively young man, St. Sigismund was usually shown as a youthful armored knight. Piero's saint, however, is an elderly gentleman with impressive forked white beard, wearing a hat like that of the emperor's (an inverted, truncated pyramid with wide brim, slashed and turned up at the front), only with the fur removed. The reason for this transformation is easy to come by. On his return from the coronation, the emperor had paid a visit to Rimini, where Sigismondo, although only fifteen years of age, was already in power. On 3 September 1433 the emperor knighted Sigismondo and raised him to the rank of *cavaliere*. A reference in the fresco to this honorific event was most appropriate, since, following his imperial recognition, the young lord of Rimini was launched on what was to be quite a flamboyant career. Moreover, the architectural setting of the painting, a marble-lined room hung with swags and Malatesta escutcheons, has the appearance of nothing so much as a formal audience hall where such a ceremony could have taken place.

In spite of these strong affinities, however, the scene does not "represent" an historical event. Besides lacking all the necessary accoutrements of knighting ceremonies —spurs, sword, gestures of various sorts—and the fact that the kneeling figure is well beyond the flush of youth, a subject of this sort would be entirely unprecedented in an ecclesiastical locale. In fact, the particular placement on the interior of the entrance wall of the chapel, with a composition moving from right to left, confirms the ecclesiastical message. In this position, the donor figure faces not only the figure of his patron saint in the painting but also the cult figure of the saint above the altar in the adjacent chapel. Astonishingly, there is an opening (filled

clearly a saint. The figure kneeling in profile, wearing a contemporary *giornea,* or knee-length coat, and short boots, is clearly mortal. Yet it is he, and not the saint, who is the center of attraction. This change introduces a new kind of devotional image that both humanizes the saint and aggrandizes the donor.

Besides this innovation in the scale of the figures, there is also a change of format. The painting field is expanded

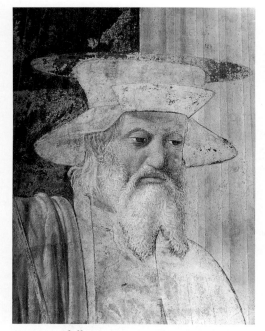

18. Piero della Francesca. *Sigismondo Malatesta before St. Sigismund* (detail). 1451. Fresco. Tempio Malatestiano, Rimini

19. Pisanello (?). *Portrait of Emperor Sigismund.* c. 1433. Tempera on parchment. Kunsthistorisches Museum, Vienna

with an iron grill) in the wall between the two precincts, making it possible to see from one room to the other. In this vein, we note an identity between the architectural decoration in the Sigismund Chapel and the painted architecture in the fresco. Both real and painted walls are lined with veined marble; both are articulated periodically with flat, Ionic pilasters; both are hung with swags and Malatesta escutcheons. Supervision of the interior

decoration of this project was previously attributed to the architect and sculptor Matteo de' Pasti, but now it is agreed that Piero was the designer. Thus, it was Piero's conscious effort to identify the setting of his fresco with its ecclesiastical environment. As surely as he referred to Sigismondo's political life by citing the emperor's face, with equal clarity he cited Sigismondo's devotional life by placing his confrontation with his patron saint in a throne room of heaven.

The structure of the setting as a whole has still other elements of meaning. With one full intercolumniation in the center of the background and partial panels at the sides, a triptych-like arrangement is called to mind. In this tripartite setting, Sigismondo appears as the central unit, while at the sides, in the wings as it were, are his attributes: his patron saint on the left and his castle on the right, and surprisingly enough, his dogs. This visual conceit shifts the discourse to a verbal level when we discover that these seemingly disparate elements all share Sigismondo's name in one form or another. Translating the original Germanic name *Sigismund* (modern Sigmund) into Italian, Pandolfo Malatesta may have wished to honor the reigning Hungarian king when he named his son Sigismondo. The Malatesta family had military ties with the Balkan state going back over two generations, and Sigismondo was the first in the clan to bear this name. After the young man secured a grip on his father's territorial legacy, he almost immediately put the name to use in publicizing his power, both civic and intellectual. Like other petty states in Italy of this period, Rimini was a center of humanistic learning. Foreign languages and the newly regained knowledge of classical Greek and Latin were embraced so enthusiastically that punning and other kinds of wordplay were often the result. So it was with Sigismondo. The origin of his name is found in two medieval German words: *Sigis* (modern German, *Sieg*), which means "victory," and *Munt,* which means "hand" or "protection." Together they mean "Victorious Protector," an epithet applied to Sigismondo on several occasions in poems and inscriptions both in Latin (*Victoris*) and in Greek (*nikephoros*).

A small-scale, circular depiction of his massive dwelling (still extant in Rimini), appears behind the kneeling figure, wedged between the pilaster and the border (fig. 20). The building is identified with a painted inscription that reads: *Castellum Sismundum Ariminenses 1446,* the name, location, and the date it was ready for habitation. The same castle image and inscription is on the reverse of bronze portrait medals of Sigismondo, many examples of which were buried at the entrance to the St. Sigismund Chapel (fig. 21). What is important to observe in all these images is that the castle's name is Sismundum, which, while taken from "Sigismondo," is spelled differently and has different roots. *Sis* in Latin is an interjection meaning "as it were" or "if you will"; *mundus* means "world" or "cosmos." The name thus says that the castle, which

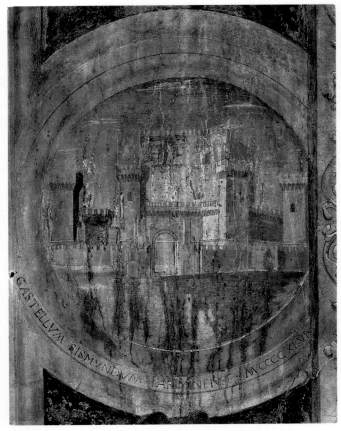

20. Piero della Francesca. *Sigismondo Malatesta before St. Sigismund* (detail). 1451. Fresco. Tempio Malatestiano, Rimini

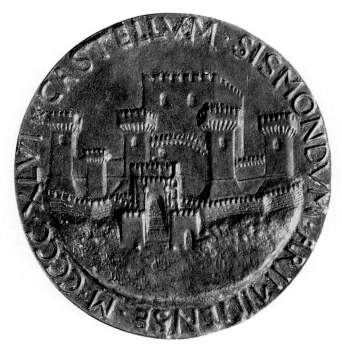

21. Matteo di Pasti. *Castellum Sismundum.* c. 1450. Bronze medal, verso. National Gallery of Art, Washington, D.C. Kress Collection

stands for the lord and his city, is "as it were, the world." In other words, the lord's castle and dominion is a microcosm reflecting the perfect structure of the cosmos, the dominion of God. This idea is carried onward by the circular format, the circle being the most perfect geometric form, the shape, according to tradition, of the ideal city and of the cosmos. A further allusion in this formula is found in a fourth-century book called the *Hieroglyphica* of Horapollo, the manuscript of which was discovered a few decades before Piero's painting. Representing a palace in the center of a circle, says Horapollo, shows the owner to be a "cosmic ruler." Thus the representation of the Castellum Sismundum framed in a circle with its explanatory inscription marks Sigismondo as a sovereign ruler and Rimini as an ideal political unit. Again, Piero has created an image that combines the real and the divine.

Just below the castle image are Sigismondo's dogs, two magnificent, attentive greyhounds, lying in reverse "couchant" poses. Although it may at first seem irreverent to find dogs in such a lofty environment, these two greyhounds also carry deeper meaning, and again on two levels. Because of their innate attachments to their masters, already in classical times, dogs were considered symbols of fidelity. For Christians during the Middle Ages they took on the symbolism of Faith, one of the cardinal virtues. It is the Latin word for faith, *fides,* incidentally, that generated "Fido" as a conventional canine name. Like the dogs in the fifteenth-century illumination by Jacquemart de Hesdin, where two small dogs assist Jean, duc du Berry, in his prayers before the Virgin and Child, Sigismondo's dogs stand for their master's religious faith.

They also carry allusions to his politics. Sigismondo's second name (from his father) was Pandolfo, a word again composed of syllables with intrinsic meaning. *Pan* is Greek for "all," "every," or "cosmic," once more referring to the ruler's position in the universe. *Dolfo,* having passed through a number of medieval transformations, stemmed from the Latin *delphinus,* meaning "dolphin." Many dolphins are represented in the building, including in reliefs above the door to the fresco's chapel. But the Latin form *dulfus* also has a relationship to the name "Adulfus," which is also Germanic in origin. Its root is *Adulf* and the still earlier Gothic form "Athaulf." Figuratively this name means "noble hero," an epithet suited to describe a leader. But literally the word means "noble wolf." It would be difficult to propose these well-groomed greyhounds as representing wolves if it were not for a tradition that brings the two species together. According to several classical writers, the Gauls bred dogs and wolves together to produce a breed they called *lycisci,* hounds with an outstanding ability to lead. Remembering that St. Sigismund was king of the Gauls, I propose that these vigilant creatures go beyond the dogs of daily life; they are Piero's visualization of the *lycisci,* their nobility and seigniory standing for these qualities in their master.

The occasion of this commission, which ultimately led to a rebuilding of the entire church, was as a thank-offering for the 1447 victory in the war between Florence and Venice on one side, and Naples, Milan, and the pope on the other, in which Sigismondo played a spectacular role. On the exterior of the building at the façade end of each flank, are twin inscriptions, carved in Greek, recording these facts. The lines speak of Sigismondo as the "bringer of victory" (*nikephoros*) in the war he "won through prayer." They go on to say that as of now, the building has a new dedication. The patron is no longer the simple friar from Assisi, St. Francis, but instead has become two forces for which Sigismondo claims to have fought: *THEOI ATHANATOI KAI TEI POLEI,* for God Immortal and the City. Two in number to signify this dual rededication, the inscriptions postdate the fresco by several years. Thus in his dual expression of devotion and dominion in every aspect of his painting, Piero provided the first and most succinct statement of Sigismondo's surprisingly devout self-consecration to church and state. Conserving traditional forms of both the donor portrait and the ceremonial scene, and doing violence to neither, Piero fused them in a way that goes far beyond either tradition. Moreover, by structuring the pictorial field with a mathematically consistent network that guides the placement and size of all the forms, he evoked, with unprecedented strength, a peculiar reciprocity between divine and mundane and between universal and particular that was to remain one of the chief hallmarks of his art.

FLAGELLATION OF CHRIST. In the Malatesta fresco, Piero created the deliberate impression that the represented space extends laterally beyond the painted field. In the *Flagellation,* done seven or eight years later (1458–60), the spatial illusion is very different. It is now one of great depth, an open urban area that recedes far into the distance behind the picture plane. Rather than a mural decoration with almost life-size figures, the *Flagellation* is painted on a wooden panel less than 2 feet high by 3 feet wide (58.4 × 81.5 cm). And yet it gives the impression of great monumentality. Indeed, it is one of the most impressive and memorable works of the early Renaissance. The composition is primarily noted for its abstract strength, appearing as a series of rectangles and squares that work as shapes on the surface of the field, as well as elements in a set of mathematically perfect, diminishing transparent planes (figs. 22, 23). The figures and the architectural forms merge as implacably vertical solid bodies, stained with pure colors and bathed in crystalline light. One twentieth-century painter, Philip Guston, despaired at its perfection, confessing that, after seeing Piero's *Flagellation,* he found himself confronted with "the impossibility of painting."

The work was unknown until the late eighteenth century, when, after the cathedral of Urbino's vaults collapsed, an inventory of surviving furnishings was taken

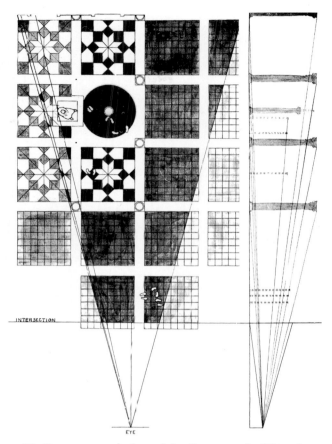

22. Reconstructed plan of the foreground of Piero's *Flagellation,* after Wittkower and Carter

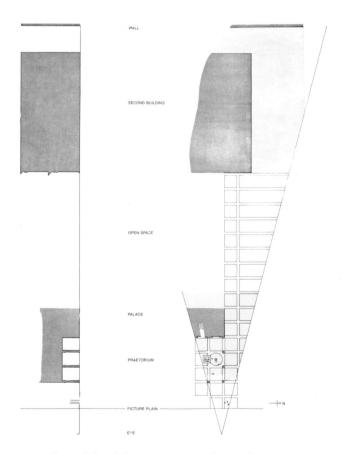

23. Plan of the full composition of Piero's *Flagellation* by Thomas V. Czarnowski

19

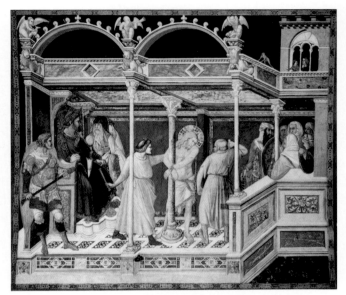

24. Pietro Lorenzetti. *Flagellation.* c. 1320. Fresco.
San Francesco, Lower Church, transept, Assisi

25. Sienese School. *Resurrection Altarpiece* (predella
panel: Flagellation). c. 1340–50. Pinacoteca,
Palazzo dei Priori, Sansepolcro

and the *Flagellation* was listed among the contents of the
sacristy. Lacking other documents, we can only guess that
the painting was done for someone in Urbino; but for
whom, for what purpose, and for what locale, we do not
know. In practical fact, the panel is somewhat small for an
independent altarpiece and rather too large for a predella.
It might have served as an altar frontal or a portable altar
to be set up by a devotee in private quarters or on a
journey. But even then, the narrative subject for an iso-
lated devotional image is extraordinary for the period.

As an iconographical type, the *Flagellation* represents
the moment in the Passion after Pilate has washed his
hands, when Christ is scourged, just before he is taken to
be crucified. Prior to Piero's painting, it had never ap-
peared outside a sequence of episodes recounting this full
story. If this *Flagellation* is indeed an autonomous work, it
would be one of the first examples in what became a
characteristic later in the Renaissance, a tendency to
transform narrative episodes, by changes of composition

and expression, into devotional images with independent
iconic value.

The traditional composition of Flagellation scenes was
symmetrical. Christ is in the center tied to a column, with
an equal number of ruffians at either side beating him with
whips and flails. Frequently, a crowd of spectators, in-
cluding soldiers, high priests, and scribes, along with
Pilate and his counselors, observes the scene. In about
1320, Pietro Lorenzetti in his Passion cycle on the tran-
sept vault of the Lower Church of San Francesco in Assisi
introduced a second type of composition (fig. 24). He
moved the Praetorium, or judgment hall, off center and
far to the left and opened a small plot of exterior space
outside the building to the right. Within the overall
scheme of Lorenzetti's cycle, this arrangement was bal-
anced by other episodes with complementary asymmetri-
cal compositions. The same approach appears in a tiny
Flagellation by an unknown mid-fourteenth-century Si-
enese painter that forms part of the predella of the
Resurrection Altarpiece formerly on the high altar of the
main church in Sansepolcro (fig. 25). Though very sim-
plified, the Praetorium in this scene is again flush with the
picture plane off center to the left, with a small outside
area, now provided with a door at the right. The asym-
metricality again is part of an overall pattern in the
consecutive Passion cycle that makes up the predella. It is
highly likely that Piero, at some point in his career,
journeyed to Assisi and saw the Lorenzetti fresco first-
hand. There is no question that he knew the small-scale
version in his hometown. In any event, he clearly returned
to this century-old formula for his composition. But in
doing so, he not only lifted the arrangement out of a
sequential narrative, he also changed all its spatial rela-
tionships in dramatic ways.

As in the prototypes, he moved the Praetorium to the
left margin of the panel, but he set it far behind the picture
plane; he likewise opened an exterior space on the right

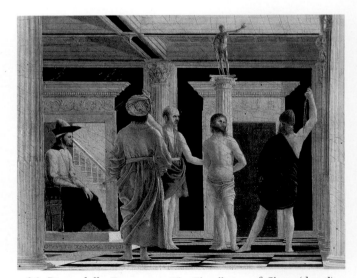

26. Piero della Francesca. *The Flagellation of Christ* (detail).
1458–60. Tempera. Galleria Nazionale,
Palazzo Ducale, Urbino

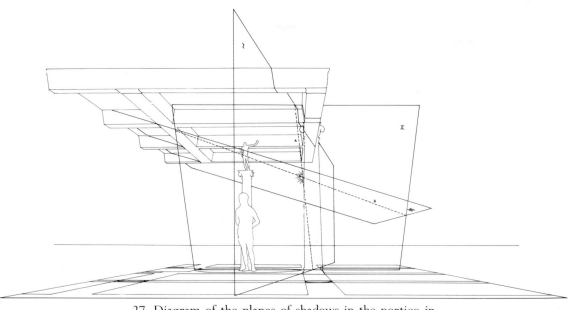

27. Diagram of the planes of shadows in the portico in
Piero's *Flagellation* by Thomas V. Czarnowski

side but projected the area both in front and deeply behind the loggia. Along the edge of this area, he introduced a second range of buildings behind the figures and closed the vista in the depth with a high wall, over the top of which landscape elements project. This rearrangement placed the actual scene of the Flagellation in the middle distance where the figures are greatly reduced in scale. At the same moment, the three ancillary figures from the story are thrust to the foreground where they receive prominence in an unprecedented way. Literally turning their backs on the Flagellation, these looming figures are separated from it in a psychological as well as in a physical sense. The asymmetrical format thus gave Piero the opportunity to create an unobstructed view of the Flagellation scene, while providing a separate area of space in which the figures in the foreground function independently. Splitting the scene in this fashion was very unusual. We must therefore take it as a signpost, pointing the way to a new and very special meaning.

The reason for these innovations becomes evident when we take note of a number of visual anomalies Piero has included (figs. 26–28). The first and most obvious of these is found in the light effects inside the Praetorium. There it may be observed that, although the ceiling of the first and third bays are shadowed, the bay in the center, over Christ, is ablaze with light. Clearly this phenomenon alludes to the metaphor of Christ as the Light of the World. Close inspection, however, reveals that the light on the ceiling does not emanate from Christ. There is a halo of golden rays around his head, but they do not shed light. The statue on the column behind him, for example, is lit not from below but sharply from the right. Upon further observation we note that all the forms under the loggia receive light from the right side, including Christ's own body, the front of Pilate's dais, even the studs on the door in the back. The direction of this light flow, more-

over, is opposite from the flow of light in the piazza. There light falls from the left and causes the columns and foreground figures, as well as other forms outside the Praetorium, to cast shadows to our right. Thus in the painting as a whole we are faced with what can only be called an irrational reversal in the direction of the light flow. If the light in the piazza is the ordinary, everyday light of the Northern Hemisphere, then left in the painting is south and right is north. Light in the loggia comes from the right, that is, north, and therefore it cannot be natural nor of this world. In a manner that we may now accept as typical, Piero has employed an entirely rational construction to create an effect that appears irrational. (The construction of this effect is discussed in detail with

28. Axonometric view of Piero's *Flagellation*
by Thomas V. Czarnowski

29. Donatello (?). *Ludovico Gonzaga, Marquis of Mantua.*
c. 1445–47. Bronze bust. Staatliche Museen,
Berlin-Dahlem. Stiftung Preussischer Kulturbesitz

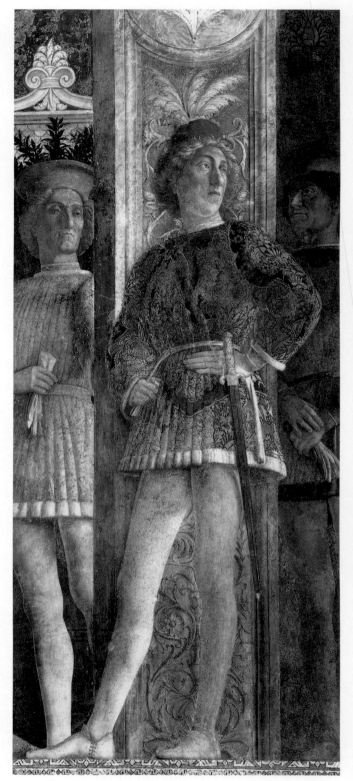

30. Joos van Ghent. *Astrology* (detail). c. 1475.
Formerly Berlin, now destroyed

31. Andrea Mantegna. *Gonzaga Court Scene* (detail). c. 1464.
Fresco. Palazzo Ducale, Camera degli Sposi, Mantua

Colorplate 5.) By doing so, he marks the Praetorium as a divine sanctuary and the biblical event taking place within it as a miraculous apparition.

The three men standing together outside the Praetorium are deep in conversation: one man is talking, one is listening, and the third, the young blond boy, rapt, is gazing into space. The similarity in pose and arrangement between this group and that of the Flagellation implies a relationship that goes beyond a simple narrative situation. I propose, in fact, that the foreground conversation concerns parallel events, tragedies that the two older men recently experienced, to which Christ's ultimate triumph over suffering during his Passion is held up as a paragon of hope. I emphasize that there are no documents to bolster the remarks I am about to make. I predict, however, that when and if such documents are found, the

explanation will follow the pattern I will now outline because it alone brings all the elements of the painting—the subject, the construction, and the visual effects—together into harmonious unity.

The profile gentleman with grizzled head on the right resembles quite closely, although at a more advanced age, a bronze bust of Ludovico Gonzaga marquis of Mantua, attributed to Donatello (fig. 29). The painted figure is dressed in aristocratic clothes and juxtaposed to an urban palace a man of Ludovico's station could appropriately call home. He listens attentively to the bearded man, whom I identify as Ottaviano Ubaldini, coeval nephew and prime minister to Federico Montefeltro, count of Urbino. In the fifteenth century, the ties between Mantua and Urbino were very strong, with frequent marriages, business transactions, and friendships among members of the families. One such attachment was between Ludovico and Ottaviano, who, after meeting at school, continued an unbroken correspondence for the rest of their lives. Ottaviano was a highly educated humanist, a bibliophile, and renowned astrologer. A portrait of him appearing with a personification of astrology by Joos van Ghent is shown here in detail (fig. 30). In fact, it was Ottaviano who was chosen to cast the horoscope for the consummation of the marriage between Gonzaga's granddaughter and Guidobaldo da Montefeltro, Federico's only son. With his exotic clothes and black beard, the figure in the painting is dressed as a wise man, or magus, and he appears before the buildings of the biblical scene. He is thereby associated with a superior knowledge and an understanding of the past. He is represented as speaking, with opened mouth and one hand making a gesture of emphasis.

In the late 1450s these two men, Ottaviano Ubaldini and Ludovico Gonzaga, were companions in sorrow: in 1458, Ottaviano's teenage son and heir, Bernardino, contracted the plague on a trip to Naples and died before he could reach home. There is much literary evidence for Ottaviano's mourning. Ludovico's loss was also due to illness. Of the many children at the Gonzaga court, his favorite seems to have been a boy named Vangelista, his dead brother's son. This young man was singled out by court chroniclers as being: ". . . blond and beautiful beyond belief, so beautiful that everyone spoke of it. At the age of sixteen he already showed the soldierly but generous spirit that made him dearly loved by the Marquis who supported him." The document goes on to say, however, that after only a few years at court, between 1458 and 1460, Vangelista contracted a disease from which he suffered two years. "It left him monstrously crippled and incapacitated, and caused him to lose all his beauty." I propose it was these events that brought Ottaviano and Ludovico together in sadness and were the motivation for the commission. The painting shows the two men searching for consolation for their incomprehensible losses. As Ottaviano compares the causes of their grief to the Passion of Christ, his words on the

Flagellation are made visible behind them. At the same time, the substance of his thoughts takes allegorical form. The blond youth standing in the center of the group, while physiognomically close to a member of the Gonzaga court (fig. 31), is idealized: his feet are bare and his golden eyes are set in an unearthly gaze. He is an allegory of the beloved son who, they must believe, will overcome physical decay, as Christ overcame his physical torment. As Christ remains unblemished by his Flagellation, so the memorial of the worldly son is whole and beautiful. As Christ is surmounted by a triumphal column with a statue signifying Glory, so the allegory of the beloved son is wreathed in laurel by the distant tree behind the wall.

The subject of the painting is thus not a simple Flagellation but a message of consolation. As such, it takes its place within a larger body of consolatory expressions, familiar in the humanist tradition, such as in the classical "Letter of Consolation" and in eulogies. Again Piero has combined the universal with the specific. He conveys the message visually, and by using the regular members of traditional iconography set into a mathematically idealized framework, he makes consolation inevitable within the scheme of God's perfect order.

THE BAPTISM OF CHRIST. Piero's *Baptism of Christ* is dated by most critics among his earliest works. However, because it has so much in common with the *Flagellation,* it more probably dates from the same time, that is, about 1460. Once again, a traditional narrative moment is isolated as the subject of a devotional altarpiece and structured with a spatial no-man's-land in the foreground. As in the *Flagellation,* a vista sweeps far into the distance, and the figures appear in separate groups at different depths in the depicted space. Their volumetric grandeur, silhouetted directly against the distant backdrop, once more makes them function as cylinders and cones, with all but tangible spatial intervals between them. The difference, of course, is that the *Baptism* is pure landscape, and the spatial projection is built not of geometric shapes as in the *Flagellation* but of the unpredictable forms of nature.

The very existence of this perspective penetration into space seems to contradict the fact that, originally, the *Baptism* panel was the centerpiece of a monumental Gothic-style polyptych, all the other panels of which have gold backgrounds (fig. 32). Besides an elaborate carpentry frame with scrollwork finials, there were tall figures of St. Peter and St. Paul standing in the wings. Next to Piero's rounded forms, these figures seem quite retarditaire in style, looking flat and crinkled like crushed metal. The superstructure of the frame included graduated rondels with images of God the Father blessing in the center (lost) and Mary Annunciate and the angel Gabriel at either side. These accessory panels, as well as a predella with narratives of the Baptist's life, were painted by Matteo di Giovanni, a Sienese artist who is documented in San-

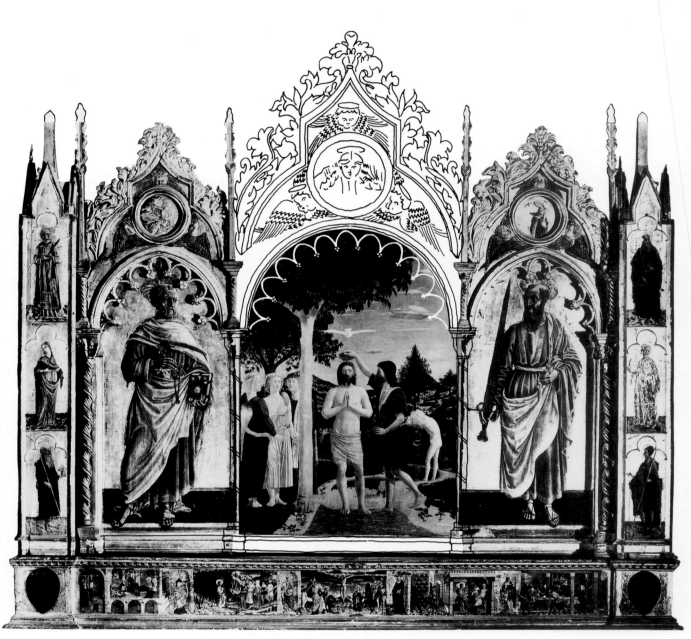

32. Reconstruction of Piero's *Baptism of Christ* by J. B. Neuenschwander

sepolcro in the 1460s. As anomalous as these combined styles may seem, the altarpiece was probably conceived as a unit to serve a chapel dedicated to St. John in the Camaldolite Abbey Church of Sansepolcro. Although it was moved more than once, the ensemble stayed together until 1859, when the *Baptism* panel was extracted and sold.

The subject of Piero's panel follows biblical accounts of Christ's Baptism, which took place when John was preaching repentance at the Jordan. The people of Jerusalem came to listen, and those who were persuaded (the catechumen) undressed to receive John's cleansing bath (fig. 39). When Christ appeared among the crowd, John recognized him and called him the "Lamb of God." As Jesus entered the water, angels assisted, the Holy Ghost in the form of a dove (the Paraclete) descended, and the voice of God was heard, saying: "This is my beloved son in whom I am well pleased." Medieval theologians designated this first manifestation of Christ's divinity on earth

as the "Descent of Divine Illumination," the "first revelation of the Trinity," and the moment of the "Marriage of Christ and the Church."

Piero has included all the traditional figures of the scene: Christ and John, shown as the sacral water spills forth from John's cup; angels standing in attendance; a beautiful white dove hovering over Christ in perfect frontal foreshortening; a half-naked catechumen at the river bank; and elder citizens of Jerusalem in the distance. Although not in the landscape space, God the Father originally appeared in the rondel above, probably leaning forward in a sharply foreshortened pose of blessing. What is new about the scene is the setting: a sunny country landscape, full of flowering trees, backed by rolling hills and a distant village, and covered with a brilliant azure sky. The atmosphere is luminous, the mood is peaceful, and the action static and in perfect balance. This fully developed landscape is one of the first on a monumental scale since classical antiquity.

24

Yet for all its tranquillity, the scene evokes a haunting sense of portent. Pensive glances, tremulous poses frozen at the high point of a gesture, and a rigid feeling of fragility shatter the apparent calm. The scattering of the figures through the space brings with it a sense of isolation, and the painted individuals, though earthy folk, seem unapproachably statuesque. Christ and John, in particular, concentrate with unwavering seriousness, appearing as human paradigms, one a fully frontal, classicizing nude, the other in perfect profile, clad in a rough hide tunic. The winning youths dressed as angels, with rainbow-colored wings and variegated clothes, do not hold Christ's garments or pray, as usual in a baptism scene, but stand clandestinely behind a tree, their faces full of sympathy. Quite oddly, they touch each other in various ways. Farther back, the catechumen is alone, arching over the river with his head buried in his shirt. Behind him are exotically dressed older men who do not watch the Baptism but gesticulate among themselves. Thus beyond requirements of the narrative, Piero has instilled the well-known biblical characters with mysterious power and again evoked a second nature for his scene.

The baptismal group itself is not a duo but a threesome that includes, in an astonishing way, a tree growing on the river bank and all but filling the panel's semicircular top. Its smooth, silvery trunk and a lush growth of green-black leaves and ripening nut pods identify it as a Mediterranean walnut (*noce* in Italian). As such, it balances John not only physically but symbolically as well. As John is known to be Christ's forerunner, so the walnut is said to predict his future. In Christian symbolism, the walnut had come to represent Christ's Crucifixion, the hard outer shell of the nut representing the wood of the Cross and the soft meat inside, the flesh of the Savior. The tree's presence thus brings to the image of John's "baptism of water," allusions to Christ's later Baptism, that of blood, when his final sacrifice will be made.

Beyond this theological symbolism, the tree has a second, more particular meaning. By its very genus, the walnut identifies the setting of the painting in the environs of Piero's native town. Val di Nocea, or Valley of the Walnuts, is the ancient name for the crater bed where the river Tiber begins and where, in the tenth century, the town of Sansepolcro was founded. According to local legend, at that time two pilgrims, named Arcano and Egidio, returned from the Holy Land with relics from the tomb of Christ. When they arrived at the Val di Nocea they stopped to rest. As they slept, God appeared and told them to end their journey and make a home for the relics there. They obeyed the command, and the shrine they built in a clearing in the forest became the core of what was later a large Camaldolite monastery around which, still later, the town of Sansepolcro developed. The church of this very monastery (after 1518, the cathedral) housed a chapel of St. John for which the painting was probably made. Because the pilgrims' relics were part of Christ's

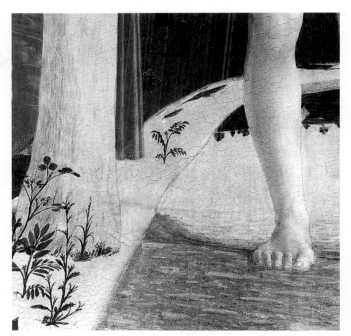

33. Piero della Francesca. *The Baptism of Christ* (detail). c. 1460. Tempera, 167 × 116 cm. National Gallery, London. Reproduced by courtesy of the Trustees

tomb, because the church building was called a copy of the Holy Sepulcher, and because the town had been "Christian from its birth," the citizens of Sansepolcro not only called their town a New Jerusalem but proclaimed their place to be a "holy site." By bringing the Baptism of Christ to the city's outskirts, Piero fulfills this self-image. Showing the sepulchral city in the background, he resanctifies the River Tiber as the Jordan and, with the symbolic tree, identifies the Baptism as the beginning of the Passion. The tree is thus not only a compositional counterpoint to John, its significance completes the action that John's gesture initiates.

One of the most striking elements in the setting is the way the river meets the picture plane head on. Starting in the background, the river meanders through the valley and swings around in a final S-curve to flow directly forward toward the spectator. This dramatic confrontation leads us to observe a startling fact: the glassy, reflective surface comes to a stop behind the feet of Christ (fig. 33). Although thin lines at his ankles show he is actually in shallow water, the effect makes Christ seem to stand on dry ground. An ancient tradition records that at the moment of the Baptism, the waters of the Jordan recognized Christ's divinity by reversing their flow ("Conversus est" [Ps. 114:1-2]). During the Middle Ages this Miracle of the Jordan was often represented by an allegorical figure seated in the water with his back turned. An example is the stone relief of 1220 by Marchionne on the façade of Santa Maria della Pieve in Arezzo, which must surely have been known to Piero (fig. 34). He represents the same miracle but, once again, does so in an entirely rational way. By placing the point where the sunlight shifts from reflection to refraction precisely

34. Marchionne. *Baptism of Christ.* 1221. Stone relief. Santa Maria della Pieve, right portal, tympanum, Arezzo

behind Christ's foot, he creates the illusion of a prodigious phenomenon. In doing so, moreover, he summons a whole chain of allegorical types and figures for baptism from the Old Testament—the stopping of the Red Sea, Elijah stopping the Jordan with his cloak, Joshua crossing the stopped Jordan with the Ark of the Covenant. Since all of these events involved similar watery miracles, they serve as proof of the presence and the power of Christ's divinity. Most important, with this image, Piero defines the Baptism as a theophany: the first public appearance of the Lord in his hypostatic state, shown as both man and God. This concept underlies the iconic quality he gave the stony face, the shining body, strong as an athlete's, framed and sustained by his erect and steadfast cousin, John the Baptist.

In the calendar of the Catholic Church, the Theophany is celebrated as a liturgical feast on 6 January. Its institution in the early centuries of Christianity replaced an ancient festival of the sun's rebirth held on the winter solstice (calculated as occurring on this date before the Julian calendar reform). By the fifth century, two other feasts of Christ's manifestation were joined to this cele-

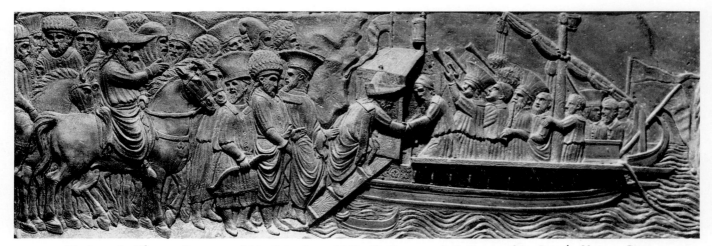

35. Antonio Filarete. *Departure of John Palaeologus.* 1443–45. Bronze relief. Doors of St. Peter's. Vatican City

36. *Adoration of the Magi.* Late 3rd–early 4th century. Fresco. Catacomb of Domitilla, Rome

bration: One was the Epiphany, the liturgical name given to the Adoration of the Magi. As the Baptism is often defined by the Church Fathers as the first manifestation to the Jews, so the Epiphany is called the first manifestation to the Gentiles. The other feast joined to the celebration on 6 January is the Bethany, or the Miracle at Cana; this feast celebrates the manifestation to the Apostles.

The association of these three manifestations of Christ on earth is announced in the liturgy of second vespers of this feast, in the Magnificat Antiphon, which reads:

> *We keep this day holy in honor of three miracles: this day a star led the wise men to the manger; this day water was turned into wine at the marriage feast; this day Christ chose to be baptized by John in the Jordan, for our salvation, alleluia.*

Not surprisingly, there was an unbroken tradition in liturgical manuscript illumination giving visual form to the doctrine of the triple manifestation. The three scenes that represent the miracles are often shown framed together and stacked one above the other in the order they are mentioned in the antiphon (fig. 37). Piero follows this tradition by making the same triple allusion but again modernizes it into a single visual structure. As John and Christ act out the Baptism, the gesticulating elders in the background refer to the Magi of the Epiphany. And, at the same moment, the hand-clasping angels allude to the

37. Illustrations of the Epiphany from the *Missal of Odalricus.* 1st half of 12th century. Manuscript illumination. A.A.35, fol. 60v. Landisbibliothek, Fulda

38. Jacopo della Quercia.
Stone tabernacle (detail). c. 1420.
Museo Comunale, Bologna

Marriage of the Bethany. In his version, the naturalism of the spatial construction, and the single moment of time it implies, express the theological unity of the feast in an entirely new way.

The reason for alluding to the feast of 6 January takes us back to the identification of the setting as the Val di Nocea. The donor of an altarpiece dedicated to St. John the Baptist had a choice of suitable subjects for a devotional image: an isolated figure of the Baptist would have been the most common at this period. The donor also could have chosen a scene of John's birth or one of his death; both of these events are celebrated as religious feasts (24 and 29 August). The Baptism, on the other hand, is not a feast of St. John but of Christ. And by including references to the other Christological feasts celebrated on the same day, Piero has made this liturgical identification inescapable. By choosing the one moment in John's life in which he interacts with Christ, and by including the walnut tree as a major actor in the drama, Piero relates the Baptist, in the only way possible, directly to the city of Christ's tomb. By isolating the liturgy of the Baptism as the center of a devotional altarpiece, and by giving it a naturalistic landscape setting, he has portrayed to the local worshipers in Sansepolcro the symbolic

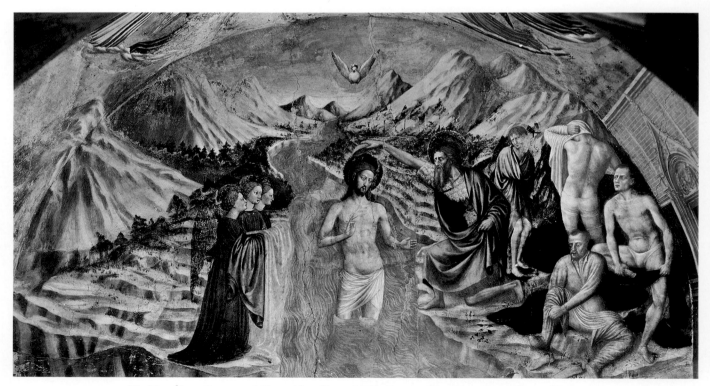

39. Masolino. *Baptism of Christ* (detail). c. 1430. Fresco. Baptistry, Castiglione Olona

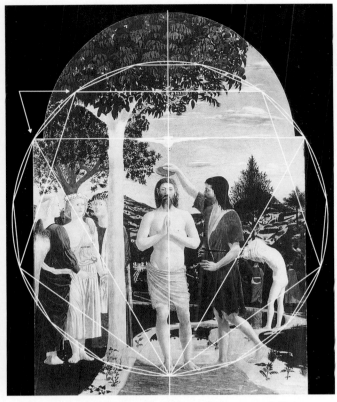

40. Geometric overlay of Piero's *Baptism of Christ* by B. A. R. Carter

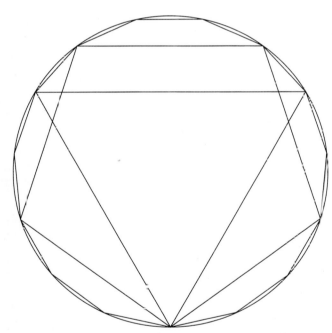

41. Diagram of Euclid's Proposition 16, Book 4: Construction of a 15-sided equilateral, equiangular polygon

meaning of their homeland as an ideal Christian realm.

The disturbing equipoise so apparent in the painting and the substance of its symbolism stems, in a remarkable fashion, from its geometrical framework. This framework was discovered by B. A. R. Carter (fig. 40), whose earlier analysis proved so important for an understanding of the *Flagellation*. Mr. Carter and I worked together to produce

the following analysis of the *Baptism* as an example of the indivisibility of Piero's science and his art.

The panel is composed of two geometric shapes, a rectangle (112.25 × 116.2 cm) and a semicircle (dia. 109.5 cm). Their combined heights measure almost precisely half the width of the rectangle plus the diameter of the semicircle (167.3 cm). This simple relationship reveals a proportion of height to width of 3:2. The figure of Christ, placed at the geometric center of the panel's lateral dimension, is 83.7 cm tall, or exactly one half the panel's overall height. The real measurement of the width, moreover, proves fundamental: 116.2 cm convert to almost exactly two Florentine *braccia* (or "arm's length"), a standard Renaissance measurement that equals 58.36 cm. As opposed to most Renaissance panel paintings, usually made of three planks of wood, this one is made of only two, and each plank standing vertically is one braccia wide (a fact that has caused a major crack down the middle, somewhat damaging the body of Christ). This "one braccia" measurement seems to have been the "given" from which Piero evolved all the rest of his calculations.

The analysis begins where the outstretched wings of the dove align perfectly with the join of the semicircle and the rectangle. Using the top side of the rectangle, an equilateral triangle can be drawn by dropping lines to the tip of Christ's right foot. The center of this triangle falls precisely at Christ's fingertips. These relationships contribute vastly to the stability of the surface. Moreover, in plotting a three-sided figure, with its strong trinitarian allusion, Piero symbolizes the Descent of the Holy Spirit. Now using the center of the triangle to generate a circle that enscribes the triangle, and then overlaying an equilateral pentagon, the number five is added to the sequence, bringing the further allusion to Christ's five wounds, appropriate to the meaning of Baptism at the beginning of the Passion.

From a mathematical point of view, the configuration in this manner is reminiscent of the Euclidian Proposition 16 (Bk 4), which gives the formula for constructing a fifteen-sided figure, equilateral and equiangular (fig. 41). It is from the points of this figure that all the measurements in the painting were generated. One must recall that the distance between an angle of the triangle and an angle of the pentagon (known as the chord of a segment) equals one side of the proposed polygon. This chord subtends at the center of the circle at 24 degrees. The chord's finite measurement of 27.897 cm is the painting's fundamental unit. First of all, it determined Christ's height, being exactly one third of 83.7 cm. Taking the chords of multiples of 24 degrees yields the following: the chord of 48 degrees equals the radius of the upper semicircle; the chord of 72 degrees (one side of the pentagon) equals the distance from Christ's fingertips to the bottom of the panel (locating Christ's position in space); the chord of 120 degrees (five times 24) equals one

side of the triangle and therefore the width of the panel.

It is the chord of 24 degrees, however, that remains the most propitious. One of the great astronomical problems of antiquity and the Middle Ages was the attempt to measure the angle of the declination of the sun toward the earth, called the "obliquity of the ecliptic." This tilt in relation to the plane of the equator gives us the seasons. The belt of the sky extending about 8 degrees on each side of the ecliptic is the region known as the "zodiac." By the fifteenth century, most astronomers (including Paolo Toscanelli, whose work made the journey of Columbus possible) agreed that a definition of the ecliptic as 24 degrees (minus a few decimal points) was acceptable. As we have seen, the Feast of the Epiphany is celebrated on 6 January, the day considered still in the fifteenth century to be the winter solstice and the birthday of the sun. What this analysis reveals is that Piero has identified Christ with the sun (Sol Invictus is one of his epithets) in mathematical terms. By using a Euclidian construction to determine the scale of the painted space and the absolute dimensions of Christ's body, Piero put Christ in the center of the ecliptic, the center of the zodiac, and thereby (according to ancient cosmology) the center of the universe. In effect, while creating a naturalistic setting, he found a mathematical way to symbolize Christ as Divine Light. The theological value of this abstract construction goes a long way in explaining the unexpected sense of portent we perceive at the heart of this sunny, rural landscape.

THE LEGEND OF THE TRUE CROSS. In the commission for painting the cycle of the *True Cross* in the church of San Francesco in Arezzo, Piero was the second choice. The property in the chancel of the church had been purchased in the early fifteenth century as a burial site by an Aretine mercantile family named Bacci. As was usual with such transactions between monastic orders and lay supporters, the permission to purchase was counterbalanced by a promise to provide the area with suitable decoration. After forty years, however, no work had been done. Not until 1448 did the Bacci heirs begin to honor their commitment when they hired Bicci di Lorenzo, a prolific, workaday artist from Florence, to do the job. By 1452, the Evangelists on the ceiling and a monumental Last Judgment on the exterior façade of the triumphal arch had been completed, at which point Bicci died. These features, along with the Fathers of the Church on the underface of the arch (the intrados were painted later), set the stage of orthodoxy for the painted legend that was planned to embrace the entire chamber where the high altar stands. Although there are no documents concerning Piero's participation in the project, Bicci's death is taken as the terminus post quem for his arrival. The ante quem for completion of the job is 1466, gleaned from a reference to it in a document of that date written in the past tense. During the fourteen years circumscribed by these dates, how Piero allotted his time can only be surmised.

Given the slow pace of the commission up to this point, he might have planned his contribution before he left for Rome in 1458, but he surely did most of the painting after he returned to Tuscany the following year.

As in many monumental cycles of the time, Piero's frescoes appear on all three walls of the chancel, each divided into three superimposed tiers. The subject of the True Cross, a complicated compilation of legend and history, appears often in Franciscan churches of the fourteenth and fifteenth centuries. In it, the history of the sacred wood of Christ's Cross is traced from its origins in the time of Genesis, through the reign of Solomon, to the period after the Crucifixion when it began to work miracles. The story ends in the seventh century, with the theft of the relic by the king of Persia and its recovery by Heraclius, the emperor of Byzantium. The relevance to the Franciscan order is not far to find. Of the many manifestations of St. Francis's devotion to the Cross and all it symbolized, the most important was his Stigmatization, when he received the wounds of the Crucifixion in his own body. This event was said to have occurred while he was meditating at Mount Alverna, on or near the Feast of the Exaltation of the Cross (14 September). The Exaltation is one of two liturgical feasts dedicated to the Cross (the Invention of the Cross, 3 May, being the other) that celebrate all the events represented in the cycle.

Besides this mystical relationship, another motivation for Franciscan interest is the story's Jerusalemic context. Thirteen of fifteen episodes represented take place in Jerusalem, where, beginning in the early fourteenth century, the Franciscans had a mission as custodians of a number of holy sites. The order thus had a vested interest in documenting its prerogatives in the face of contemporary territorial claims from the Muslim community.

The most illustrious representation of the True Cross legend before Piero's—and the very first to represent it on a monumental scale—was that by Agnolo Gaddi (1388–93, Santa Croce, Florence; fig. 42). Paying homage to this venerable prototype, Piero alluded to some of Gaddi's innovative compositions with his usual respect for previous tradition. At the same time, as we have seen before, he went far beyond the limits of tradition and raised the story and its implications to new heights of universal meaning.

He began by organizing the wall surface in a very simple manner (fig. 43). He painted heavy architectural moldings around the lunettes and between the tiers. But although he included more than one episode on four of the six side-wall tiers, he excluded all vertical framing devices between them. With few exceptions, multiple figure compositions spread across the full width of the wall and simply disappear from view at the edges and the corners. Next, he made no perspective adjustments for the height of individual tiers. No matter how high or low, each composition is seen at eye level. Moreover, backgrounds of rolling hills, or trees, or sky seem to lock the figures

42. Agnolo Gaddi. *Seth and Michael* and *Death of Adam*. 1388–93. Santa Croce, chancel, right lunette, Florence

onto shallow frontal planes, trading cool blues that retreat with warm reds that thrust forward and suppress perspective diminution. With the solemnity of sarcophagus friezes densely populated with high reliefs, the characters appear in a world of measured classicism where anecdote and storytelling play a minor role. Yet even in this classic calm, a sense of place prevails. The background hills and streams are decidedly Tuscan in cast, and the portrait of Arezzo that Cézanne found so impressive (second tier left) includes an image of the very church in which the cycle is painted.

In contrast to its visual sobriety, and to most viewers' great surprise, the arrangement of the narrative is distorted almost to the point of chaos (fig. 44). The starting point of the chronological sequence is at the top, on the right wall rather than the left, as one might expect. The first three episodes proceed, moreover, from right to left. On the second tier the order reverses, and after two scenes, the sequence jumps all the way back to the altar wall on the second tier to the right of the window. The chronology then moves diagonally toward the left, down to the bottom tier. Reversing again, it passes across to the lower right side of the altar wall and afterward turns the corner, moving back to the right wall on the bottom tier. There it reads across, left to right to the outer edge of the

precinct. Again, it zooms back to the altar wall, now on the upper tier left of the window. Remaining on the same tier, it jumps to the outer edge of the left wall and moves back through two episodes to the inner corner. Dropping to the bottom tier and after passing across its width, the story climbs up to the lunette where, in a final scene, it ends.

The erratic path of this perambulation has always been a sticking point in understanding the cycle. Because the story does not read in a simple sequence from left to right, Piero's intention was claimed to be not only incomprehensible but unique. It was thus with great elation that the iconographers of the 1960s and then the structuralists of the 1970s and 80s saw that the scrambling of the chronology led to a series of pairs facing each other across the chancel and matching in both formal organization and in theme.

The pairing of tiers is indeed striking: the lunettes show the beginning and the end of the story, with a great spreading tree on the right balanced by the exalted Cross held high on the left. Both compositions have elements that run perpendicularly to the picture plane, leading to small-scale figures in the background that enrich the sense of time and space. The second tiers on both sides have two episodes, one set in landscape, the other in

31

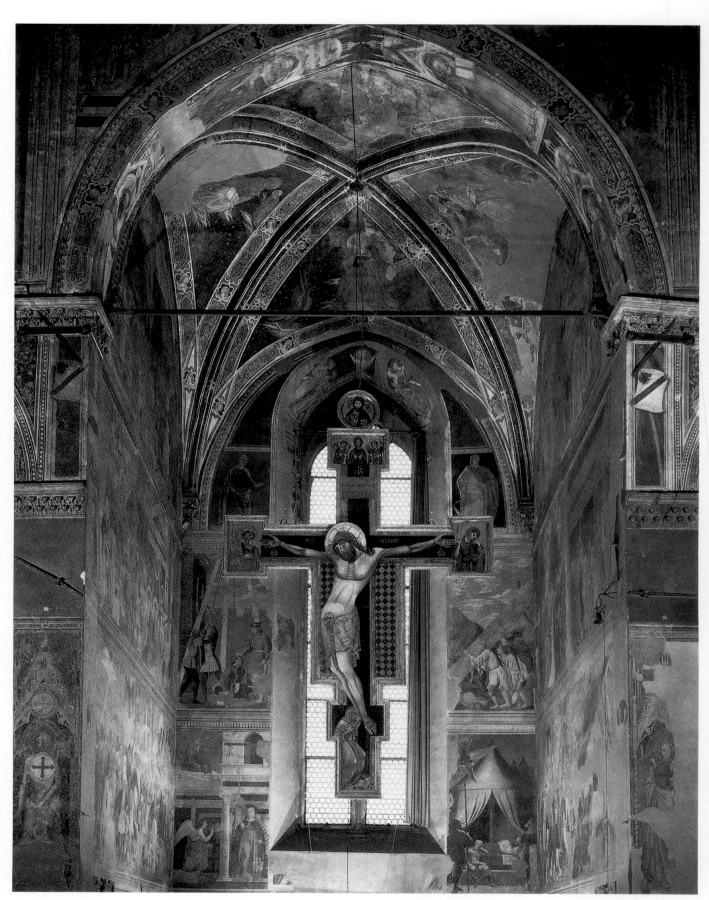

43. Chancel of the church of San Francesco, Arezzo

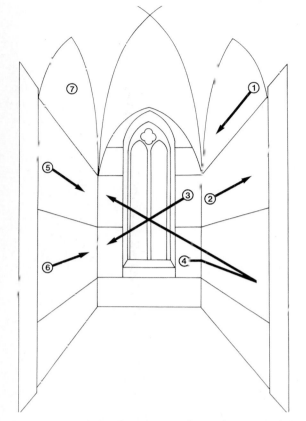

44. Diagram of the disposition of Piero's *Legend of the True Cross* by Susanne Philippson Ćurčić

architecture (Colorplates 16, 24, 25). One shows the mystical prescience of queers: on the right, the Queen of Sheba kneels before the log of wood she recognizes as sacred; on the left the Empress Helena venerates the miracle-working True Cross. Sheba bows to the superior knowledge of Solomon on the right. Helena cedes to the advice of Judas on the left. On the altar wall, the upper tiers show the lowering of the wood on the right and the raising of the Jew on the left, both scenes dominated by strong diagonals. The two lower scenes are annunciations: on the left, the Annunciation to Mary, the beginning of the scheme of salvation, and on the right, the Vision of Constantine, the annunciation of the end of paganism. On the side walls, both bottom tiers are friezelike battle scenes; both show victories under the cross of Roman emperors. On the right is Constantine the Great, who established Christianity as the state religion; on the left, the Byzantine emperor Heraclius, who liberated the Cross from the Eastern "pagans."

It must be pointed out, however, that techniques of pairing in this manner had been in use long before Piero's time and remained so long after. What is new about his version is the clarity, consistency, and strictness of the symmetry he creates. His structures and thematic pairings are so pervasive that, coupled with the formal abstraction of his style, they became a part of what has characterized his modernism most deeply for many of his twentieth-century admirers.

From a more sober point of view, it is unlikely, in any case, that a fifteenth-century artist could have manipulated a narrative sequence without consultation and advice from his patrons. He also would not have produced such pairings without a motivation deeper than the desire for pure symmetry. Upon examining the history of mural painting more closely, in fact, it becomes clear that rearranged chronology was not an exception but the rule, and that the purpose of the "irregular" monumental mode was to express the concepts of morality, theology, and politics embedded in the apparently simple stories depicted. Long before Piero's time there were developed a number of set patterns for making such rearrangements, and along with colleagues like Fra Filippo Lippi and Mantegna, Piero put these patterns to use. For example, the reading order on the upper two tiers of the right wall is first right-to-left and then left-to-right. I have named this pattern the "Boustrophedon" (after the path farmers take in plowing). With it, Piero emphasizes the movement through time and space represented in those scenes. The four episodes on the altar wall are arranged in what I have called the "Cat's Cradle": crossing diagonals move from upper right to lower left, and lower right to upper left. This pattern calls attention to the essential connections between scenes of disparate origin, in this case Roman history and medieval myth. The fact that the cycle starts at the upper right reinforces the story's orthodoxy, referring to a protocol followed in almost every medieval church in Italy. Here the overall movement of the narrative is first downward; then, passing to the opposite wall, it rises from the bottom to the top. This path traces the "Up-down Down-up" pattern, traditionally used to place scenes of exaltation in the upper region, closest, as it were, to the celestial realm. Indeed, the upper tier on the left wall takes this mandate literally by housing the ritual scene of the Exaltation of the Cross. Piero's novelty was to use so many patterns in such a complex bond. But, clearly, he followed tradition to set up his hectic order, and he kept his chronological dislocation evident to make sure it would be noticed.

What this abruptly turning structure resembles is nothing so much as the narrational arrangement of chivalric romances. Troubadour songs like the *Chanson de Roland* are presented as a series of adventures loosely strung together without a logical sequence of time or place. The themes involved in the chanson tradition— stalwart knights in battle, pious and courageous ladies, the quest for a holy relic, and above all, the liberation of Jerusalem, are the same as those in the story of the True Cross. Both the songs and the holy legend, moreover, bore heavy political burdens. Recounting the Christian mission in the conflict, they both made overt propaganda against the Muslims who were sweeping around the Mediterranean basin. The "Turkish Question," as it became known, remained an important issue long after the great Crusades of the twelfth and thirteenth centuries

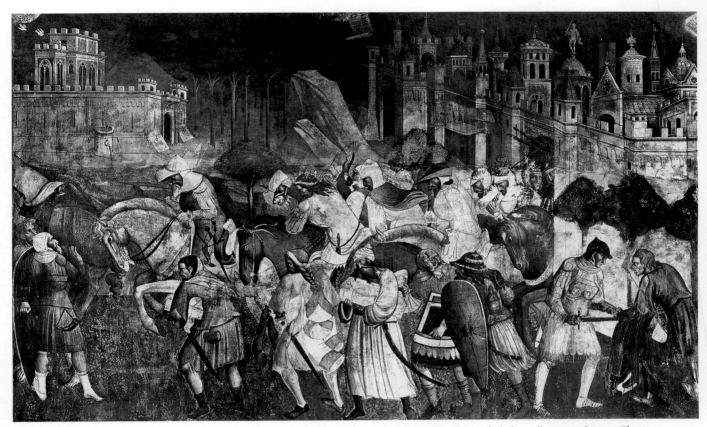

45. Agnolo Gaddi. *Chosroes Steals the Cross.* 1388–93. Fresco. Santa Croce, chancel, left wall, second tier, Florence

and was still very much alive in fifteenth-century Italy, where the mainland around Venice was being directly threatened. In fact, just before and after 1453, when Constantinople fell to the Mamluk Turks, popes Eugenius IV and Pius II, during the years 1448–64, both tried without success to launch Crusade-like counterattacks.

Nevertheless, aside from general concern for the order's custodial duties in the Holy Land, neither the Franciscan friary of Arezzo nor the commune itself had much to do with these political activities. Although Piero's cycle, by its very nature, could not but make reference to contemporary events, no direct connection between the Aretine Franciscans or members of the Bacci family—the actual sponsors of the cycle—and the war effort has ever been found.

Much more pertinent for Piero's conception were elements in local Aretine history. A bitter rivalry between Arezzo and Florence went back to pre-Roman times. Throughout the Middle Ages the two communes were constantly at war, besieging each other's walls and occupying territories. Though a proud and brave people, the Aretines tended to lose because they were constantly weakened by internal strife and were never able to present a united front. In 1385, in the wake of a conquering French invasion, the town and its properties were sold for 40,000 florins to a jubilant Florence. In a day, Arezzo lost its autonomy. The ruling families were subdued and a Florentine administrator was imposed as governor. Minor rebellions erupted with regularity over the next hundred

years, but to no avail. For many centuries thereafter, Arezzo remained a Florentine province.

At the moment of the fateful purchase, and in relation to the same political events, the story of the True Cross acquired strong Franco-Florentine associations. Owing to a major role played by Charlemagne in Florentine foundation legends, the mythologized French king and his son Roland became the city's Christian knights par excellence. The troubadour poems that recount their adventures were translated into Tuscan dialect and sung almost as national anthems. Started just after Florence purchased Arezzo, Agnolo Gaddi's True Cross cycle in Santa Croce displays this chivalric character. The scene *Chosroes Steals the Cross* (fig. 45), for example, with its galloping horses speeding out beyond the borders, looks for all the world like an illustration to a chanson episode. However, even after living seventy-five years under Florentine rule, the last thing the Aretines would have wanted was to have such a reference in their fresco cycle. Piero's assignment actually might have included orders to relieve the subject of its Franco-Florentine bias.

Yet he refers to it with the displaced chronology. And the very tension between the "out-of-order" narrative disposition and the symmetrical pairing of the scenes calls attention to the polemic. As the picaresque chronology summons vision of the romances, they are contradicted by the harmonious classicism of the pairs. It is through this very tension that we notice all allusions to Charlemagne and his knights have been dramatically re-

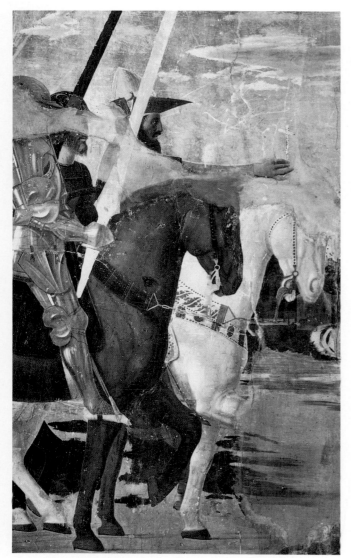

46. Piero della Francesca. *Legend of the True Cross:
The Battle of Constantine* (detail). 1452–66. Fresco.
San Francesco, chancel, right wall, bottom tier, Arezzo

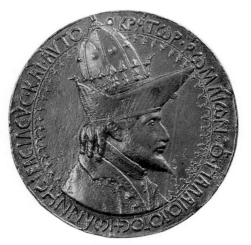

48. Pisanello. *Emperor John Palaeologus.* c. 1438.
Bronze medal. Louvre, Paris

placed by Emperor Constantine. Two scenes of Constantine, the *Vision* and the *Battle,* transport the story immediately back from medieval France to imperial Rome.

Although forming an important part of the written version of the story, Constantinian episodes had not appeared in art for more than three hundred years. Piero's scenes of the Roman emperor are the first in a postmedieval cycle, and the first ever on a monumental scale. On one level, introducing Constantine effectively doubled the number of battle scenes and made a pair. On another, Constantine's presence is redolent with Aretine civic mythology and therefore makes a political statement. All Aretine chronicles emphasize the fact that, while the town was founded by the Etruscans and sustained by Rome, it was uniquely blessed for having converted to Christianity at a very early date. Part of the civic self-image took shape from the fact that the first bishop of

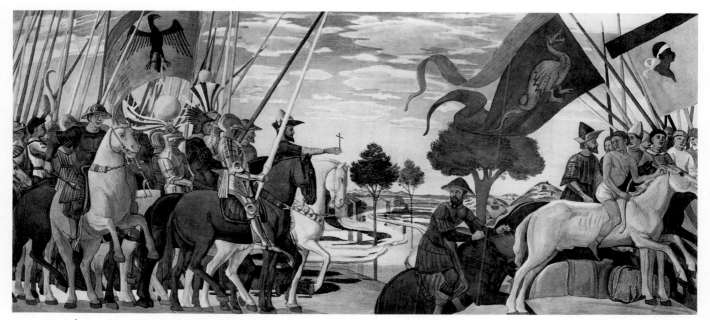

47. Johann Antoine Ramboux. Copy of Piero's *Legend of the True Cross: The Battle of Constantine.* c. 1820. Watercolor.
Kunstmuseum, Düsseldorf. Graphische Sammlung

Arezzo was nominated by St. Sylvester, who, in turn, was appointed pope by Constantine himself. On this account, the city saw itself as benefiting from the virtues of its classical past, greatly augmented by the spiritual riches of the new faith. In the scene of Constantine's victory on the right wall's bottom tier, the event is shown correctly at the River Tiber, but not at Rome (fig. 46). The setting of the stream that winds its way into the distance behind the struggling horse is not at the Milvian Bridge, where the historical battle took·place, but in a simple Tuscan landscape, resembling the Alta Valle Tiberina in the hills behind Arezzo.

In this light, the exaggerated symmetry of the thematic pairing takes on an almost patriotic air. Symmetry is but one of a series of classicizing elements that characterize the cycle and contributed to its modernity in its own period: the compositions are grave and dignified; the figures are posed with decorum; emotional expression is strong but reserved and unified; the scenes are filled with variety but not cluttered; the spatial constructions are rationally controlled and have proportional harmony. There are even some elements that blend the serious with the humorous without disgrace. These characteristics were modern in a fifteenth-century sense because, unlike the chanson illustration tradition, they have rhetorical cohesion. It is important to note that at this very moment in history humanists throughout Italy, relying heavily on what they knew of Aristotle through the screen of Horace's *Ars poetica,* were striving to revive the classical epic. This goal in literature was not achieved for another century in the poems and theoretical works of Tasso.

Long before, however, Piero found the visual equivalents to Horace's requirements. With his compositions of balance and symmetry, he bent the erratic serial fable into an heroic myth of Christianity's foundation and displayed

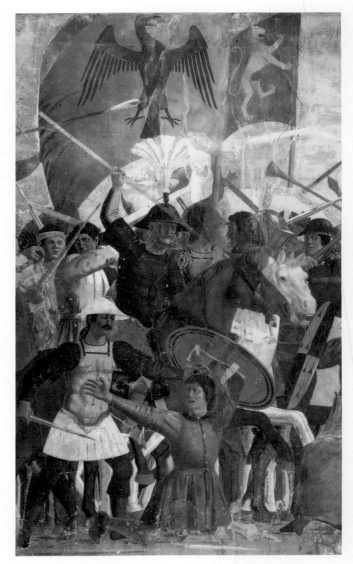

49. Piero della Francesca. *Legend of the True Cross: The Battle of Heraclius* (detail). 1452–66. Fresco. San Francesco, chancel, left wall, lower tier, Arezzo

50. Arch of Constantine (detail: Trajanic battle scene). Rome

36

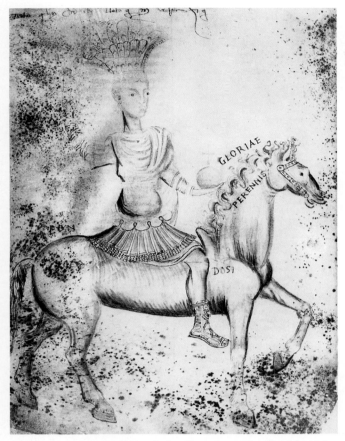

51. Anonymous. *Byzantine Rider.* Drawing. Ms. 35, fol. 144v.
University Library, Budapest

52. Anonymous. Illustration for Boccaccio's *Decameron*
("Story of Andreuccio"). 1492. Woodcut.
Stampa di Gregori. Fondazione Giorgio Cini,
Istituto di Storia dell'Arte, Venice

it with the grandeur of the *Iliad* or the *Aeneid*. His purpose was to represent the history of the Christian state: preparation for the Messiah in patriarchal times; official conversion of the pagans; establishment of the cult of relics; suppression of heresy; and the liberation and protection of the Holy Land. And he achieved his goal. He satisfied the Franciscans with a cycle celebrating the Cross. By representing Constantine and doubling the number of battle scenes, he purged the story of its latent French accretions and made it stand for Aretine independence. But more important, he called attention to the universality of the story of the Cross as religious history and thereby raised the theme to the level of a foundation myth. What seems modern to us in the cycle, its dignity and grandeur, seemed equally modern in the fifteenth century. For Piero used his abstract, ideal, classical style to create the first full-fledged modern epic.

THE RESURRECTION OF CHRIST. Some time before 1474 Piero painted a fresco of the Resurrection of Christ on the wall of the town hall of Sansepolcro (fig. 53). Although mentioned in a document of that date concerning structural repairs the building was then undergoing, the date of the actual commission is unknown. The Residenza, as the town hall was then called, was divided into two long communicating chambers, the first used as the entrance hall and the second as the official meeting room of the

town council. Piero's painting appeared in a place of prominence high on the wall dividing the chambers, facing the main entrance to the building. Communal meeting halls of the Middle Ages and Renaissance often received mural decoration, for the most part with subject matter concerning military victories, properties owned by the commune, or allegories of governance and civic virtue. An isolated image of a Christological subject, as in Piero's case, was rare if not unique.

The image is placed within a painted architectural framework resembling a Corinthian portico. Centered between two fluted columns, the figure of the Risen Christ confronts us as a stationary, ghostly ruffian fixing us with burning eyes, repugnant yet hypnotically compelling. He stands erect inside his sarcophagus, with one foot poised on the ledge, holding the labarum, a standard of victory—in this case, over death—in his right hand. With his left, he grasps a drape of springtime pink to cover the virile nudity of his hard, metal-like body. Made up of pure shapes and pale colors, Christ's heavy plasticity causes relentless tension between the reality of his presence and the ideality of his form.

At the foot of the sarcophagus four soldiers sleep in a variety of fitful poses. The one on the right falls backward as if magnetically attracted to a chunk of stone lying on the ground behind him. The one on the left covers his eyes with his hands. Paradoxically, these guardians are blind to Christ, who himself seems all-seeing.

This triangular quintet of figures is set before what purports to be a view of nature. But instead of an illusion of distant space, the perspective of the landscape is reversed. Columnar trees do not converge as they recede into the depth, but rather they splay outward and thus converge forward on Christ. Moreover, the trees themselves are treated unrealistically: each side connotes a

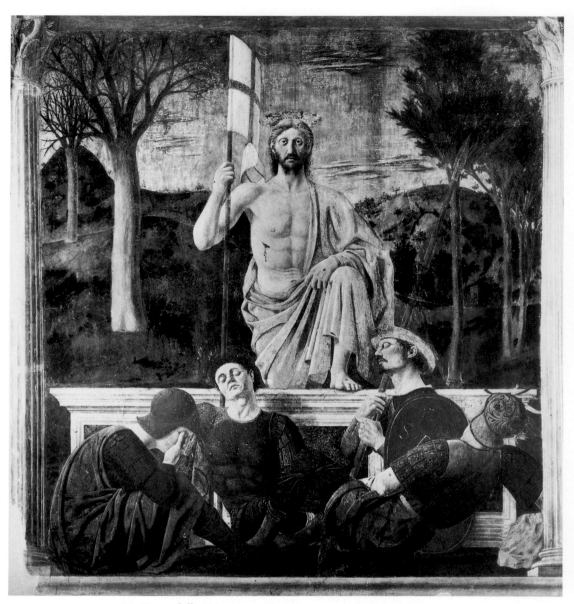

53. Piero della Francesca. *The Resurrection of Christ.* 1463–65.
Fresco. Pinacoteca, Palazzo dei Priori, Sansepolcro

different season. On one side, the trees are thin and young, green with new growth; on the other, they are large but bare. This view is in the tradition of "moralized landscapes," where opposite sides of a composition are meant to offer the spectator the choice between good and evil. But like the perspective, the sides seem to have been reversed because the barren, ostensibly sinful, trees are on Christ's right, traditionally the more honorable side. In fact, however, the sides are not switched and the right side is the one of higher virtue. The attractive blooming trees on the left trace a downward path leading to a comfortable country villa. This way is easy, even beguiling, for it leads to pleasure. The leafless trees are not sinful but strong and mature. They march up a hill toward the higher reaches of a distant mount. This path is more difficult than the other, lacking even the comfort of shade from the trees. But it is the more rewarding, for in describing the rigors of the ascent, it points the way to virtue. The structure of the landscape thus echoes the call to morality in Christ's commanding gaze.

The moment of the Resurrection is not described in any written source. Biblical accounts state that after the Crucifixion, Christ's body was placed in a rock-cut tomb made for another man; the cavelike structure was closed with a large stone and sealed with wax. Guards were set to watch the tomb to ensure that Christ's followers would not steal the body and claim that it had risen, as Christ predicted. After three days the followers returned; the earth quaked; an angel descended and rolled back the stone to show that Christ had gone. The guards then shook with fear. There were thus no witnesses to the moment of returning life.

Representations of Christ newly revived—in or near the tomb, swathed in drapery, holding a banner, and surrounded by military guards—were an artistic invention of the late tenth or early eleventh century. Several

38

54. Sienese School. *The Resurrection Altarpiece.* c. 1340–50.
Pinacoteca, Palazzo dei Priori, Sansepolcro

different positions for the figure of Christ were developed. Piero chose the one that had particular resonance in Sansepolcro: standing in a frontal pose with the left foot on the rim of the tomb. In all its basic elements, his version replicates the central panel of the altarpiece from the town's main church, to which we referred in our discussion of the *Flagellation*. Painted by a Sienese artist in the mid-fourteenth century, because of its auspicious subject, it was a major object of veneration in Sansepolcro (fig. 54). The difference in setting in Piero's work from this prototype is only apparent. The older panel has a dark, abstract background, filled with hierarchically placed angels. Piero's has a landscape strongly Tuscan in character, yet, as we have seen, it is symbolic in content. Any confusion with a natural view in the fresco is further blocked, moreover, by the painted portico that acts as an architectural proscenium and separates the image from a narrative moment. Like its predecessor, Piero's *Resurrection* is an archetype, out of natural time and space and equally, if not even more so, identified with the local setting.

As we have seen in discussing the *Baptism of Christ,* the name "Sansepolcro" came from the precious relic of Christ's tomb brought from Jerusalem to this Tuscan valley. Because of its identification with the Holy Land, the town had always considered itself to be a holy site. By painting the miracle of the Resurrection in the seat of government, Piero transformed a devotional image into a civic ensign. In this light, we must recognize the chunk of stone beneath the arm of the tumbling soldier on the right

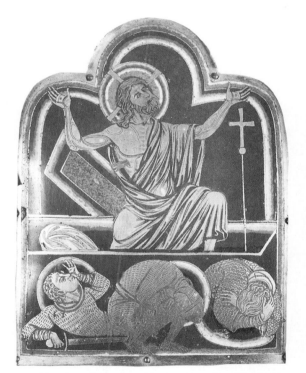

55. Nicolas of Verdun. *Verdun Altar* (detail). 1181.
Gold and enamel. Klosterneuberg, Austria

as the founding relic. Carried from the Holy Land by Arcano and Egidio, the relic of Christ's tomb gave life, as well as name, to Piero's native land. In return, Piero used his abstract scheme to charge the image with political meaning, proclaiming both protection for and responsibility to the commune.

56. Anonymous. *Arma Christi.* c. 1320.
Manuscript illumination. Ms. 4459–70, fol. 150v.
Bibliothèque Nationale Albert 1er, Brussels

THE MONTEFELTRO ALTARPIECE. There is unmistakable visual evidence that during the early 1470s Piero was an intimate of the court of Urbino, offering advice on more than one of Federico da Montefeltro's artistic projects. Comparing details of doorways and other stonework in Piero's painted architecture with those in the Palazzo Ducale, under construction from at least 1468, one can see how much the real architecture owed to Piero's ideas. His contact with the court, moreover, remained long-standing. In the year after Federico's death in 1482, Piero dedicated one of his major theoretical works, the *Libellus de quinque corporibus regularibus* (Theory of the Five Regular Bodies), to young Duke Guidobaldo, Federico's only son, born with such jubilation and such tragedy in 1472.

Federico da Montefeltro entrusted Piero with painting an altarpiece presumably destined for Federico's future tomb, *Montefeltro before the Madonna and Child with Saints.* Because Federico is shown without his wife, the painting most probably dates from after her death in July 1472, but before August 1474, when Federico received a number of honors the signs of which he is not yet wearing in the painting.

A cleaning in the mid-1980s revealed an astonishing range of pictorial effects: brilliant, enamel-like colors, gleaming precious stones, gold-shot fabrics, transparencies of crystal and gauze, and reflective surfaces of polished metal and marble. Nothing demonstrates more

57. *The Virgin between Santa Prassede and Santa Pudenziana.*
9th century. Fresco. Santa Prassede, crypt, Rome

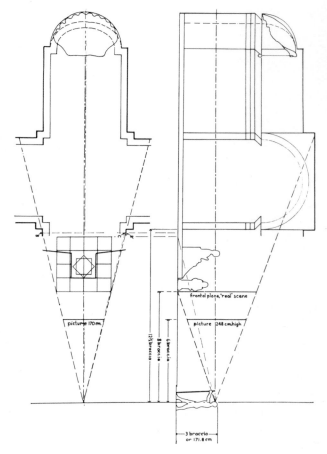

58. Ground plan of Piero's *Montefeltro Altarpiece*
after Millard Meiss

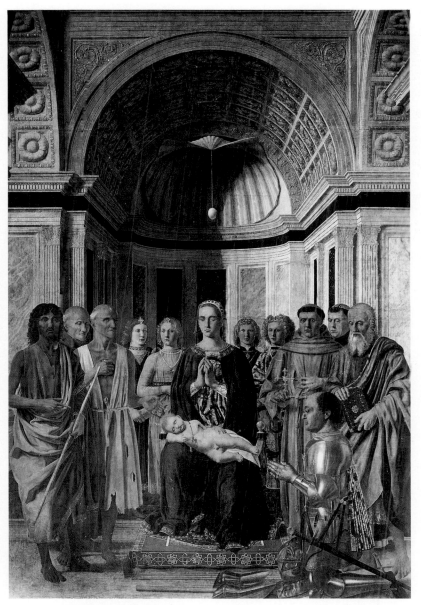

59. Piero della Francesca. *Montefeltro Altarpiece* (detail).
1472–74. Tempera. Pinacoteca di Brera, Milan

clearly than the presence of these refinements in a major religious work that Piero was seeking a new and wider avenue to the visualization of the world of religious efficacy.

In terms of subject, the painting is rather ordinary: the Madonna and Child with a donor, surrounded by saints — one of the most hallowed subjects, repeated often as altar decoration. Piero's respect for the tradition is evident. The strict profile of the kneeling donor could not be more familiar. Mary forms the center of the composition, seated on a backless throne set on a platform covered with an oriental rug. She prays with fingertips together over the body of the infant who shows his manhood as he sleeps upon her outspread knees. Six saints, three to each side, flank the Madonna, while slightly smaller-scale angels complete the circle, standing behind the saints in silent attendance. Their fancy clothes and curling hair make a fine contrast to the simplicity of the penitential saints.

What is out of the ordinary about Piero's version is the background. There is no remnant of Gothic structure; no gold or patterned background. Instead, we see a spacious building, filled with light, housing the figures within its generous grasp. A subject known as the "Madonna in a Church" was familiar in northern art: Jan van Eyck had painted more than one such image before 1440. Piero's is the first instance of such a setting in Italy, and the very first anywhere to show the church as a spacious interior in the newly conceived monumental Renaissance style. The semicircular vaulting is fully coffered, the fluted Corinthian pilasters are finely carved; the walls are covered with marble paneling, changing in color according to the flow of light. Most astonishing of all is the furnishing of the semidome of the apse. It is filled with a sculptured conch shell, inverted so the pointed tip curves outward from the top. As a beam of light catches the flaring shape, there hangs a stunning, snow-white egg suspended from a

41

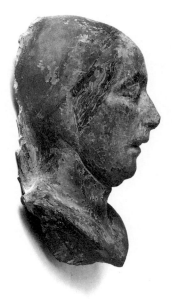

60. Death mask, presumably of Battista Sforza.
Wax with traces of paint. Louvre, Paris

golden chain (fig. 59). This perfectly constructed ovoid shape acts as a little model in the air for the larger one, Mary's head, that seems to be directly below it.

While an egg as church furniture may strike the modern viewer as bizarre, the Renaissance worshiper would not have found it so. From time immemorial, and for obvious reasons, eggs have symbolized fertility and regeneration, and as such, they were often placed in ancient tombs. Under Christianity, the egg came to signify specifically the fecundity of Mary's womb and, more generally, the resurrection of man in the death of Christ. Thus many such eggs, most frequently the precious, large-size ostrich egg, were, and in some cases still are, actually suspended in churches in this way. What is out of the ordinary about Piero's egg is the purity of its form. Real examples are usually encased in decorative metal supports, combined with oil lamps and disklike braces to repel rodents (see, for example, Mantegna's version in his altarpiece in Sant'Zeno at Verona (fig. 61). Piero's egg, by contrast, is utterly simple and unadorned, emphasizing, in the artist's usual way, the geometric perfection of the form. But this purity of form is only part of the story.

The lack of decoration on the egg permits a reading both in space and on the surface of the painting. Only when we begin to ponder its true position do we realize that what seems at first to be a straightforward composition is actually one compounded of mystery. Here is the interior of a church, a great basilica in the modern style. But where are we standing to look at it? Where, in fact, are the figures that we see before us in relation to the parts of the church? They seem once more to be in a spatial no-man's-land. Moreover, how far away is the apse, which seems to embrace the Madonna and yet appears so small? Clearly, the structure of the architecture was produced with mathematical perspective (fig. 58). Yet, as opposed to

buildings in other paintings we have seen, this one has no paving stones to form orthogonals for measuring the recession. The only clues that Piero gives are tiny fragments of the crossing piers visible along the side edges of the panel. We will discuss the reconstruction of the space with Colorplate 36. Suffice it to say here that we are standing in the nave of the church; the figure group is on our side of the crossing; and the apse is some 45 feet behind them. We think that the apse is small and that the egg hangs over Mary's head because of an optical illusion created by Piero.

In the later Middle Ages, the figure of Mary (with or without the Child) was often framed by an aedicula or tabernacle representing in miniature a complete ecclesiastical structure. This formula was yet another way to

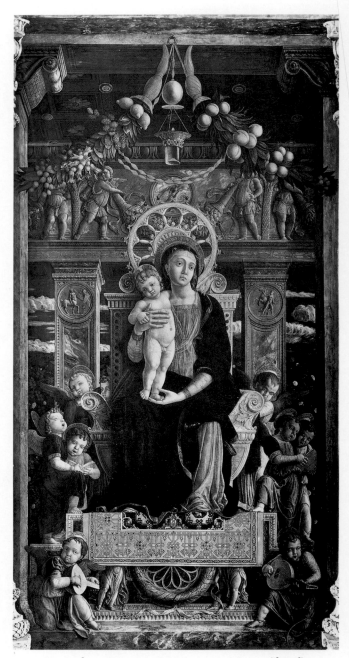

61. Andrea Mantegna. *Madonna and Saints* (detail).
c. 1460–65. Tempera. Sant' Zeno, high altar, Verona

42

visualize the theological identification of the Virgin with the Church as a corporate institution. The visual element that carries the meaning in this case is the discrepancy in scale between the figure and the building: the Virgin appears too big for the architecture. Piero treats the traditional symbolism with the utmost respect but once more transforms it into his own terms and alludes to the discrepancy with completely rational means. Constructing a very deep progression into space with mathematical perspective, and then masking the relationship between the foreground and background, he juxtaposed natural-size figures with what appears to be dwarfed architecture. Without their actually being so, the figures do seem too big for the building. The effect is what we perceive to be a mystical leap of scale. Ironically, the apparent discrepancy has a culmination and a focal point in the one real discrepancy Piero introduced: the figure of the Madonna is actually larger in scale than the rest of her companions.

Having created an image of Maria Ecclesia, Piero then extends the symbolism to include allusions to the full cycle of salvation. Besides the mystery of the Virgin Birth radiating from the pristine egg, there is reference to the Passion in the Child: on Mary's grand and monumental lap he lies asleep, an amulet of coral hanging from his neck (blood sacrifice is still alluded to in many religions when such amulets are given at the time of circumcision). As he sleeps, Christ's little body takes a pose carrying, in its own discomfort, premonitions of his death. His reclining pose is one of the only diagonals in the composition. To verify the coming sacrifice, the six male saints surround the dais, standing as pillars of the Church, a theological honor guard to Ecclesia and the sacrificial lamb.

Before this august group, Federico da Montefeltro kneels in a hieratic pose. Aside from his unbending outline, the most striking aspect of his appearance is his gleaming suit of armor. It had been more than a hundred years since an Italian donor came before the Madonna in military garb, and moreover, those trecento warriors had had a different air about them. They came always in the company of a patron, usually a military saint, and they looked imploringly up at Mary (fig. 62). In effect, they were shown praying through their intercessors for protection in their warlike deeds. Federico's gaze, by contrast, implies no such supplication. He is not presented by a patron, and although he is in close physical proximity to the holy personages, he does not look at them; he is, in fact, emotionally isolated from them. The traditional motif of the kneeling, profile donor now expresses a new idea. Federico comes before the Virgin not as a supplicant but as a soldier and, specifically, as a soldier of the

62. Altichiero. *Giacomo Cavalli Presented to the Madonna and Child* (detail). c. 1369–76. Fresco. Sant' Anastasia, Verona

43

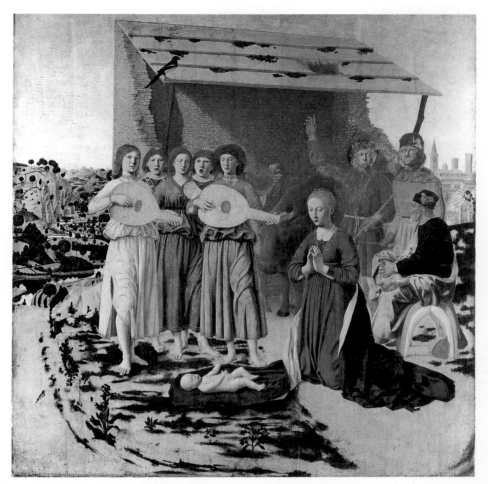

63. Piero della Francesca. *The Adoration of the Child.* 1478–1480. Tempera and oil, 124.5 × 123 cm. National Gallery, London. Reproduced by courtesy of the Trustees.

Church. Through his conjunction of traditional subject matter and modern structure, Piero portrays Federico as an eternal sentinel guarding the ecclesiastical organization of Christianity. And once again, contemporary sentiments achieve universal meaning through the interweaving with traditional subjects.

THE ADORATION OF THE CHILD. Most of Piero della Francesca's works make him seem quite somber and aloof. In fact, we know nothing of his personality. His writings yield only his intellectual activity. The contracts he signed are completely standard. Although his name appears often in the rosters of elected officials in Sansepolcro, there are no records of how he participated in civic affairs. A decade after his death, his property turns up in the inventory of his brother's son, meaning he had no direct heirs. Even in death, then, his personality remains opaque.

The panel of the *Adoration of the Child* (fig. 63) is listed in the inventory as still belonging to the family. This fact probably means it was painted without a commission. Since it seems to have been among his last works, he may have intended it for his own tomb. It comes to us in an incomplete state, but it is impossible to judge whether it was left unfinished or was later ruined. Conceptually, however, it is a whole and confirms what we have been

saying about Piero's belief in the reality of the mystical world. But more importantly, it also demonstrates a facet of his personality that up to this point has remained invisible.

The scene takes place on a promontory, a kind of natural podium rising between a rural landscape on the left and an urban vista on the right. The Christmas manger outside Bethlehem has become a farmer's ruined feeding shed in the environs of Sansepolcro. Elements of the composition follow a widely read account of the Nativity by the fourteenth-century mystic St. Bridget of Sweden. In her vision, Bridget claims to have seen a lovely young, light-haired woman who, after a painless birth, knelt to adore her child lying naked on the ground. Shivering with cold, the baby lifted his arms to his mother. "I heard the singing of the angels," says Bridget, "which was of miraculous sweetness and great beauty." Piero represents this moment, showing the Madonna with light red hair, kneeling in prayer before the earthbound newborn. The Child reaches toward her with outstretched arms, protected only by a portion of her robe. Five angels serenade him, as an ox and ass participate from under the shed. Two shepherds (both rather badly abraded) enter from the right behind St. Joseph, who, lost in thought, is seated on a saddle. Bridgetine

44

64. Hugo van der Goes.
Portinari Altarpiece. c. 1475. Oil.
Galleria degli Uffizi, Florence

65. Domenico Ghirlandaio.
Adoration of the Shepherds.
1485. Tempera.
Santa Trinita, Sassetti Chapel,
Florence

motifs had been introduced into painting a hundred years earlier and were still used by Piero's contemporaries from both the south and north: Baldovinetti in the 1450s, Hugo van der Goes in the early 1480s, and Domenico Ghirlandaio, whose *Adoration of the Shepherds* in Florence is also dated 1485 (figs. 64, 65). But Piero somehow avoids their visual rhetoric, finding ways to elevate his theme without losing its humility. He has, in fact, recharged each detail to be a kind of summa of his philosophy of the high significance found in the lowly forms of life.

The naturalistic splendor of his cloudless sky brings the light of divine illumination to this moment. The manger as a collapsing structure was by now a staple symbol of King David's fallen tabernacle. Many artists like Ghirlandaio, expressing contemporary humanist values, showed the building as a decaying classical ruin, the crumbling columns and sarcophagus referring also to paganism's fall. Piero, by contrast, re-creates the broken structure in lowly field stone, its lean-to roof supported with nothing finer than two unworked staves. In this form, the struc-

66. Sarcophagus cover, stone relief. Early 4th century.
Vatican Museums

ture resembles most the flimsy covering, or tegurium, of Early Christian art, often said to have been used to hide the truth of the Savior's royal status from his unbelieving foes. Mary hides none of her loveliness. No longer the amazonian matriarch, she is more lyrical and conventionally beautiful than any other of Piero's women, with braided hairdo and jewels at her head, neck, and breast. Yet, in her humility, she kneels directly on the earth and slips her mantle down to protect the infant king who has come to crown her.

The shepherds come from the field still carrying their working staffs. Although their faces have suffered serious damage, they still show expressions of great solemnity. One raises his hand to point to the heavens. This gesture is the same one Piero used years before for the Magi in the *Baptism,* and here, as there, it indicates a miraculous source of knowledge. Yet this rustic figure portrays still further allusions. Combined with the staff he carries like a kind of baton, this gesture follows a famous statue type first used for figures of the Emperor Augustus (fig. 67). According to medieval legend, Augustus had mystic connections to the story of Christ's birth. On the day of the winter solstice, the birthday of the sun and the original date given to Christmas, Augustus celebrated a great victory and closed the gates of peace. Then, standing on the Capitoline Hill, he asked his soothsayer, the Tiburtine Sibyl, if ever there would be a greater leader than he. Her answer was a vision of the Madonna and Child known as the "Ara Coeli," the Altar of Heaven. Piero's promontory is that altar, presenting on earth a vision of heaven. The same paradoxical combination is found in Joseph. In apocryphal stories about the Holy Family's journey, Mary rides to Bethlehem on a donkey. The old man here sits on the saddle, and the water bottle that leans against it is part of the gear from the same trip. The figure, however, is anything but narrative. No longer the despondent husband of tradition, Joseph is ennobled by his pose. With his hands folded before him, he seems lost in philosophical thought. He takes the "heel-on-knee" position of an antique statue known as the *Spinario* (fig. 68). which at this very period had just been mounted on the Capitoline Hill where the Ara Coeli vision took place. Thus the Jewish

67. *Augustus of Prima Porta.* c. 20 B.C. Marble.
Vatican Museums

68. *Spinario.* Bronze. Museo Capitolino, Rome

46

Joseph joins the pagans in recognizing the presence of the Lord in a setting that sanctifies Piero's homeland.

In these pages I have tried to show how Piero expressed divinity in simple worldly forms, which, through his mathematical prowess, he brought to the ideal perfection we find so modern. In this, his final painting, he makes the theme of "high and low" his overt subject by presenting in every element of the composition the eternal in its mundane guise.

As the purveyor of his final expression of universal worship, Piero chooses a quite unlikely subject, a monumental magpie, called *gazza* in Italian, perching here on the roof of the shed (fig. 69). To understand the magpie's meaning, we must remember that throughout history, birds have been taken as symbols of the soul, free to soar far and wide and finally ascend to heaven. Their entrails were read for auguries and their endless circling carried the notion of immortality. The small birds in the grass around the Christ Child here have this significance. The magpie, on the other hand, is usually considered a bothersome pest. A large and bony bird, it is known as easily domesticated but a robber that hides the shiny things it steals. Most of all, it is annoying because of its continual and senseless chatter. The ancients said the magpie was the very opposite of Calliope, the muse of music, and a Tuscan proverb moves the slander to a woman's scolding tongue (*Le donne son sante in chiesa, angeli in istrade . . . e gazze alla porta.* [Women are saints in church, angels in the street . . . and magpies at the doorway]).

Piero's magpie is silenced. He perches on the corner of the shed where the long black plumage of his tail can extend to its full length, and the massive head and black beak can be seen in dignified isolation. He stands above the scene, noble in his perfect profile, elegant in his abstract black and white. In Piero's hand, the magpie is not a thief of worthless objects but the bringer of sudden knowledge. He is a hieroglyphic grosbeak whose newfound silence (stifling the false words of the Old Law) recognizes the arrival of the new, "true" Word. I like to think that by thus expressing the fundamental dogma of the Church with lowly creatures of the earth Piero has at last revealed not only his profound respect for nature but his own good humor and sense of divine joy.

Because of the cool passivity of Piero's style, art lovers of the twentieth century thought they could ignore the religious subject matter of his work. The mathematical underpinnings of each composition make the construction so important, it seems to be the paintings' main issue. In the fifteenth century, the same qualities of structural rationality, clarity of form, and emotional reserve struck an equally new but different note. In the Middle Ages, the characters of the religious hierarchy had been forbidding and distant. Now Piero gave them humanity in a new, perfected form. His figures are lofty and charismatic, affective and potent, worthy of their eschatological responsibilities. But they are also familiar and accessible. They are not the fleshy, cloud-enshrouded beings of Leonardo and Raphael. His people have a country air and are slightly awkward, simple, and artless. He gives them architectural ambients of quiet dignity and detailed beauty, where the transparent atmosphere brings them close and keeps them admirable. It is not, as Berenson claimed, that Piero did not speak and is therefore gloriously communicating pure existence. On the contrary, as we have seen, he communicates very specific ideas and took a great deal of trouble to do so. But his language is purely visual, requiring an ingestion of all the information he so generously and meticulously provides. He guides the mind as well as the eye with his language of visual structure, and that, in the end, is the real reason he finds a place in our hearts.

THE MISERICORDIA ALTARPIECE
(detail, main panel)

1445–c. 60

tempera, 34 × 91 cm

Sansepolcro, Pinacoteca (Palazzo dei Priori)

The main panel of the *Misericordia Altarpiece* is made up of an almost square rectangle and a perfect semicircle. With a diameter a few centimeters less than the width of the rectangle, the round top forms short shoulders at the point where the two shapes meet. A line drawn across this juncture, passing through the center of the brooch on Mary's breast, equals one side of an equilateral triangle, the vortex of which coincides with Mary's toe. The sides of this triangle pass through a number of critical points in the composition: Mary's hands at the thumb joint, as well as the features of the upturned faces and the shoulders of the man and woman with their backs turned. When a second equilateral triangle of the same dimensions is dropped from the height of Mary's halo, it, too, passes through salient points, such as Mary's shoulders and the ears and back of the two profile worshipers. Thus rather than the "Gothic" pointed shape usual for polyptychs, the panel not only has the newly revived classical rounded arch, but its shape and proportion are also irrevocably linked and geometrically bound to the scale and proportions of the main figure.

This rational linkage is nevertheless set before an "old-fashioned" gold ground that retains its time-honored allusion to the celestial realm. Such metallic backdrops are meant to provide an unreal, even antispatial ambient, a universe of splendor, glowing with spiritual inspiration. All these values Piero accepts. But then he steps beyond. He has not applied the gold leaf in a thick, dense mass but as a screen that breathes with pliancy. Within this mass, in a locked position, the Madonna stands as a heavy central support to the circular void she creates with her mantle. Within that imaginary space, her body and those of the devotees are modeled by light flowing from above at the right. The definition of forms concentrates on vertical tubular shapes. The gray lining of the robe hangs in nine parallel cylindrical pleats. The red gown responds to the pull of the belt with similar convex shapes. The jackets, scarves, and dresses of the devotees likewise give the illusion of starched material, filled with atmosphere that inflates the pictorial space. This space, however, has certain restrictions. All the figures are set upon a rigid platform, with clearly demarked corners and a completely visible front edge. Moreover, the devotees are arranged in symmetrical groups: four men on Mary's right, four women to her left, each pose tied in perfect balance with its opposite number. The arrangement has the quality of a statuary group set upon a base and housed in the space generated by the Virgin's gesture. The allusion implicit in the subject of the *Misericordia,* that of Mary as the Tabernacle of the Lord, is thus reinforced with a new artistic reality.

The members of the confraternity are well-dressed adults, in very good health. Their fervent petition to the Madonna of Charity, therefore, is not for improvement of their physical state but for the future of their immortal souls. Their worldliness and physical presence serve to emphasize the reality of their spiritual values. Their concentrated devotion is focused on the overshadowing figure of Mary, the first of Piero's many unforgettable women and a completely new interpretation of the character.

The most striking aspect of this image, once the colossal scale has been digested, is her scrubbed "country-girl" air. Although she wears the Queen of Heaven's crown and is surmounted by a golden halo, she has the earthy features and thick, strong body of a peasant. Looked upon as helper of the people, she appears to be their servant, capable and steadfast. But in her homeliness she is also ideal. Her veiled cranium, on which the most delicate modeling is concentrated, is a nearly perfect oval, barely marred by the imposition of features. The mouth is fleshy but modest; the nose is nearly pug but small. The high, shaved forehead is dented only at the eye sockets, casting shadows on the heavy, down-turned lids. The oval stands on a sturdy, pedestal-like neck that branches smoothly into the outstretched arms. Within the tabernacle of her cloak, the concentric circle of her draped body tells the story of salvation. The stocky width implies her pregnancy. The belt infers virginity; its stiff cruciform fastening, repeating her own pose, foretells Christ's sacrifice on the Cross. The silent young woman, poised motionless on tiny feet, shares the weighty symbolism of the Christian Savior. This deeply moving combination of the real and the ideal, this nesting of the highest ideals in the aspect of the low, remains a leitmotif in Piero's work, which we will follow throughout these pages.

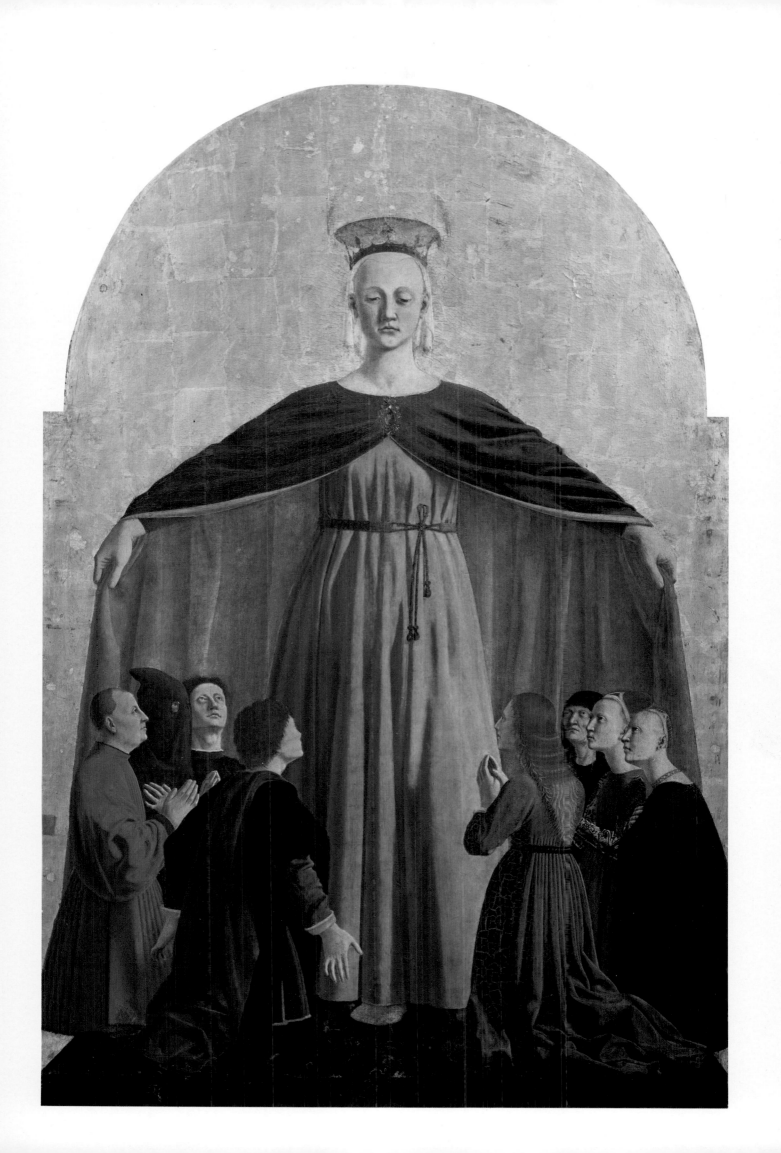

SIGISMONDO MALATESTA BEFORE ST. SIGISMUND

1451
fresco, 257 × 345 cm
Rimini, Tempio Malatestiano, "Chapel of the Relics"

During the bombings of World War II, the fresco of Sigismondo Pandolfo Malatesta was removed from the wall of the chapel for safekeeping. In the process of removal, a badly damaged sinopia, or full-scale underdrawing on a lower level of plaster, was discovered on the wall beneath the fresco. This discovery came as a surprise, since by the mid-fifteenth century the sinopia method of preparing a wall, used throughout the later Middle Ages, was somewhat antiquated. In Piero's sinopia, the decorative border is fully developed in tempera, the lower leg, foot, and other parts of the saint are lightly sketched, and the area of Sigismondo's figure is surrounded by multiple rough hatchings. By contrast, the escutcheon at the top of the composition is plotted by two very precise perpendicular ruled lines, the vertical marking the exact center of the fresco's width. At the same time, on the fresco itself, there is evidence of the more modern cartoon method of transferring preparatory drawings to the painting surface. In this process, full-scale drawings are "pounced" or pricked along the contours of forms, and charcoal dust is then blown through the holes. This method leaves black dots on the plaster that guide the painter as he works. Pouncing can be seen quite clearly in several areas of this fresco, particularly on the faces and hands and along the edges of the buildings in the architectural portrait.

A painted border, decorated with Malatesta roses and cornucopia, surrounds the figure composition on three sides; the lower margin imitates a marble base inscribed with the titles of the figures, the artist's name, and the date 1451. This border is not a frame but rather the outline of an opening onto a fictive corridor that seems to extend beyond our vision laterally in both directions.

Effecting this illusion are a series of rhythmic repetitions in the overall construction of the composition, and by testing the painted surface with a measuring stick, one finds the two basic units from which Piero generated his design (see A in fig. 14). One is the width of the side panels of painted marble background, designated as (B) in our diagram; the other is the width of the painted border, designated in the diagram as (C). The height of the fresco, including the base and upper border, equals precisely 6B; the width including the frame equals 4B plus 6C. Measurements (B) plus (C) create a third unit, designated as (A), that equals half the width of the central marble panel at the back of the painted room. These building blocks give the vertical dimension a vibrant monumentality, while the width is characterized by a rhythmic pattern that can be expressed by a number of interlocking combinations: CBC AA CBC, or ACA ACA, or C AAAA C, and so on. It is these rhythmic repetitions that help create the illusion of lateral extensibility and make reconstruction of the imaginary corridor possible. We may imagine the pilasters marching along on either side, with the jade-green swags, woven with leaves and flowers, looping on and on in the intervening spaces. The point of this architectural illusion is to imply that the saint, in his gray velvet mantle and gown of brilliant blue, has made his way from above the altar in the adjacent sanctuary down this corridor to settle here for the devotional ceremony we see. As a result, Sigismondo pays homage to his patron saint, with the trappings of his private life, in an auditorium-like space decorated in ecclesiastical style. The painter's artifice has created a hall that eliminates the distinction between the celestial and terrestrial.

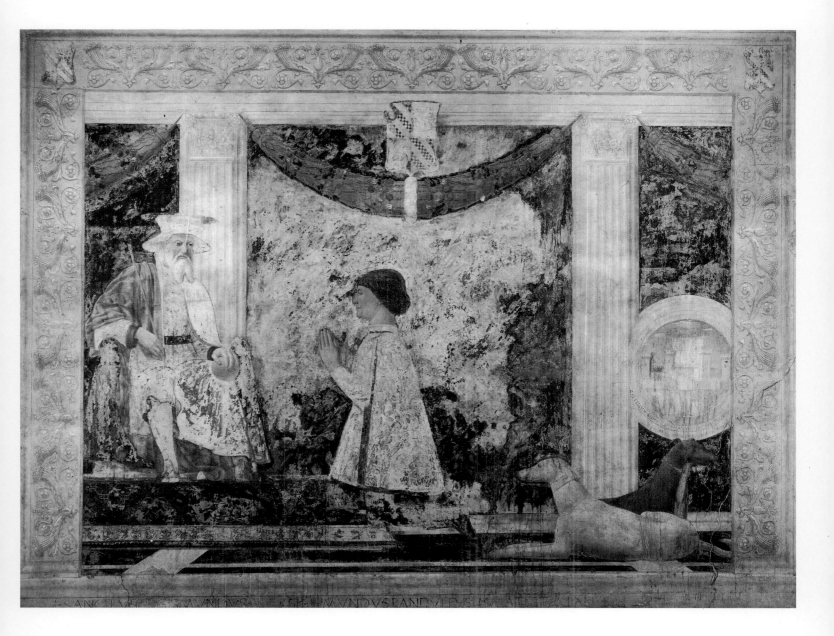

PORTRAIT OF SIGISMONDO MALATESTA

c. 1450
tempera, 44.5 × 34.5 cm
Paris, Louvre

When Piero was called to Rimini, Sigismondo Malatesta was riding high. He had just won a great military victory at Piombino, after a dramatic switch of sides, and he had grand hopes for his political future. The commission he gave to Piero was the first phase of what developed into a major artistic campaign in his family's burial church. By 1450, Leonbattista Alberti had inaugurated his design for what became the Tempio Malatestiano, a reliquary-like covering of rich marbles that sheathed the face and sides of the Gothic church in a new and elegant classical style. Piero's fresco had already set the tone of aspiring gratitude, and the actual portrait of the donor is one of the great images of the century.

The likeness was apparently prepared in full scale on an isolated panel, where Sigismondo's profile is fiercely silhouetted against an almost too solid black background. His dark red hair is made to fit like a tight cap around the skull. His tucked cut-velvet jacket stands as stiff as a pedestal, supporting the column of his neck. By contrast, the face has the quality of breathing flesh. A counter-light coming from behind illuminates the back edge of the neck with a warm glow. The same light etches the jaw and shines under the chin on the side of the face turned away from our view. This backlighting throws the jaw and cheekbone into high relief, while adding strength to the determined mouth and nose, and to the meditative eye. This painting has no other function than to represent the features of the sitter, not as he is in life, but conceptually, as the visual idea of Sigismondo. The lack of setting was never to be repeated by Piero; its use here is perhaps related to the fact that the profile head in the fresco is juxtaposed to a dark marble wall, now so badly damaged that the effect of dramatic contrast is lost. The frescoed profile is, if anything, softer than in the panel. The skull is less pugilistic and is higher in the crown. A change of design, called a "pentimento," in fact can be seen in the fresco, where the bangs and curls at the nape of the neck are also more expanded. The skin colors are warmer, the modeling softer, and the light flow more harmonious. Yet in spite of these modulations, the frescoed image loses none of the iconic strength of the prototype. The upright stasis of the head and body, echoed in the alert gaze of the greyhounds, qualifies the likeness as a metaphor of power.

Because of his somewhat checkered career, and the fact that one of his bitterest enemies was a pope (Pius II), Sigismondo was chosen by nineteenth-century writers as the paradigmatic tyrant, described as a cruel and selfish villain who murdered his wife to live openly with his mistress. Because of the classicizing sculptures in his Tempio, he was called a pagan and compared unfavorably to Federico da Montefeltro of Urbino, for whom Piero worked in later years (see Colorplates 34, 35). The same writers who vilified Sigismondo picked Federico to epitomize the just and learned ruler. Neither generalization is historically correct. Most of the stories about Sigismondo are romantic nonsense, and Federico was no better than he should have been. They were both brilliant, lusty soldiers who, after victories on the battlefields, discovered the thrill of learning and the power of the intellect. If they were despots, it was in the republic of culture.

But Sigismondo was never, in fact, a real aristocrat. He always lacked the "perpetual" inheritance he sought. His family had ruled the lands around Rimini for more than a hundred years, but always as vicars of the pope, needing to renew their authority periodically by petition. In 1448 and 1450 Sigismondo's vicariates of Rimini and Cervia were confirmed in two of the most generous grants ever to have come out of Rome. It was perhaps in response to these promising events that the rebuilding and redecoration of San Francesco was begun. But Sigismondo's most anxious petition was to have his title raised to marquis, and this he was denied. His political indecision lost him his chance and in the later 1460s made an enemy of the pope. It was only Piero's fresco image that gave proud Sigismondo regal dignity, even providing a crown of Malatesta roses in the chaplet that surrounds the swag above his head. Indeed, this lofty position in the world of art has lasted as long as any title he might have borne.

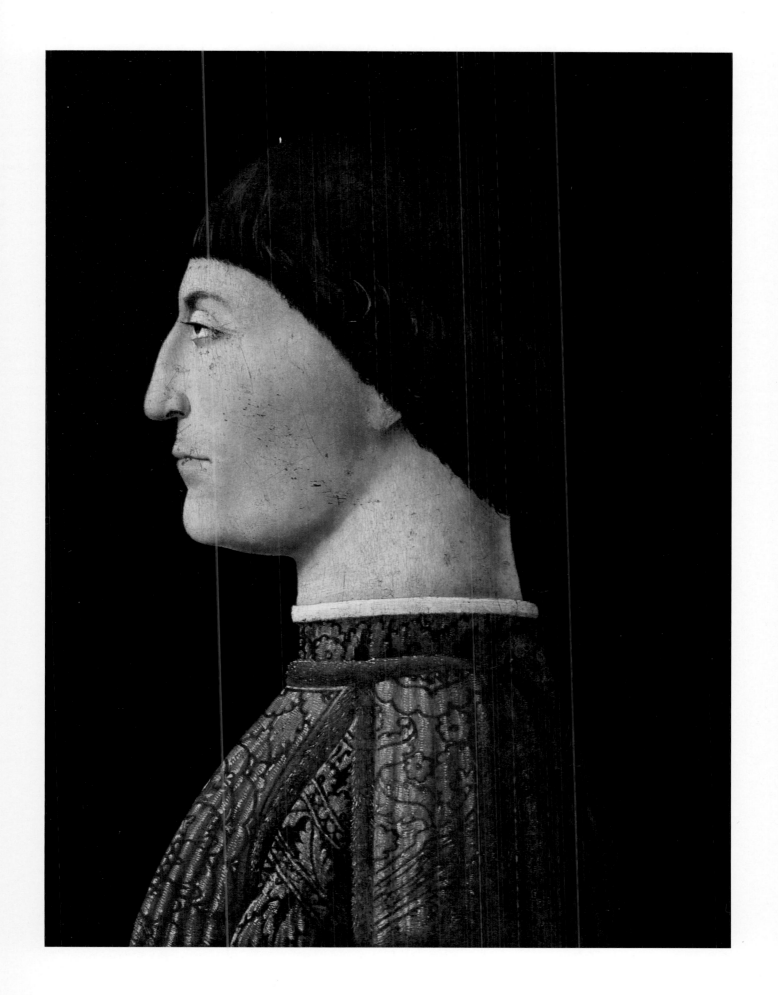

SIGISMONDO MALATESTA BEFORE ST. SIGISMUND

(detail, oculus and dogs)

1451

fresco, 142 cm

Rimini, Tempio Malatestiano

The site of the Castellum Sismundum is that of an ancient Malatesta citadel on the inland limit of the city of Rimini. Sigismondo's rebuilding, said to have been designed by Ghiberti, was initiated in 1437. Built to withstand artillery, it served the lord of Rimini as a residence as well as bastion. In the painting, the castle is shown from directly in front of the main entrance, as one would see it from Rimini's central piazza. The naturalism of the image is assured by the meticulous use of perspective projection, effected with a tiny cartoon (pouncing dots are visible). It is enhanced by the consistent flow of light and shadow and, above all, by the morning-blue sky in the background.

The inclusion of such a detailed architectural representation may be related to many earlier votive frescoes and mosaics in apses of churches, where the donor stands opposite a saintly patron holding a miniature version of the building being dedicated. Similarly small in scale, Piero's building, in spite of its patently secular nature, must have the same value of a votive offering with religious implications.

But since the donor does not hold the "model," we may ask what is the circular area in which it appears? At one moment it seems to have the form of a medal or a seal; both are circular and have inscriptions on their borders. But the painted circle is too big and its image too naturalistically rendered for this identification. At the next moment, it seems to fit into an architectural element and to open as a window through which we see the real castle. Like such elements, this circle is molded of the same marble as the other architectural decorations, and the moldings seem to pass out of the picture field on the right and be part of the adjacent pilaster on the left. Yet the circle is placed too low for fenestration, and as an architectural element it lacks the necessary twin on the opposite side of the room.

Our diagram (fig. 14) solves at least one aspect of the problem. It has not been previously observed that, in abstract terms, the circle has a rational place within the geometrical surface design. The diameter of the inner circle corresponds exactly to the measurement (B) in our diagram, and its placement is precisely in the third square from the bottom of the painted marble side panel at right. This cogent placement explains why, even without understanding its precise level of meaning, we accept the oculus as an integral part of the design. Still and all, the ambiguity is striking: like the portrait of the saint, it is another hybrid image that combines multiple allusions with strict naturalism. And because of its placement, it mysteriously retains the character of both a graphic symbol and optical reality.

The dogs that appear beneath the oculus also have a dual nature. First and foremost they are real animals, strong and muscular, well bred and well trained, each wearing a massive collar studded with gold. At the same time, their eerie rigidity gives them an almost hieroglyphic quality. One might suppose they had heraldic meaning since their crossed bodies could be defined as "counter-addorsed." Nevertheless, dogs do not figure among Sigismondo's armorial bearings. There is no doubt, however, that their formalism is part of the votive ritual. Representing the extremes of light and dark, they face forward and back in perfect unison. From their vantage point, they survey the full extent of the imaginary corridor that passes inside the painting and beyond. By their poses, their colors, their breed, they guard their master's faith, as it were, before and aft, by night and by day, for all eternity. As white is associated with the cardinal virtue of Faith, the dog that looks into the painted space represents *fides catholica*. His bluish black partner, who seems to carry the castle on his head, looks fixedly out into the real world. He represents his master's political faith, *fides publica,* or the faith that flows between the ruler and his subjects. Throughout the Middle Ages, the noble hunting dog had been identified with kingship and its responsibilities. The political hero awaited in Dante's *Divine Comedy,* for example, who would come to save Italy from its political woes, is called the Veltro, the "Greyhound." These overlapping painted dogs are the final duality that completes the scene: together they represent their master's twofold faith and his dedication to both "devotion and dominion."

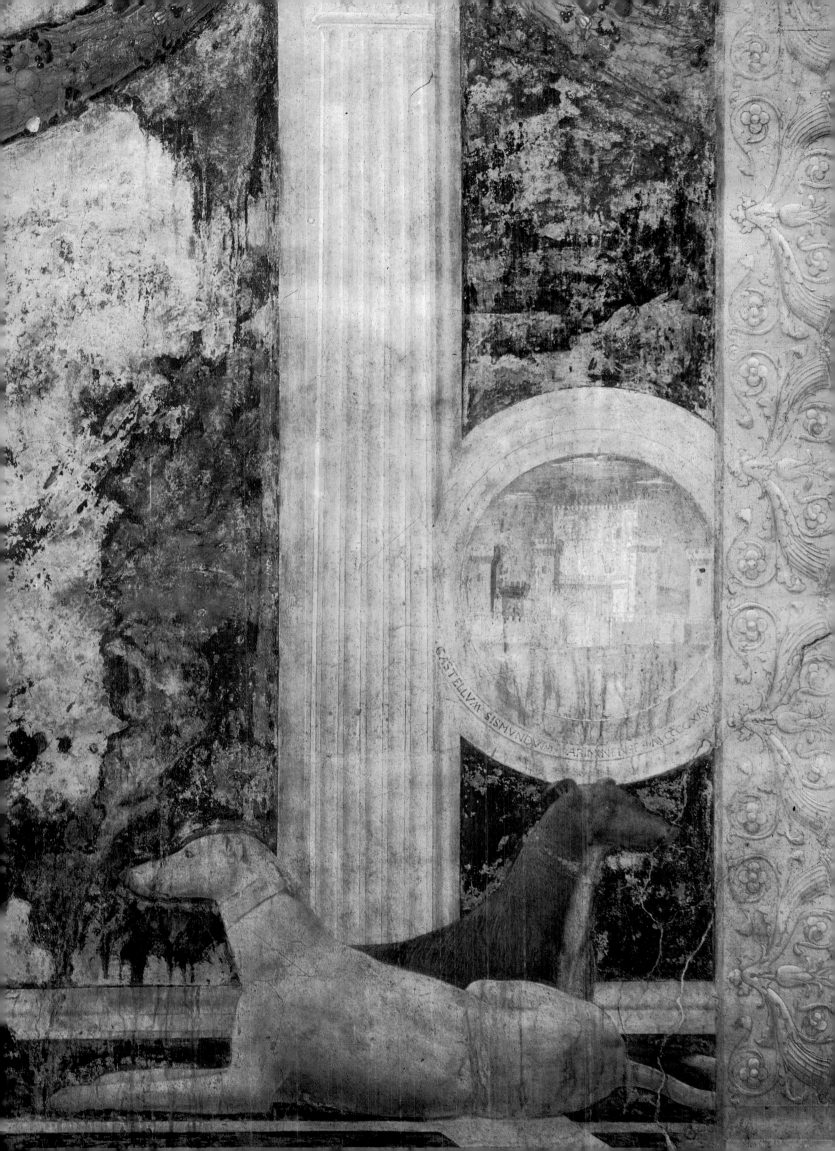

THE FLAGELLATION OF CHRIST

c. 1458–60

tempera, 59 × 81.5 cm

Urbino, Galleria Nazionale delle Marche, Palazzo Ducale

In 1839, the *Flagellation* was described as bearing "nearby the figures," the biblical phrase *Convenerunt in unum* (Ps. 2:2). The inscription was probably on the lower part of the original carpentry frame, which by mid-century had disappeared, leaving the raw wood surface that surrounds the painted field on all four sides. Lacking support, the panel began to warp, and by the end of the century, dovetail wedges had been inserted in the back. The counterpressure of these additions caused three horizontal cracks in the panel that pass through all the figures and split the face of Christ in two. Other areas of the surface were damaged by direct attacks: the name "Maria" was scratched into the lower left corner, and a deep plume-shaped gouge was dug into the face of the flagellator on the left. To remedy some of these wounds, a restoration was carried out in 1951–52. Layers of yellowed varnish and overpaint were removed, and the support at the back was rebuilt. Unfortunately, after little more than a decade, the in-painting (or, neutral fill) along the three cracks began to lift and a second, more thorough, cleaning was initiated in 1966–67. In this restoration, not only were areas of exquisite reflected light and secondary shadows revealed but also the lost face of the flagellator was miraculously found crammed in the depth of the gouge. The tiny fragment of no more than a few millimeters, including part of the nose, cheek, mouth, and chin, was extracted, straightened, and reset in place, making the extraordinary expression of the face readable once more. When the work was complete, the painting was set in the display case with a protective glass cover in which it is seen today.

The composition of the *Flagellation* is one of the most complex architectural settings of the fifteenth century. This structure was something of a mystery until 1953, when Rudolf Wittkower and B. A. R. Carter observed that the measurements of the red tiles covering the ground line provide a basic module (fig. 22). Although they appear rectangular, the tiles are squares seen in perspective. They are laid in larger squares, eight tiles by eight, and surrounded by white pavement strips, also of a consistent size. Counting back along the horizontal strips,

one finds that the Praetorium is set almost two large squares behind the picture plane, and the loggia itself is three squares deep. It was always known that the floor of this area was covered with decoration, but not until Wittkower and Carter straightened out the perspective and looked at the pavement from above was the complicated pattern revealed. The first and third squares are paved with eight-pointed stars of porphyry red and white. The square in the center, where Christ stands, is covered with a perfect circle of serpentine green with pink spandrels in the corners. The loggia ends with a marble-encrusted wall pierced by two doors, one closed, the other partly open onto a rising staircase. The Wittkower-Carter reconstruction finally made it possible not only to decipher the pattern but also to plot the true distance between the separate figure groups, which is surprisingly great. No matter how helpful this first analysis was, however, it was incomplete, because it did not proceed beyond the loggia. Yet, Piero's indications show there is much more to be seen (fig. 23).

To follow his clues, we must first remember that the figures in the foreground stand in bright sunlight, casting short shadows on the ground. The light angles in from the upper left, and the shadows lie to the right of the figures. The loggia also casts a deep shadow behind the figures on the pavement of the piazza, matching precisely the three bays of the interior and then extending back for three more squares. The second half of this shadow implies the building's depth behind the back wall. Sunlight returns as the piazza continues for eight more squares, after which a second building rises (seen only between two of the foreground figures). This building, too, casts a shadow, but now at a point where the spatial projection is so steep the squares can no longer be counted. The distance behind the picture plane can be measured, however, by mathematical calculation, and it has been computed at the extraordinary depth of about 250 feet, or almost 84 meters. Thus, with great care, Piero created an extravagantly deep projection into space, and one may well wonder why he did so.

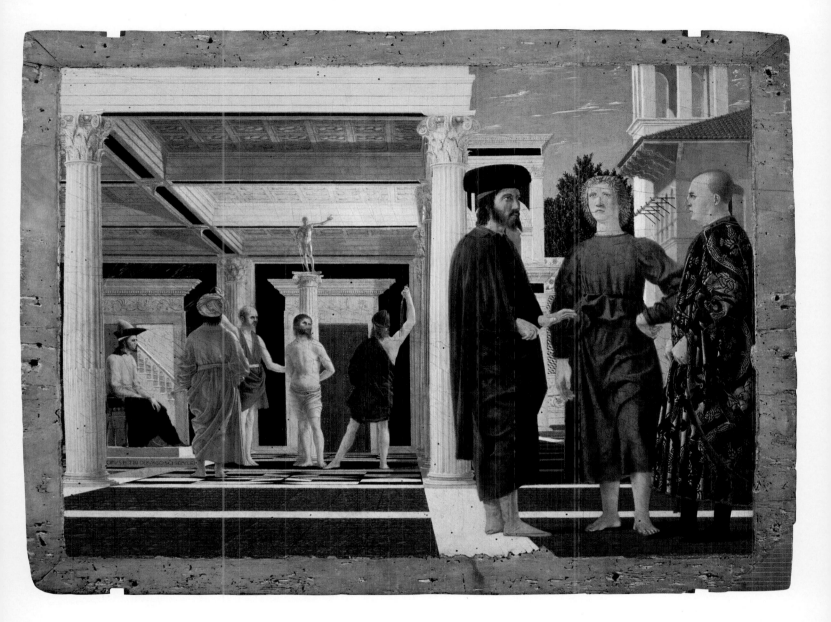

THE FLAGELLATION OF CHRIST
(detail, figures in the foreground)

One of the most striking elements of the composition is the separation between the Flagellation proper and the figures in the foreground. Directly juxtaposed to the background and visually wedded to it, the three men stand in a kind of spatial no-man's-land with no architecture in their immediate vicinity. Thus forced forward into our vision, they are presented as individuals with differentiated personalities. The man on the left, speaking with parted lips and a gesture of the hand, is dressed exotically. He wears a mushroom-shaped hat made of wavy black goat skin and a raspberry-colored coat draped on his shoulders with the extra-long sleeves hanging down below the knees. This particular mode is known to be Byzantine in style from the historical reliefs on St. Peter's doors showing contemporary visitors from Constantinople (fig. 35). This gentleman's growth of wiry hair is also un-Italian, and his double-pointed black beard proclaims him a person of special knowledge. Still today in Italy, Barba Nera ("Black-Bearded One") is the conventional name for an astrologer. Piero uses the convention to identify the "superior wisdom" of his character.

The figure, moreover, is silhouetted against the buildings of Pilate's magnificent marble palace, his heels touching the white pavement strip that supports the loggia columns. In an astonishing feat of detailed painting, Piero has outlined the upper part of the body against the barely visible second building of the palace, deep in space but readable in all its parts. It is two stories high and arcaded on the second floor: a wooden shutter stands slightly ajar in the first arcade. The frieze below the top cornice is black, and the one on the first floor is porphyry red. These horizontal elements combine with the lifted hand and foot below to anchor the figure in space. The wall work in the first bay on the second floor is again porphyry; in the second bay it is black marble, the vertical strip making it

difficult for the viewer to distinguish the black of the goat skin hat in the foreground. In this way, the lecturing man who wears this hat is visually imbedded in the biblical buildings and thus, by association, privy to esoteric information. These characteristics suit well what we know of Ottaviano Ubaldini's personality.

Facing the Barba Nera, a clean-shaven, balding man hooks his thumbs in his belt and listens with grave attention. His clothes are from the West and are decidedly aristocratic in cut. With a crimson scarf circling one shoulder, he wears a fur-edged robe of blue and gold cut velvet in the regal "pineapple" pattern. The illusion created by the perspective makes him seem to stand before an urban palace of impressive size. These attributes identify him as a nobleman of some stature, and his focused attention indicates intelligence and breeding. The same characteristics have been applied to Ludovico Gonzaga.

The youthful figure between the older men is of another order. He wears a red, classical-style, calf-length gown, with flairing peplos, and a thin, woven belt. His feet are bare. His golden hair waves in spikes around his head, and he stares from strange gilt eyes. His backdrop is again architectural but this time of undetermined social value: a diaper-patterned wall with scrolling acanthus rinceaux at top and bottom. But above the wall a giant laurel tree rises and spreads to make a wreath around the figure's head. Thus crowned, the figure is identified as an allegory, the subject of the conversation given visual shape as a perfect youth, extraordinarily fair and beautiful. His pose, with weight on the right leg and left arm akimbo, echoes that of Christ as well as the statue atop the column. In fact, the whole triad mirrors the Flagellation group, making the spiritual parallel clear. Like two sides of a diptych, the groups harmonize, one from the world of human experience, one from the world beyond time.

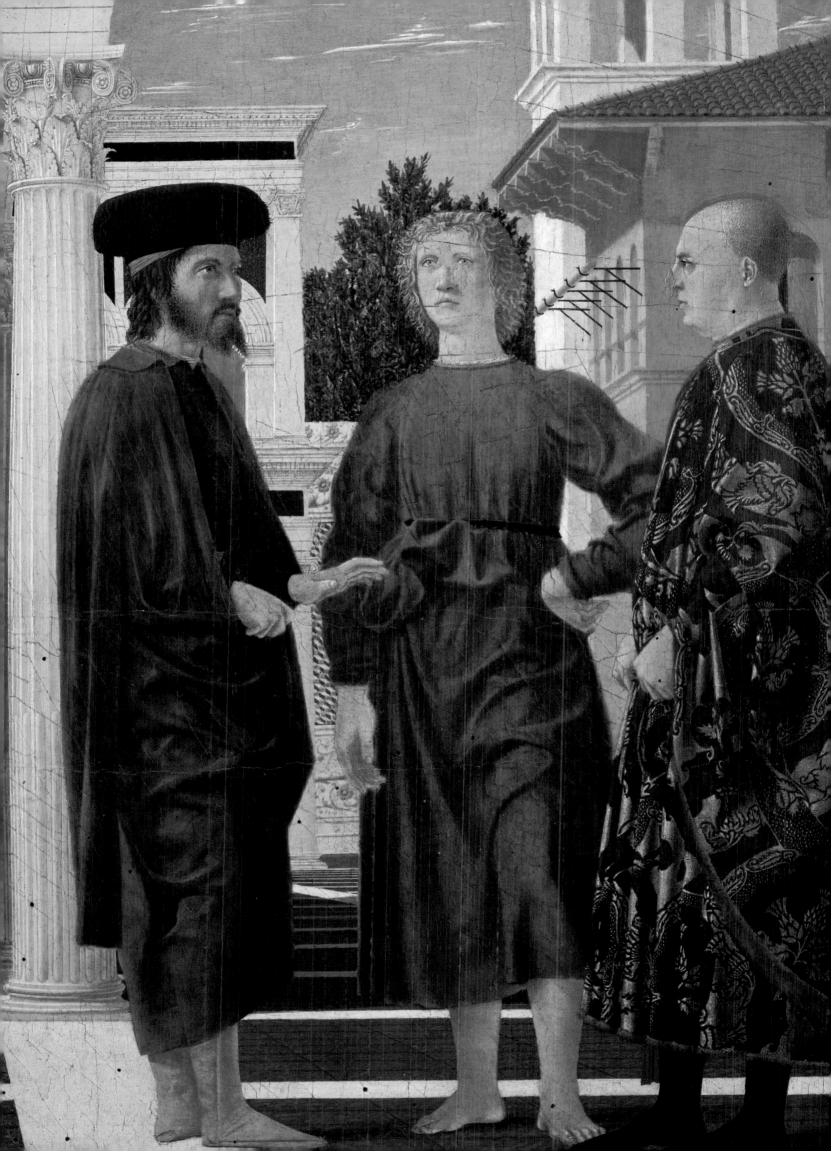

THE FLAGELLATION OF CHRIST
(detail, the Praetorium)

Although he designed the Praetorium according to a long established tradition, showing it as a columned loggia opening on a public square (the biblical Lithostratos), Piero treated the Flagellation scene in an unprecedented manner: he removed it to the middle distance, where the figures are miniaturized. Further, he represented Pilate's palace as a superb classical structure: the carved leaves of the Corinthian capitals gleam with fine details; the shafts of the columns are meticulously half-fluted. The wall at the back of the loggia is revetted with porphyry and other rich marbles and pierced by two doorways with jambs and cornices elaborately carved with palmette and curling-acanthus patterns. The coffered ceiling is divided into several sections and decorated with large rosettes. Soon to become characteristic of Renaissance architecture, at the time of the painting this advanced form of classical style existed only in theory. Nothing of the sort had yet been built.

Completely out of the ordinary in a Flagellation scene is the stairway seen through the door behind Pilate's throne. The reference here is to the Scala Santa, the venerable relic of Christ's tortured crawl, believed since the eighth century to have been taken from Pilate's house in Jerusalem by Saint Helena and transported to Rome. The actual flight of steps, which is housed in a building near San Giovanni in Laterano in Rome, is composed of twenty-eight steps. The view through the door in the painting invites us to complete the painted flight in our minds as something very near that number. For the figure group in the central bay under the loggia, Piero creates another triadic arrangement with the palest figure in the center. Surmounting the column where Christ is tied, a golden statue is the third figure to assume the right-legged contrapposto. The Flagellation scene has two spectators: in the bay at the same depth as Christ, Pilate is seated impassively on his curule chair (the face is damaged),

wearing a visored hat and bright red shoes, both imperial in style. In the first square of the loggia, a turbaned counselor with his back turned likewise observes the scene, making the same palm-down hand gesture as the bearded foreground character. As if to verify the visibility of the scene, this anonymous Arabic gentleman has the same relationship to the Flagellation proper as we, the real spectators, have to the painting itself. Piero paid particular attention to this figure, using a tiny cartoon to trace the folds of his turban (the pouncing points are still visible) and modeling his whole right side with light.

The exaggerated brilliance here is one of the details that alerts us to the mystical phenomenon occurring in the portico. This detail, as well as the unnatural glow in the section of ceiling immediately above Christ, is part of a general light flow that comes from the right, starting, it would seem, at the colonnade. In fact, observing the colonnade quite closely, one sees that the flutes of the second column are dark and those of the third are light. The same is true of the lintel surface between the first and second column, which is shadowed, and that between the second and third column, which is lit. Along with these surprising light effects, Piero painted a series of cast shadows, again executed with such care that it is possible to complete their planes and find their point of intersection. This operation is carried out in our diagram (fig. 27). The point where the planes intersect locates the source of the light flow, and this point is indicated in our Axonometric View (fig. 28). The position in space for the source of light is a short distance behind the second column, slightly within the intercolumniation, about two-thirds up the column. The closest form to this point is the arm of the flagellator on the right, one of the brightest spots in the painting. What Piero did is quite astonishing. He made it possible to discover the totally rational construction that makes an unnatural phenomenon look realistic.

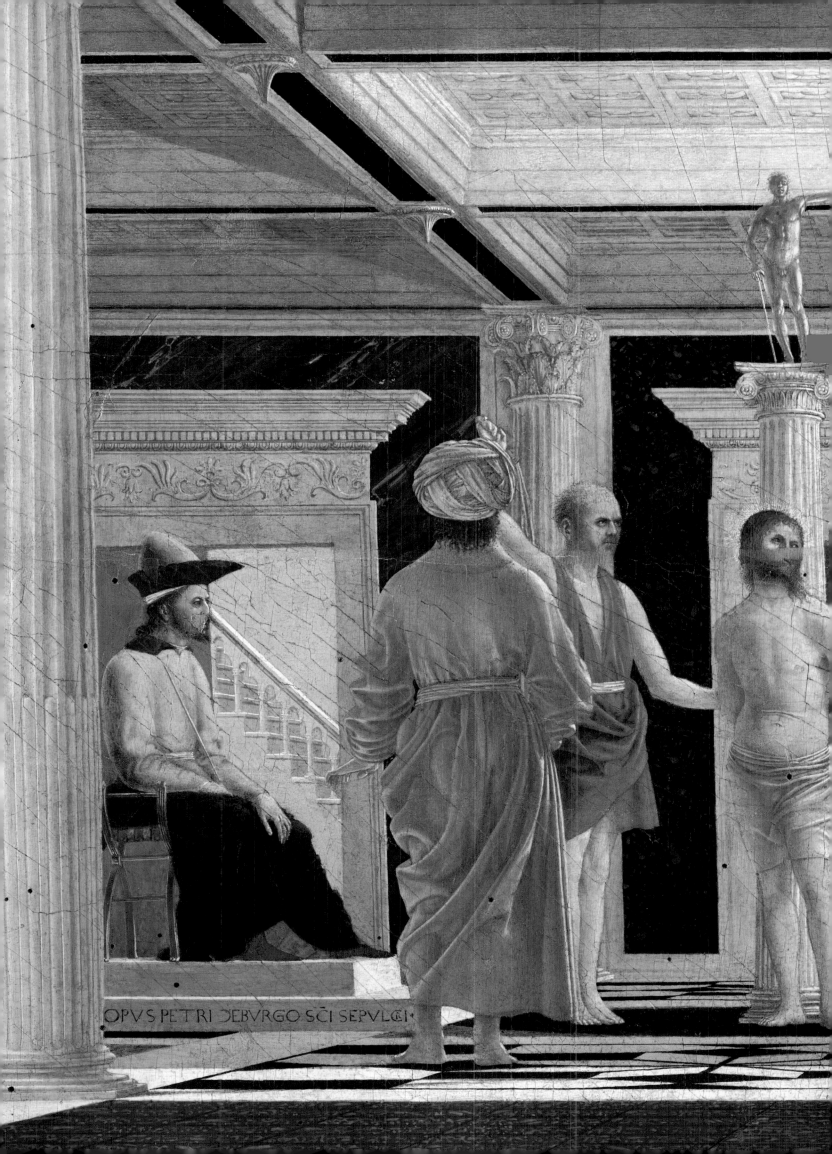

OPVS PETRI DEBVRGO SCI SEPVLCRI

THE BAPTISM OF CHRIST

c. 1460
tempera, 167.3 × 116.2 cm
London, National Gallery

Although in no way geometric, the two sandy banks that line the river recall orthogonals in a pavement floor and lead the eye into the pictorial depth. As they slant together, they suggest convergence toward a single point that can be estimated as somewhere near Christ's knees. Behind the figures a measured vista unfolds back across a valley to a ring of hills in the far distance. Without the benefit of ruled lines or the regular forms of architecture, Piero produced a coherent, unified outdoor space, a kind of vegetal cathedral, based on the principles of linear perspective. The density of upright forms blocks all but the narrowest slice of the ground-level view. Yet the patches of valley floor, the terraced hills, and the distant towers of Sansepolcro are enough to characterize the particular locale in all its warmth and earthiness.

In the foreground, the illusion of the stopping water can be followed closely. As the river swings into its lazy S-curve, the glassy surface mirrors various forms: the red and orange-yellow robes of the elders standing near the banks; the hills dotted with trees; the blue sky and pale gray clouds; and two little shrubs along the shore. Behind the feet of Christ and John, the reflections stop; one final curling ringlet, colored blue, laps between Christ's feet. From this point forward, cream-beige pebbles, rocks, and sand define the dry river bed. The threadlike brush strokes seen on all three ankles are repeated along the ridges of both river banks. There they unambiguously portray the water surface: what is above the line is bank; what is below is reflection. Rounding the final bend, the waterline begins to rise. As if propelled by mystic force, it moves upward gradually, reaching the full height of the banks just at the points of change from reflection to refraction (fig. 33). A curving shape at the left, defined by a darkened edge, implies that the water has turned under and bulged forward in a kind of sack. A brown area beneath the bulge is its shadow, which, in turn, reflects on the convex surface of the bulge. These meticulously rendered effects call attention to the "unnatural" stoppage and heighten the mystery of the sacred rite.

The premonition of divine healing implicit in baptism is repeated in the plants on the banks of the river. There, instead of flowers, we find a series of small, inelegant weeds, all of which are medicinal. Ranunculus (buttercup), seen on both sides of the river, with tiny yellow blossoms near the angels' feet, serves for soothing toothaches, curing lunacy, and cleansing the kidneys. Glycyrrhiza (licorice), on the edge of the left bank, is an emetic and laxative. Convolvulus, or bindweed, the spade-shaped leaves, is a diuretic. Clover, silhouetted against the tree, is taken for snake and scorpion bites and is used as a proof against spells and witchcraft. There is also plantain, growing flat on the ground near John's foot, below the central angel and cut off by the bottom frame line. Its juice protects the gums, its seeds stave off constipation, its roots soothe hard swellings and, most important, staunch bleeding. Clover and plantain both have Christological meaning: by its very shape trifolium symbolizes the Trinity (one variety bears this name). Not only is plantain associated with the Passion and Christ's wounds because of its ability to coagulate blood, it is also known as Wegerich or "way-bread," symbolizing "the well-trodden path followed by the multitudes who seek Christ." In presenting all these medicinal plants, familiar in the poorest meadows and still very much in use in his own time, Piero reassures the worshiper that in the first sacrament, baptism, his own salvation is prepared.

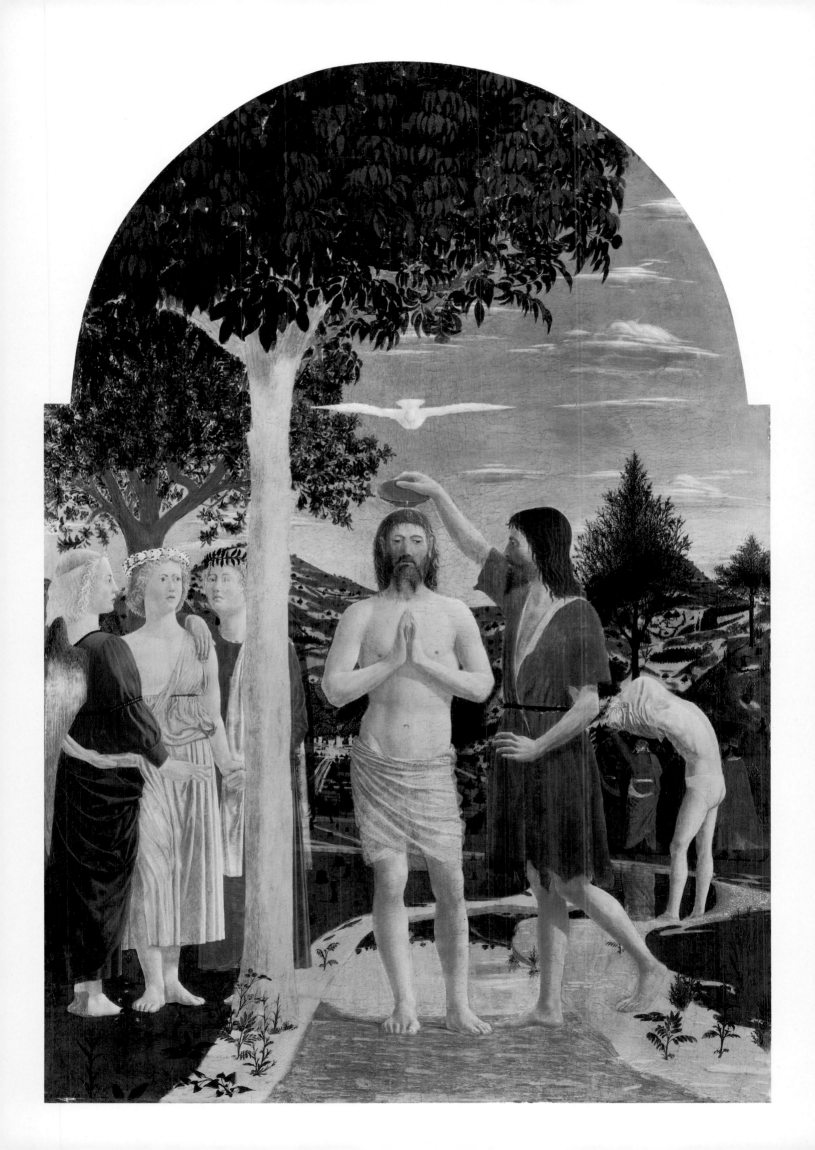

THE BAPTISM OF CHRIST
(detail, the right side)

The catechumen at the edge of the river assumes a pose that is perfectly clear yet perfectly mysterious: is this anonymous personage taking off or putting on his garment? Many such seminude figures are to be seen in earlier Baptism scenes where they are frequently occasions for pioneering experiments in human anatomy and anecdotal realism. Piero's figure differs from the others in that he neither initiates nor resolves his action. His static pose is rather meaningfully ambiguous. Undressing for baptism has been interpreted as the "stripping off of vice" to become clean in the reception of faith. At the same time, putting on the white baptismal robe is interpreted as donning the bridal garment of the new man, married to Christ in the sacrament. Removing all vestiges of anecdote, Piero gives his figure universal meaning. A perfect human specimen, permanently held in time and space, he is a representative of mankind, perpetually prepared to be born into divine life.

Under the arch of the catechumen's body, the elders appear. Usual members of Baptism scenes, in this case they wear elaborate headgear, turbans, flaring stovepipe hats, and garments of dramatic colors. Their reflections in the river turn those waters to the color of wine. The style of their clothes is Constantinopolitan, contemporary Eastern dress used again for its exotic connotations. The Wise Men of the Christmas story were all from Eastern countries, and all astrologers. The Oriental sartorial reference again identifies them as such. They saw the mystic star separately and followed it until they met. Piero portrays them at the moment of their meeting, with one figure pointing to the sky, while two others heed his words, and a fourth strides quickly in from the right. Their displacement to the middle ground isolates them, and their gestures serve to visualize the moment of the Epiphany, the second feast of 6 January, described in the Magnificat Antiphon at first vespers:

When the Wise Men saw the star, they said one to another: This is the sign of the great King: let us go and search for Him.

In this same part of the liturgy, a line based on Psalm 72 (10) is read repeatedly as the offertory, response, verse, and antiphon; it reads:

The kings of Tharsis and the Isles shall offer gifts. The kings of Arabia and Saba shall bring tribute to the Lord God.

Piero has depicted the meeting described in the antiphon. And to underscore the liturgical importance of the image, rather than the more familiar threesome, he has depicted four Magi, as in the Psalm and as often shown in Early Christian art (fig. 36).

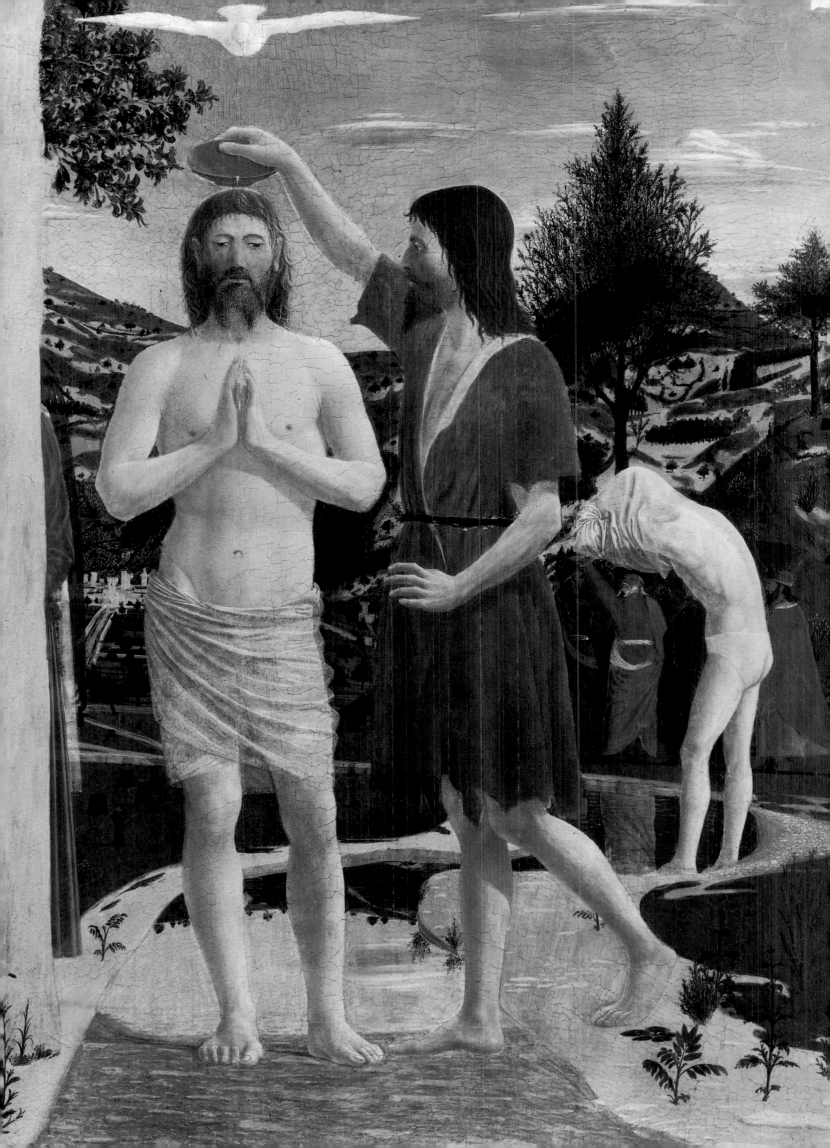

THE BAPTISM OF CHRIST
(detail, the left side)

Wedged between two trees on the left, the angels stand on the grass in a tightly knit triad. Their bare feet are posed like waiting dancers; their springy blond hair is bound with jeweled and floral wreaths. The one with iridescent wings seen from the back wears a magenta dress and drape of sapphire blue. His wreath is a ribbon with pearls at the brow; he expresses amazement with his hand, which is extended at waist height with down-turned palm. Another wears a pure white classical kiton with one shoulder bare; his head is circled with red and white roses. He seems deeply preoccupied as he clasps left hands with the figure at his left. This third angel wears a pale blue dress over a white undergarment, with a pink stole over his shoulder; his wreath is made of myrtle. He places his hand over his companion's breast as he engages the spectator with his eyes. Allusions to the Trinity implicit in the subject are reinforced by their number, as well as by the three-part choice of colors for their clothes. The intertwining poses recall, but for the clothing and the change of sex, the three graces, who signified harmony. Indeed, these intelligent and loving youths, half-hidden in the trees, seem to harmonize in their expression of concern for Christ, knowing of the sacrifice that lies ahead. The myrtle-bearing angel looks directly at the spectator, as if to say, "The sacrifice will be for you."

Meanwhile, particular details of the angels' dress, as well as their gestures, make reference to marriage and thus evoke the third feast of 6 January, the Wedding at Cana. Wreaths with jewels or flowers are constant parts of wedding regalia, and a couple clasping hands, with one laying a hand on the other's shoulder, has signified possession-taking since antiquity, when such gestures were legally binding. As performed by sexless spirits, the handclasp is transferred from the usual right hand to the left, indicating a change from action to metaphor. More-over, by completing the liturgical reference with the connubial aspect of the Bethany, the angels further evoke the theological prototype of all Christian marriage, namely, the marriage of Christ and Ecclesia, said to have taken place at the moment of his Baptism.

The passionate epithalamium of the Old Testament, known as the Song of Songs, was interpreted by the Church Fathers as an allegory of Christ, the "heavenly bridegroom," who takes the body of the Church as his "beloved bride." The Fathers read the poem as a drama in which John the Baptist and the angels were among its chief players. St. John and the angels are called the "Friends of the Bridegroom," whose roles are described as preparing for and assisting in the divine union. Another image of the angels performing this action can be seen in a stone relief by Jacopo della Quercia, where a similar group of three, accompanying the Madonna and Child, joyfully embrace and touch each other in several ways (fig. 38). In Piero's version, the complex theology is embodied in three country boys who mysteriously fuse expository action with emotional dignity and unsullied physical beauty. As the empathetic spirits concentrate on Christ, divine illumination descends and humanity is regenerated in the miraculously stopped Jordan.

The surface of this panel was abraded during restoration in the nineteenth century. As a result, in some areas a greenish underpaint dominates the general tone. The most serious loss is in the gilding, originally more than one might expect. There was a heavy shower of gold striations around the dove, for example, and the liquid that pours from Saint John's dish was totally gilt. The angel wings were gold-shot, and Christ's loin cloth had gold embroidery along the edge. The gilding was, in fact, so profuse that it would have been a major factor in expressing the mystical content we have traced.

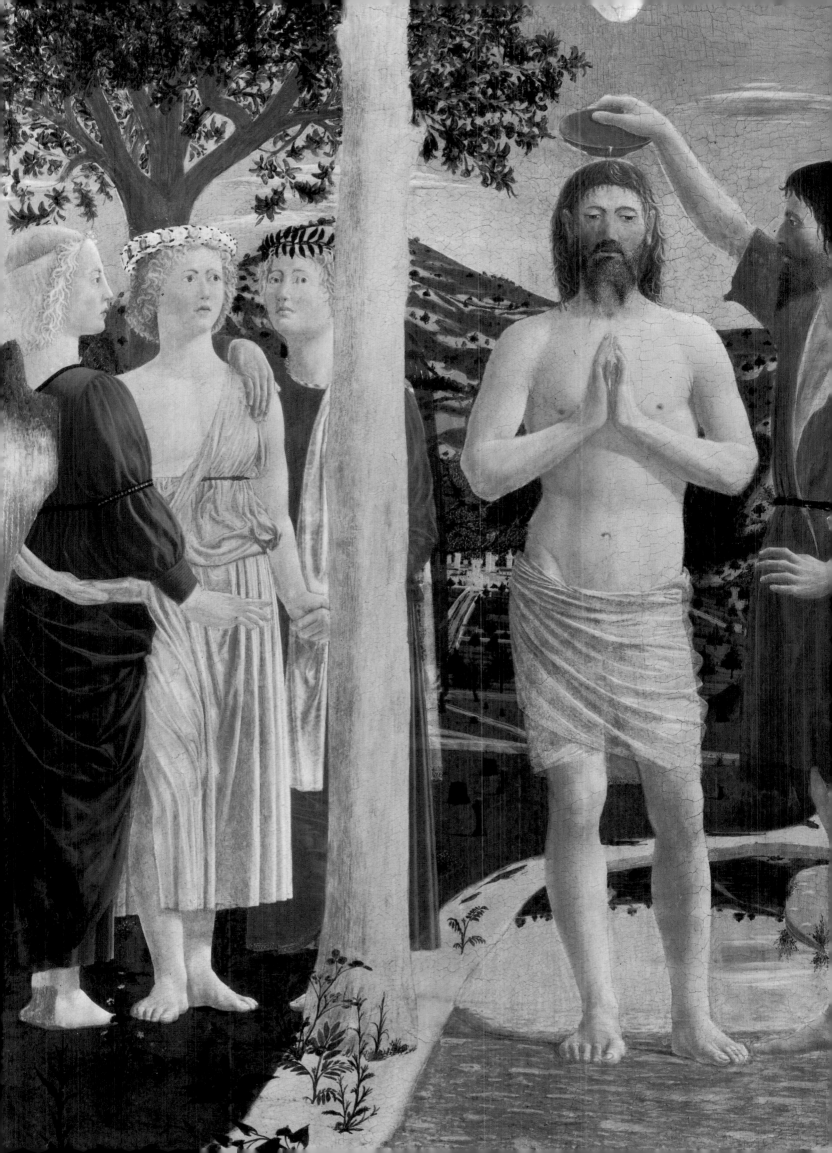

ST. LUKE EVANGELIST

c. 1459

ceiling fresco

Rome, Santa Maria Maggiore, Estoutville Chapel

Piero is documented as working in the Vatican during 1458 and part of 1459. The murals he painted there have disappeared, covered over in the next generation by Raphael in the famous *Stanze*.

What does remain from this period are some ceiling decorations in the church of Santa Maria Maggiore in Rome, in what was the Chapel of Sts. Michael and Peter, adjacent to the Baptistery. No documents refer to this decoration, although it is known that the patron was the Cardinal Estoutville, a Frenchman of much culture and learning. The chapel was later whitewashed, and an exterior entryway was cut into one of the walls. By the 1920s enough of the whitewash had worn away to reveal portions of a figure of St. Luke, which Roberto Longhi promptly claimed for Piero and dated to the period Piero was known to have been in Rome. The condition of the fresco was so deplorable, however, that no one paid much attention. In the 1970s, the chapel was thoroughly restored and the ceiling liberated from all whitewash. All four Evangelists were discovered on the webs of the vault, in varying states of preservation. It now seems clear that if every stroke is not by the master's hand, these decorations were, at the very least, executed under his direct supervision.

Between the groins of the vault, decorated with colorful flowers and scales and edged with oversize acanthus scrolls, four figures sit on clouds, each with his inspirational symbol at his side. Being on the side where the door was cut, St. Matthew is all but gone. St. John the Evangelist, in the web opposite, remains only as an underdrawing. St. Mark, in the web to St. John's right, has a voluminous gown colored light blue with strong white highlights; both the color and the deep modeling are unusual for the fresco technique at this time. Even more extraordinary is the effect of light falling from above on the skull and lower sleeve, which is painted green. The hand, lifted as if responding to a call, glows with ruddy reflected light

from under the palm. The effort to achieve this pictorial effect may be measured from the special patch of fresh plaster, or *giornata,* that was prepared for the work.

The figure of St. Luke is the best preserved of the four, and technically the most startling. The surface of the web he occupies was covered completely with a ground of gesso (fine plaster, glue, and marble dust). In northern Europe, artists often prepared the wall with a ground of whitewash before it was frescoed, and Piero may have been following such a practice (remember, his patron was from France). But his preparation goes beyond simply creating a white base. This preparation provided a truly hard surface, as though it were a panel painting. The figure was then drawn directly on the ground with red pigment. The design of the body was drawn free, but that of the face was transferred to the wall by means of a cartoon; again, the pouncing holes are still visible around the features. The face was then painted not in the usual watercolors on wet plaster but entirely in tempera (pigment mixed with egg binder), again as in a panel painting. Even more astonishing, the features are highly modeled and treated with a series of glazes. Other surface treatments include incisions in the ground to make the halo, and gold leaf applied to the edges of the saint's scarf.

Conceptually the figure is equally interesting. As opposed to almost all other representations of the third Evangelist, Luke is here portrayed as quite young and very blond. With a strongly provincial quality in his features — he could almost be a cowherd — he seems quite at home with his apocalyptic animal, the bull (badly damaged). Similar to the figure of St. Mark, who looks like an old farmer, Luke's lowly social status enhances the miraculous nature of his inspiration. Such nonnarrative, nondevotional figures, high above the spectator's vision, in the hands of a lesser artist are often treated as staffage. With Piero, they became a battleground for technical experimentation and for the expression of ideas.

ST. MARY MAGDALENE

c. 1460

fresco, 190 cm high

Arezzo, Cathedral

Closely related to the *St. Luke Evangelist* in Rome is another undocumented fresco, a standing figure of St. Mary Magdalene in the cathedral of Arezzo on the wall next to the sacristy door. This figure, too, turns slightly to the left and pauses to reflect with lowered eyes. In this case, the topography of the face is enriched by broad modeling that inflates the cheeks, the mobile mouth, and eyes that deeply move us with their asymmetricality. The woman stands on red pavement before a low balustrade. Surmounting a painted panel of variegated marble, flat pilasters with molded capitals mark an entranceway under a semicircular arch, lavishly decorated with simulated classical details. The arch, echoing the pattern of the figure's head and shoulders, is seen in steep perspective from below, and though its parts are monumental in proportion, it seems stunted by the grandeur of the figure's scale. The illusion is that the Magdalene has been removed to a high-placed balcony in a superior realm where, her halo silhouetted by the open blue sky, she fulfills her function as a divine intercessor.

In iconic isolation, as a physical being, Mary is massively grand. Her head rests on a sturdy neck and her draped body is voluminous. She is dressed in three unmodulated colors: white, green, and red. In spite of their simplicity, all three colors have deep Christian meaning that symbolize the cardinal virtues: the white of the lining of her cloak is Faith (the faith that led her to follow Christ); the green of her dress is Hope (the hope for salvation through repentance); and the red of her mantle is Charity (the love she bore for Christ). By arranging her cloak with one side thrown over the shoulder and the other caught up in her powerful hand, Piero emphasizes the colors. His Mary Magdalene is literally clothed in virtue.

Historically, this woman is a composite of three biblical characters. Overtaking the other two at this very period was the prostitute who repented her sins. She was identified as such by carrying a jar for oil, a traditional attribute of women of this profession. As her religious dedication progressed, however, the Magdalene's unguents took on a deeper meaning. When she returned to Christ's tomb after the Crucifixion, she planned to anoint the body before its final burial. In this way, as with the woman herself, the oil was raised from ignominy to exaltation. In Piero's version, the attribute reaches a kind of visual glorification. Draperies form a cloth mandorla around the jar made of crystal with bands and finial of gold. Its cylindrical form and pointed top are that of a liturgical pyx used to hold the consecrated host. With a delicacy of detail quite extraordinary in fresco painting, Piero has represented the luminosity of the light-struck stone reflected on the Magdalene's strongly foreshortened fingers. Rock crystal, according to popular belief, was the congelation of pure snow and therefore had magical properties difficult to define. With the visual effects of glowing stone and glowing hand, Piero has equated these properties to the mystery of transubstantiation.

Legend tells that the Magdalene spent the years after Christ's death as a hermit, meditating on this very mystery. Her one activity was receiving the sacrament. In her wilderness solitude, however, her clothes fell to tatters, and God sent a miracle to shelter her from shame. The hair that had earlier been a sign of great beauty now grew abnormally long and covered her nakedness. In Piero's impassive image of the Magdalene, she is still young and strong. But he has alluded to the full cycle of the story by representing, besides her prophetic jar, stringy strands of hair that seem to sprout with life before our eyes.

ST. AUGUSTINE

(panel from dispersed *Augustinian Altarpiece*)

1454–69
tempera and oil, 133 × 60 cm
Lisbon, Museu de Arte Antigua

The rare case of a fully documented commission to Piero is, ironically, a dismantled altarpiece whose parts are scattered through Europe and America and, worse, whose central image is lost. Created for the high altar in the church of the Augustinian friars in Sansepolcro, the painting was ordered in a contract drawn up on 4 October 1454, stipulating that Piero finish within eight years. Even with such a long period to work, as usual, he was not punctual. In fact, it took him fifteen years to bring the altarpiece to completion (1469).

What happened to the work from the sixteenth to the eighteenth century is obscure. We know that the Augustinian friars moved out of their church in 1555 into the Pieve di Santa Maria in the same town, and this second locale was demolished in 1771. But there is no way to judge when the altarpiece was dispersed.

In 1941, Millard Meiss recognized that panels in Milan, London, and New York must have formed the wings, as three parts to a set of four. He published them together: standing figures of St. Michael the Archangel in London, St. Simon Peter in New York (Frick Collection), and St. Nicholas of Tolentino in Milan (Poldi Pezzoli Collection). Their compositions are similar to that of *St. Mary Magdalene:* a stone ground line ending with a low parapet, this time decorated with a classical frieze, and blue sky above and beyond. Because of the perspectivized corner of a step or a dais in the left foreground of the Frick panel, Meiss suggested the lost central panel was a Madonna Enthroned; both the Assumption of the Virgin and her Coronation have since also been suggested. In 1949, Kenneth Clark found the fourth saint, Augustine himself, in the Museu de Arte Antigua, Lisbon. Augustine stood at the left end of the alignment, next to *St. Michael.*

The figure of St. Augustine is a tour de force of illusion. As patron of the religious order, he appears a stiff and abstract symbol, a venerable effigy. Dressed in the simple habit of a friar, he is engulfed in a bishop's cope, a ceremonial robe that is no ordinary garment. Built primarily of gold and black velvet cut in pineapple patterns, the cope is edged at the bottom with golden fringe and faced along the front borders with broad bands embroidered with scenes. The scenes are not merely suggested but are fully developed naturalistic compositions representing Christ's Infancy and Passion. What is astonishing is that, as the cope hangs in folds reflecting the forms of the saint's body, the perspectivized architecture and deeply receding landscape settings respond to the changed shapes. The Annunciation, for example, is concave, while the Nativity bends to the swelling where Augustine's hand protrudes to hold a book. The three lower scenes on the left side curve around the fold that results from this movement. For all these surface irregularities the scenes retain their pictorial integrity.

Superimposed on this illusion is the bishop's crosier. In his gorgeous white-gloved hand, spangled with gold stars and rings, the saint holds his gold-topped crook with a pole of precious crystal reaching to the ground and catching light along its length. Two embroidered saints and a Flagellation can be seen through its transparent shaft. Throughout this exercise in technical mastery, each material is treated with a different surface: the beaded miter is banded with stiff gold braid; the skin is wrinkled; the beard grizzled; the embroidery nubby; the crystal glassy; the fringe metallic. Piero's vaunted study of northern painting is undeniably demonstrated here. Indeed, laboratory studies of all the figures from this altarpiece show, for the first time, Piero's generous use of oil paint. He has made the foreign technique his own, however, by using it for its powerful decorative effects on his own figures of consummate structural solidity.

THE LEGEND OF THE TRUE CROSS
The Story of Adam (detail, the death of Adam)

The opening scene of *The Legend of the True Cross* is unique in the history of art: Piero invented an image of what we might call "Adam's Soliloquy on Death." He shows a decrepit and emaciated Adam reclining on the earth, in a position close to many scenes of man's creation. He is supported at the back by a flaccid-breasted, sibylline Eve, a far cry from the temptress of her earlier years. The father is speaking to three of his offspring, who surround him in pensive silence. According to legends of the first family, long before this moment Adam had learned the implications of the Original Sin but remained the only one to be so initiated. Now he is the only one who knows that he is dying, and he explains what this fact will mean to his sons: life that ends in death makes salvation necessary. Since the Cross is the instrument of salvation, Piero's innovation gives this story a logical beginning lacking in all previous versions.

This group sets the stage for the early phases of man's development: one boy is nude, another clothed in animal skin, a third is swathed only in a simple drape. The nude is often compared to classical sculpture because his pose is one developed in antiquity for mourning statues. But his body is encircled by a mellifluous line (actually incised in the plaster) that describes a pulsing musculature more related to linear representations, particularly those on vases. Aretine pottery was already famous in the classical period, and in Piero's day an ancient kiln, filled with high-quality vessels, was unearthed. The discovery was made by an artist named Lazzaro Vasari, a relative of Giorgio who reports the story (the family took the name Vasari because originally they were *vasari,* that is, "vase makers"). As Lazzaro and Piero quite possibly worked together at various times, Piero's acquaintance with such materials is assured.

Part of Adam's instructions were to Seth, his oldest son (after Cain and Abel), to return to the garden of Paradise and ask for the "oil of mercy," to end man's punishment. Piero retires the Meeting of Seth and the Archangel to the background, following the motif he used in his *Baptism,* a spatial breach and change of scale representing a different location and a different time. In this case, the diminished size of the distant figures tells how far the second figure of Seth had to journey to hold this meeting. St. Michael's stern glance expresses his refusal; he tells Seth that the time for salvation had not yet come. Instead, he offers Seth a branch of sacred wood to place over Adam's grave, and prophesies mysteriously that from the branch the source of salvation will spring.

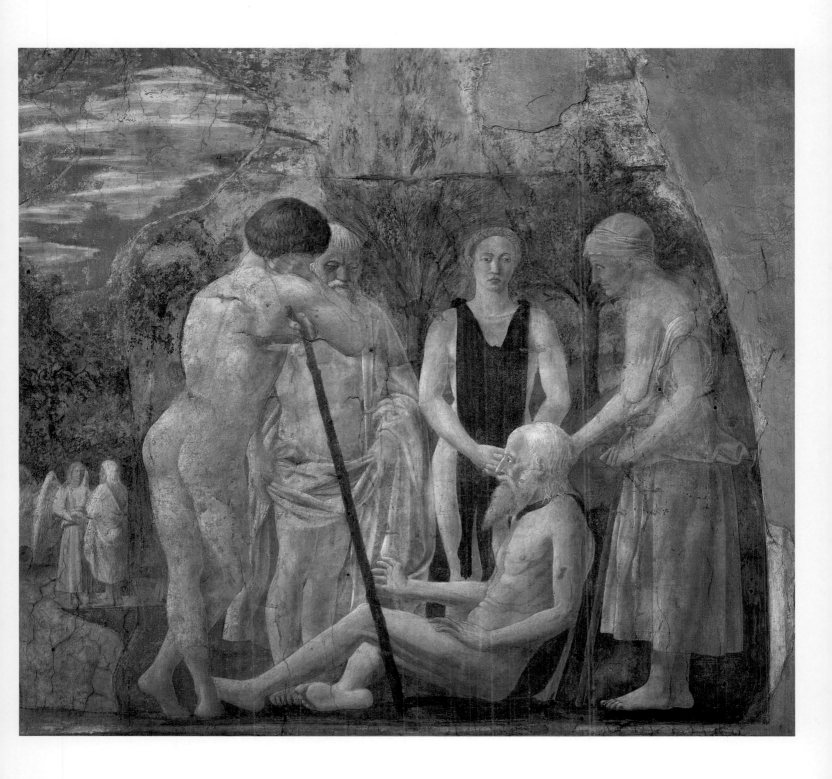

THE LEGEND OF THE TRUE CROSS
The Story of Adam

1452–66
fresco, 390 × 747 cm
Arezzo, San Francesco, chancel, right lunette

Although the narrative sequence continues to the left, with a representation of Adam's funeral—at which Seth plants the branch in the presence of many siblings—the main protagonist of all the episodes rises above the center of the composition. It is the tree that once dominated the full lunette, with its branches filling the upper reaches of the pointed arch. Today, this vast growth is partially destroyed and what remains looks black and bare. Originally, however, the tree was covered with colored leaves and sprouts (now visible only under infrared light). Legend tells that, when Adam and Eve sinned under the tree, it blackened and withered away to nothing. But when Michael promised man's salvation at a future date, the tree regenerated and burst into bloom. Piero showed it thus, in splendor. His great tree rises in triumph over Adam's melancholy death as a spectacular emblem of the Fortunate Fall, the paradoxical concept fundamental to Christian thought. Without the Felix Culpa, or "happy sin," of Adam and Eve, the Savior's advent would never have taken place and man's destiny would have been diminished.

According to Church doctrine, this destiny was forecast by the Old Testament prophets, two of whom Piero shows on the upper tiers of the altar wall. The blond youth with half-bare chest in the left corner of the lunette stares transfixedly toward one of these figures as if already hearing the prophet's voice. This boy and his companion wrapped in animal skin are among the best preserved figures on the tier in terms of surface effects. The dark yet vibrant profile on the left still bears cartoon punctures along the cheek and eye, while the three-quarter face to the right is modulated by a ruddy light and the stippling of a self-cast shadow.

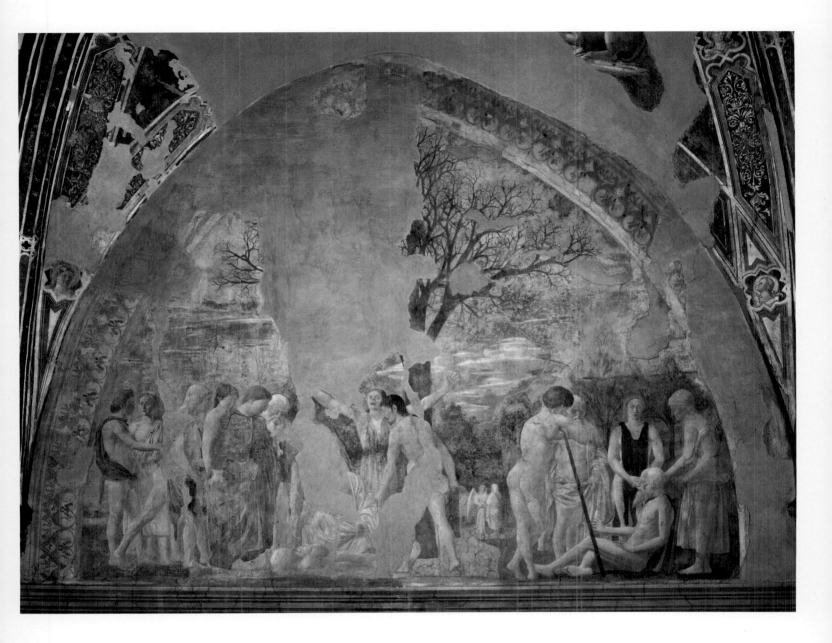

THE LEGEND OF THE TRUE CROSS
Sheba Worships the Wood *and* The Meeting of
Solomon and Sheba

1452–66

fresco, 336 × 747 cm

Arezzo, San Francesco, chancel, right wall, second tier

The tree that grew over Adam's grave was so beautiful that King Solomon ordered it cut for use in the great palace he was building. The wood proved magical, however, and no matter what the workmen did, the planks from the tree kept changing size. Thoroughly frustrated, the king had the wood thrown across the Siloah pond for use as a bridge. When the Queen of Sheba made her famous journey from the East to "try the wisdom of Solomon with hard questions," as she approached the bridge, she recognized the sanctity of the wood and knelt to venerate it.

The arrangement on the second tier right suggests a long journey from the distant hills through a broad and empty valley. At the turning on the left, the group of travelers has come to rest. Two grooms attending sturdy mounts take symmetrically opposite poses, one seen from the front, one from the back; one in gray and red, one in red and gray. Two leafy trees make a hypaethral sanctuary where the queen kneels in prayer before the wood. She is surrounded by an entourage of women who gesture in amazement at the miracle. Perhaps more than any of his figures, these "Piero women" characterize his model of perfection. They stand before us in sartorial splendor: constructed gowns of tinted hues, high waistlines, soft bound breasts, and trailing cloaks of weighted fabrics. Columnar necks support their ovoid skulls, shaved at the brow with tightly braided tresses lashed with ribbons, and ears netted or veiled in modesty. These women are the fulfillment of our dreams: beings intent on truth, using words sparingly, showing the dignity and purpose of human sensitivity.

As formal units, the figures may not be judged as merely palpable, for they are taken to a realm beyond. Legs are not legs but cylinders, each head is a perfect sphere; the wood is not a natural log but consciously crafted into a parallelepiped. Following the theories of Plato, Piero reduced all forms to universal "regular bodies." In so doing, he gave the forms abstract perfection and brought the time in which they exist to an absolute standstill. The result is action turned to ritual and meaning turned to holy celebration.

To ensure narrative continuity, in the adjacent scene of the *Meeting of Solomon and Sheba,* Piero reused cartoons from the left part of the tier, now turned back to front with only minor variations. He drew similar identities with identical types, which are repeated from Sheba's maidens in the entourage of the Empress Helena on the opposite wall (see Colorplate 25). Such repetitions amply demonstrate his unitarian view of a rationally structured world.

The same is true of his reuse of compositional motifs. The stunning, obliquely viewed Corinthian portico, for example—which he had developed for the small-scale *Flagellation* panel, where the columns have half-fluted shafts and the space is filled with intricate light play—is put to new use here. Solomon's reception hall is now placed flush with the picture plane and is evenly lit. The colonnade, which serves to separate the episodes without interruption, is made of simply fluted supports. It has, instead of coffers, a heavy marble ceiling and impossibly long stone lintels between the columns. It is, in short, simplified but aggrandized, one might say mythologized, as Solomonic architecture. It forms a regal setting for the monarchs who greet each other with a hand clasp. While this gesture ordinarily designates equality, Sheba bends to lower herself before Solomon's superior wisdom. Her maidens watch in heavy silence, once more recognizing the ritual meaning of the encounter. It was Christ himself who referred to this meeting as a figure for his own marriage with the Church.

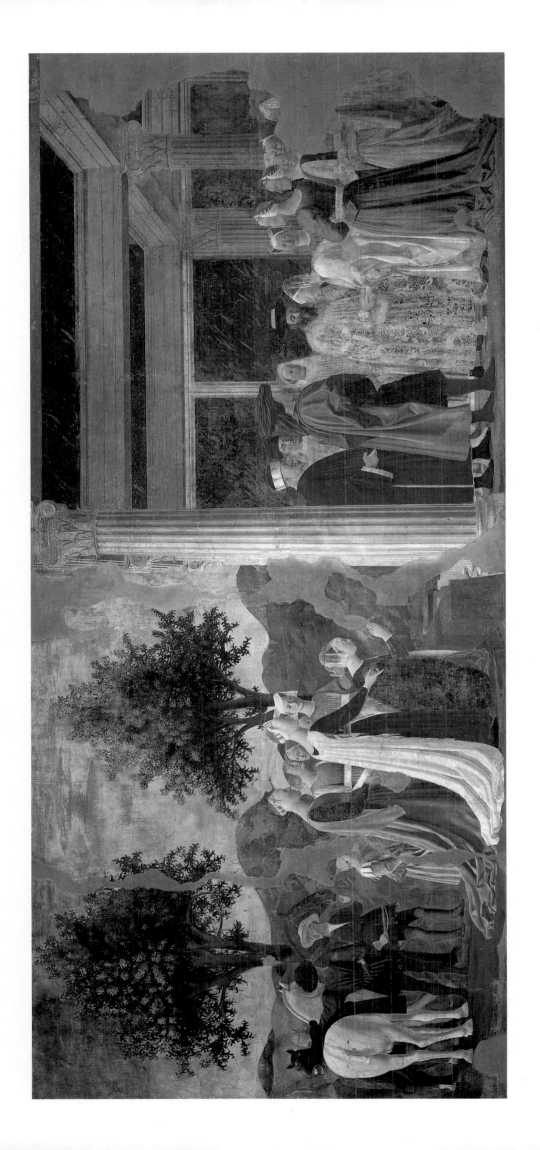

THE LEGEND OF THE TRUE CROSS

Judas Raised from a Dry Well

1452–66

fresco, 356 × 193 cm

Arezzo, San Francesco, chancel, altar wall, second tier left

The Burial of the Wood

1452–66

fresco, 356 × 190 cm

Arezzo, San Francesco, chancel, altar wall, second tier right

In the two scenes that flank the window on the altar wall second tier, Piero departs his universe of ideal beauty and enters instead what might be called a mode of "comic relief." *The Burial of the Wood* shows three brutish clods laboring together to up-end a knotty plank into a hellishly red-rimmed pool. The struggle causes them to sweat: the first has loosened his shirt; his socks are falling down; his genitals are shamelessly exposed. The second, barefoot and bare chested, hoists the plank with the aid of a strut, biting his lower lip with the effort. With shirttails bagging out, the third pushes forward and down with his bare hands. He wears a wreath of leaves and berries, suggesting pagan drunkenness and lack of wit. The compositional thrust of these unseemly acts follows the descent of the wood from upper right to lower left, directing the eye to the next episode in the chronology (the *Annunciation;* see Colorplate 19), diagonally below.

The scene to the left of the window shows the reverse action; instead of lowering, it is one of raising: *Judas Raised from a Dry Well.* This Judas (grandson of St. Stephen's brother, and a secret Christian!) is the only man who knows where the relic of the Cross is hidden. At first, he refuses to tell his secret and is thrown into a dry well. But after seven days of torture, he recants and is pulled from his subterranean prison. The compositional thrust of this scene also depends on strong diagonals, matching the plank in the burial scene with the supporting blocks of the single fixed pulley used as a hoist. The comic vein here is drawn, surprisingly enough, not from the sacred legend, but from Boccaccio's *Decameron* and the hilarious story of "Andreuccio da Perugia." After the "hero" Andreuccio has fallen into a dungheap, he is guided by two tomb robbers to a well where there had always been a rope, a pulley, and a great bucket. Finding the bucket gone, the thieves tie Andreuccio to the rope and let him down to wash. Guards of the watch come for water and, expecting the bucket, they pull up Andreuccio, much to their consternation (fig. 52). The image of foppish dandies pulling on a rope attached to a young man in Piero's version surely recalls this low-brow comic situation. The painted scene thus joins its counterpart on the right on the level of comic relief. In both the style is rougher than in the rest of the cycle, and as a result, these scenes are often attributed to one of Piero's assistants, Giovanni di Piamonte. I suggest there was a point to this change of hand, namely, to suggest the comic element by electing Giovanni to paint in a style close to but cruder than Piero's own.

Again, in both cases and simultaneously, a more serious note is struck. The plank scene, as has often been observed, recalls the Carrying of the Cross, but in a paradoxical way, since, instead of suffering, it demonstrates the innocence of stupid men who are unaware of the significance of what they are doing. In the case of Judas, his release has been likened to Christ's Resurrection. But in reality the reference is more complex. The official-looking man on the right has a ticket in his hat inscribed with a word resembling the Italian term for "prudence." He grasps Judas by the locks to haul him up. This manner of extrication is the means by which the prophet Habakkuk was carried by an angel to "a place he did not wish to go." Like Habakkuk (a prototype of Christ), Judas at this moment does not yet understand that he is being taken by force for a higher good. Unlike his evil namesake, the new Judas will show his prudence in a change of heart and soon become St. Helena's confidant, and later bishop of Jerusalem.

THE LEGEND OF THE TRUE CROSS

The Annunciation

1452–66

fresco, 329 × 193 cm

Arezzo, San Francesco, chancel, altar wall, bottom tier left

The inclusion of an Annunciation scene is out of the ordinary in a Story of the Cross. Although the Old and New Testament parts of the story are implicitly connected by the life of Christ, Christological scenes are not included in any other cycle with this subject. I suggest that in Piero's case a Marian subject formed part of the commission.

In 1298, an indulgence for forty days was conceded to worshipers who frequented this church on the feast days of Mary and three Franciscan saints ("beate Maria Virginis, beati Francisci, beati Antonii et sancte Clare"). In remembrance of this function, standing figures of the latter three were represented on the window frames and jambs of the chapel. The *Annunciation* would depict the Feast of Mary (25 March) in honor of the same remission. If this is so, Piero has again performed his duty in a characteristic manner, drawing out the inner relevance of the required subject to the subject of the cycle as a whole.

The setting of the *Annunciation* is outstanding. The simple Casa Santa, Mary's house, is made into a brilliant classical structure with columned portico and marble encrusted walls. The composition is divided into four parts, each of which carries its own significance. In the upper left, a palpable figure of God the Father carried on a shadow-casting cloud opens both hands to release miraculous, impregnating rays (very little of the original gold now remains). The Lord's gesture of initiation corresponds to the arrival of his messenger below. Neither standing nor kneeling, the angel Gabriel appears in a paved forecourt, blessing with one hand and carrying a palm branch in the other. His raised hand is silhouetted against a doorway intricately carved with geometric patterns. This portal is a reference to the gate described by the prophet Ezekiel (44:1–3) as "that looketh toward the east" through which only God can enter. As the Janua Caeli it is an epithet of Mary's eternal virginity. The palm frond, on the other hand, announces not the Incarnation of Christ but the future death of Mary. The palm is the key to Paradise, lost when Eve sinned but returned when Mary died. The sin of "*Eva*" is unlocked as the angel utters "Ave." Even as she begins her mission, Piero would have Mary's destiny as coredemptress defined: as the bride of Christ (Sponsa), she is the representative of every member of the Church. Her death and Assumption guarantee the salvation of mankind.

The construction of the figure of Mary, gesturing in surprise and resignation, expresses the same concepts. In rational terms, her monumental form is much too large for the portico, reaching almost to the ceiling. She and the adjacent snow-white column share an entasis. The Corinthian shaft, breaking strong architectural law, remains unfluted in response to Mary's unbroken virginity. Mary is thus shown as a symbol of Ecclesia, pillar and body of the Church as an institution. Her marriage to Christ (theologically said to take place also at the moment of the Incarnation) is evoked in the fancy diaper-patterned inlay wall and bower-like vaulted ceiling in the bedroom partially visible behind her. The bridal chamber has been prepared, and Mary, the "bride," awaits her lover, Christ, the Sponsa and Sponsus of the Song of Songs.

On the second story of the house there is a window crossed by a bar of heavy wood. Although the same motif appears several times in the cycle, here the image represents another epithet for Mary. The *fenestra cancellata* or barred window described in the Song of Songs (2:9) is still another reference to the Virgin Birth. Yet the structure also has a more mundane aspect. The bar is held by a meticulously painted hook supported on an iron strut from which hangs a metal ring. Often seen in paintings of this period, and still in use in smaller towns of Italy, such bars and rings serve to hold ordinary laundry (the ring is used to anchor the string ties that hold the clothes in place) and, on feast days, the linens and tapestries that decorate processional routes.

By isolating this detail, Piero makes it ostentatiously clear that the bar is empty. As it is silhouetted against the wall, its shadow seems miraculously to pass through the hanging ring. By thus referring to, but not representing, the feast day of Mary, Piero focuses not on the liturgy but on the moment of the Incarnation. The scene shows the beginning of Christ's life on earth and, therefore, of the scheme of salvation. In this way he explicates the Annunciation as the nexus between the two halves of the story of the Cross, the Old Testament preparation of the wood and its final exaltation as a relic.

Reference to the Cross, moreover, is quite explicit in the structure of the composition as a whole. The field is divided into quadrants by the central column and the strongly accented "crossbar" of the green serpentine marble frieze. Again, the compositional thrust from left to right guides the eye toward the scene that will follow next in the sequence.

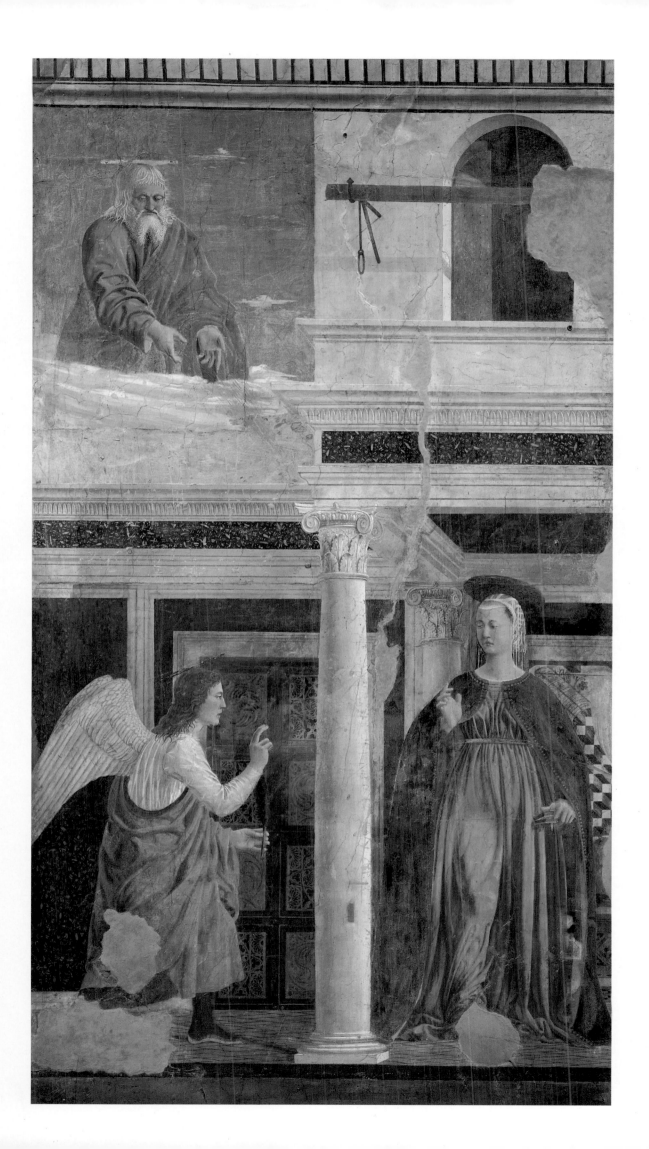

THE LEGEND OF THE TRUE CROSS
The Vision of Constantine

1452–66
fresco, 329 × 190 cm
Arezzo, San Francesco, chancel, altar wall, bottom tier right

A number of Early Christian historians give accounts of the Emperor Constantine's vision of the Cross, differing slightly in details of locale, time, and the form of the vision. They all involve a heavenly visitor, however, either Christ or an angel, who comes to Constantine on the eve of battle and shows him a mysterious sign in the form of a Cross. The visitor does not explain the meaning of the Cross but tells Constantine it will bring him victory. Piero drew on these accounts to devise an image that is essentially his own.

In one of the first night scenes in monumental painting, the mighty general is disarmed, sleeping in his military tent. An angel streaks in from above holding a small golden Cross (see next Colorplate). Emanating from this tiny emblem is a radiance that fills the night and brings the figures into view. The scene is virtually a second Annunciation, the diagonal thrust of the descent of the Holy Spirit in the first repeated in the angle of the angel's flight in the second. Two armored soldiers stand guard, one, with his back turned, approaching with a spear, the other facing out, threatening with his weapon raised. Positioned at the sides of the tent, these bodies mask the lacings and make the drawn-up tent flaps seem miraculously suspended. The sleeping Constantine thus appears to us as in a revelation. His eyes are closed and we see what he sees in a dream.

Though all accounts repeat the words Constantine hears (*In hoc signo vinces* [IHS]; "By this sign you shall conquer"), Piero makes no such reference. Rather, by not representing the famous words, he broadens the theme to show that Constantine's victory goes beyond the bounds of war.

The body servant on the edge of the emperor's bed looks at the spectator with a melancholy air. He rests his head on his hand in a pose of mourning. Constantine's position puts him perpendicular to the wooden tent pole. There he resembles nothing more than the symbolic Adam, often found lying dead at the foot of the Cross. Superceding narrative, these elements make the message clear: we are witnessing the death of paganism on the eve of Christian victory, not just over worldly enemies but over death itself. Like the scene of the Annunciation, this one, too, proleptically, carries its ultimate conclusion in its very beginning.

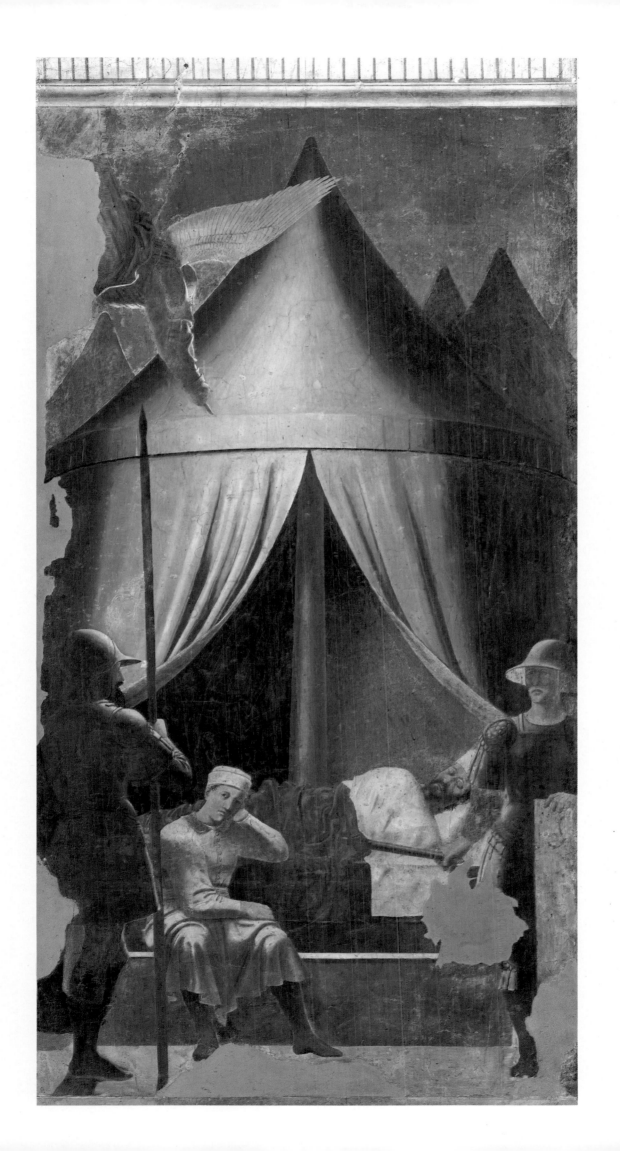

THE LEGEND OF THE TRUE CROSS
The Vision of Constantine (detail, the angel)

The angelic messenger is one of the most astonishing figures of the fifteenth century, and one of the most difficult to read. He plunges down from a star-filled sky, wing extended and one arm stretched before him. We see him almost upside down in sharp foreshortening: the back and bottom of the arm, the lower edge of the peplum at his waist, and what remains of the folds of his skirt. His action is one of proffering a Cross, which he holds upright in his fingertips with the little finger pointing up and stiff for balance. In most accounts, the Cross looms large in the sky, a shining emblem etched in light. This one is so small that, even before it lost most of its gold paint, it would hardly have been visible. By diminishing the scale to the point of insignificance and introducing brilliant light,

Piero has emphasized not the object but its power. The silent angel does not show his face, but what shines forth from his hand illuminates the world.

In pictorial terms the light models the forms into bulging convexities; where there is no light, concave spaces recede. The cylindrical shape of the tent glistens like a cone of gold, and the repeated forms of its pointed top imply a crowded camp. Unlike its partner across the window, where irrational leaps of scale and deftly placed shadows symbolize the miracle, in the *Vision of Constantine,* more than in any other of Piero's works, the painted light is the purveyor of the mystery. The drama of this visual event would remain unmatched in painting until the early seventeenth century.

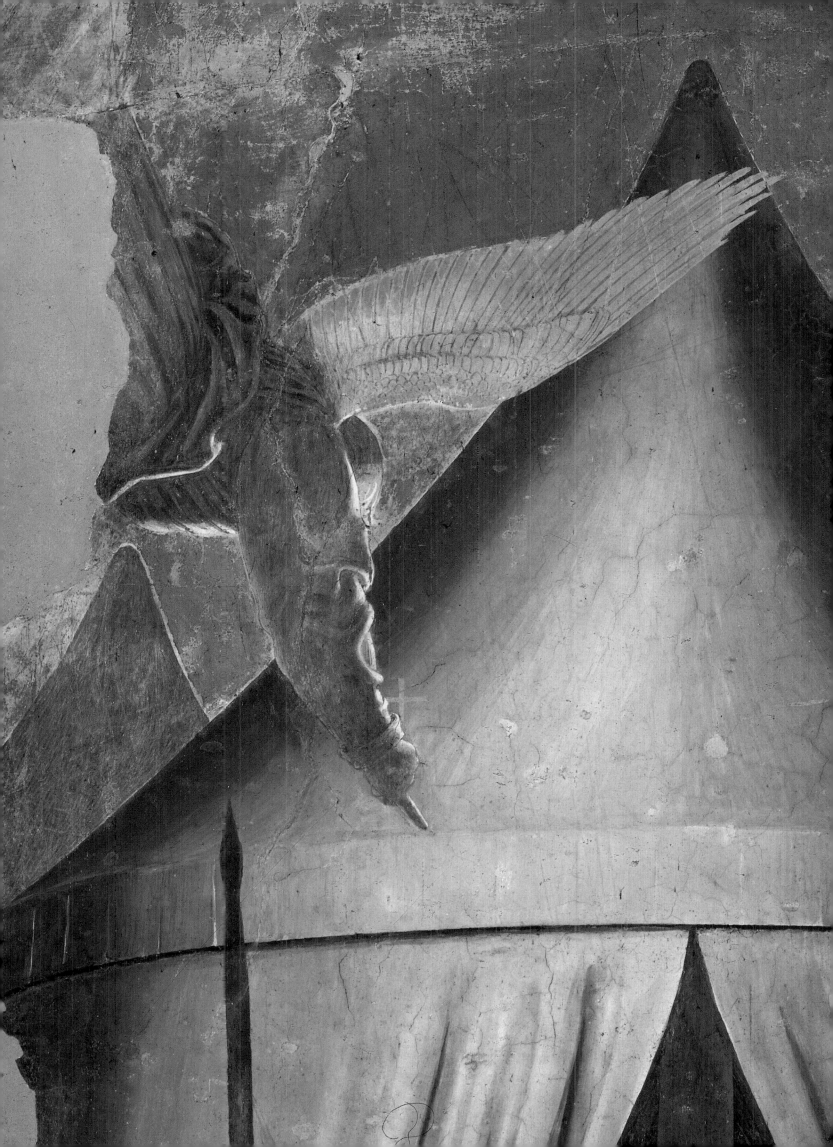

THE LEGEND OF THE TRUE CROSS
The Battle of Constantine

1452–66
fresco, 322 × 764 cm
Arezzo, San Francesco, chancel, right wall, bottom tier

As the plot turns the corner and passes onto the bottom tier of the right wall, the immobility of the *Vision* suddenly erupts into animated movement. Emerging from somewhere behind the standing guard, a portion of horse and rider springs to life. With no arbitrary framing in the corner, an irrational effect of sliced-off forms is created in the point of juncture. This fragmentation and quickening of pace is not unlike pictorial effects often used in painted chivalric cycles, where interpenetrating spaces and rapid change in visual speed are basic parts of the narrative technique. The jousting episodes by Pisanello, discovered in the 1960s in the Ducal Palace at Mantua, are splendid, near-contemporary examples. Piero used this approach, it seems, to ensure the recognition of the similarity of his subject.

This battle starts as a captain on a rearing horse and a bareheaded trumpeter signal the charge. The many lance-points held on high give the impression of more cavaliers than are actually visible. Those we can see mix classical with modern details. As proper for the followers of Constantine, some men wear Roman armor with molded leather cuirasses, skirts, and leg-guards. Others appear in laminated steel, with butterfly knee hinges in the latest Milanese fashion. All the riders use stirrups, a convenience quite incorrect for classical warriors.

The Battle of Constantine fills the tier as one uninter- rupted scene. Moving toward the right, the army becomes calm and the march organized, with no actual fighting taking place. According to all accounts, after his victory was assured, Constantine begged to win without spilling Roman blood, and his wish was granted. At the head of his men, behind his armored companion, with delicacy and care, Constantine holds out a little Cross (again, it has lost its gold paint) as talisman and causes the rival troops to flee. Forgetting the trap they had laid in the river bed, in their fright they are conquered by their own wiles.

Much of the right side of the composition is unreadable. Unhappily, the cycle has been damaged over the centuries by damp and by inept restoration. In spite of a campaign in the 1960s that liberated the surface of over-paint and dirt, the losses were already substantial. Humidity and unstable walls continue to bleach the colors. A watercolor copy made by Johann Antoine Ramboux in the early nineteenth century records the full composition as it was then visible (fig. 47). From the little sketch, for example, we know that Maxentius is the figure on the right bank under the basilisk flag. He wears the same peaked hat as Constantine, although of different colors— green crown with red brim (see next Colorplate). Behind him, one of his cavalrymen still struggles in the water. At his side, a barbarian aide flees naked and bareback on a mangy white horse.

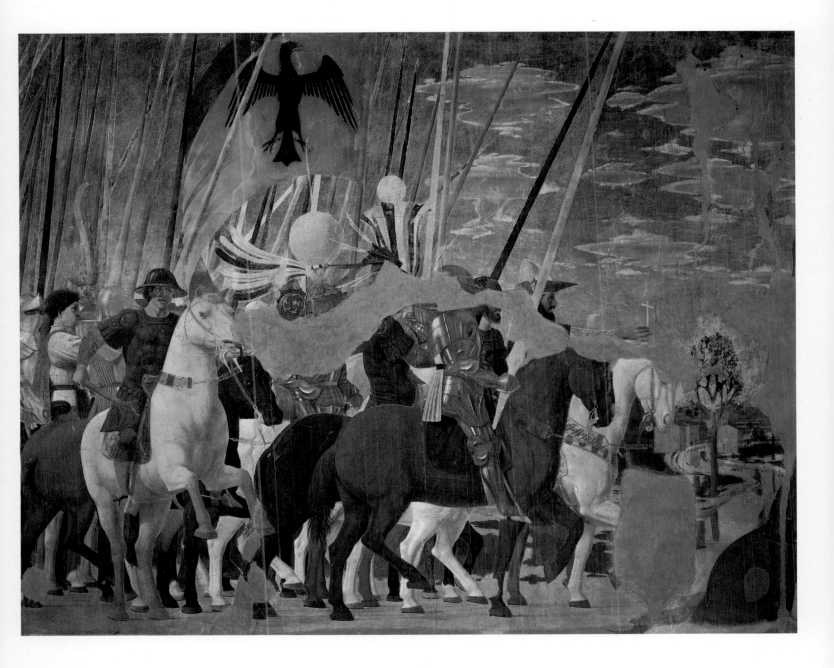

THE LEGEND OF THE TRUE CROSS
The Battle of Constantine (detail, Constantine)

Piero rivets Constantine into place with the great long spear of his companion. Passing across the head at a sharp diagonal, the shaft creates a magnificent tension that focuses on the regal bearing of the monarch. By overlaying the reined-in white steed with a chestnut horse, Piero adds to the sense of pent-up action. Happily, what is best preserved in this composition is Constantine's face with all its stunning colored modeling. The virile black beard that frames the chin is answered by the razor-sharp form of the green visor at the brow. Indicating imminent victory, the pointed pink dome of this hat is already circled by a crown.

For generations, art historians have discussed the striking resemblance of Constantine's profile to that of John VIII Palaeologus, emperor of Byzantium (d. 1448), as portrayed on a medal by Pisanello made in 1439 during the Council of Union held in Florence (fig. 48). At this meeting, beside trying to bring together the Eastern and Western Churches, Palaeologus had sought to garner Western aid in staving off the Mamluk Turks who were menacing his country. In the end, both these efforts were unsuccessful. He failed to gain ratification for the document of union, and after his death Constantinople fell to the Turks (1453). Even so, there is no doubt that with this physiognomic likeness, Piero refers to the papal pressure, current in his day, for a new Crusade against the same enemy. A few years earlier (1451), he had relied on

another portrait by Pisanello, that of Sigismund of Hungary, for the head of a saint of the same name, and he alluded to a historical event. He does the same in this case, again somewhat modifying the headgear; Palaeologus's hat was known to have been snow-white and topped with a huge ruby. Theorists and chroniclers in Piero's day believed that Byzantine potentates still wore the clothes of classical times. Thus, by representing Constantine, in battle with a pagan enemy, with the features of a Christian heir to the Roman Empire, he gave his battle scene historical status. But again, as the fresco of St. Sigismund also shows a universal condition, so this scene, too, has a wider scope than contemporary politics. The very inclusion of the *Battle of Constantine* in a True Cross cycle speaks to the Franciscan locale. In his biography of Constantine, the fourth-century historian Eusebius compares the episode at the Milvian Bridge to the victory of Moses over the Egyptians at the Red Sea. He calls Constantine a "New Moses," who saved his people from the pagan pharaoh and led them to the Promised Land of Christianity. The same epithet was often used for St. Francis, and for similar reasons. The saint was called a "New Moses" by others and himself because through his preaching and his special brand of prayer he led his followers (whom he called the Chosen People) to a new Exodus. The parallel between St. Francis and Constantine would not have been lost on the Aretine congregation in this Franciscan church.

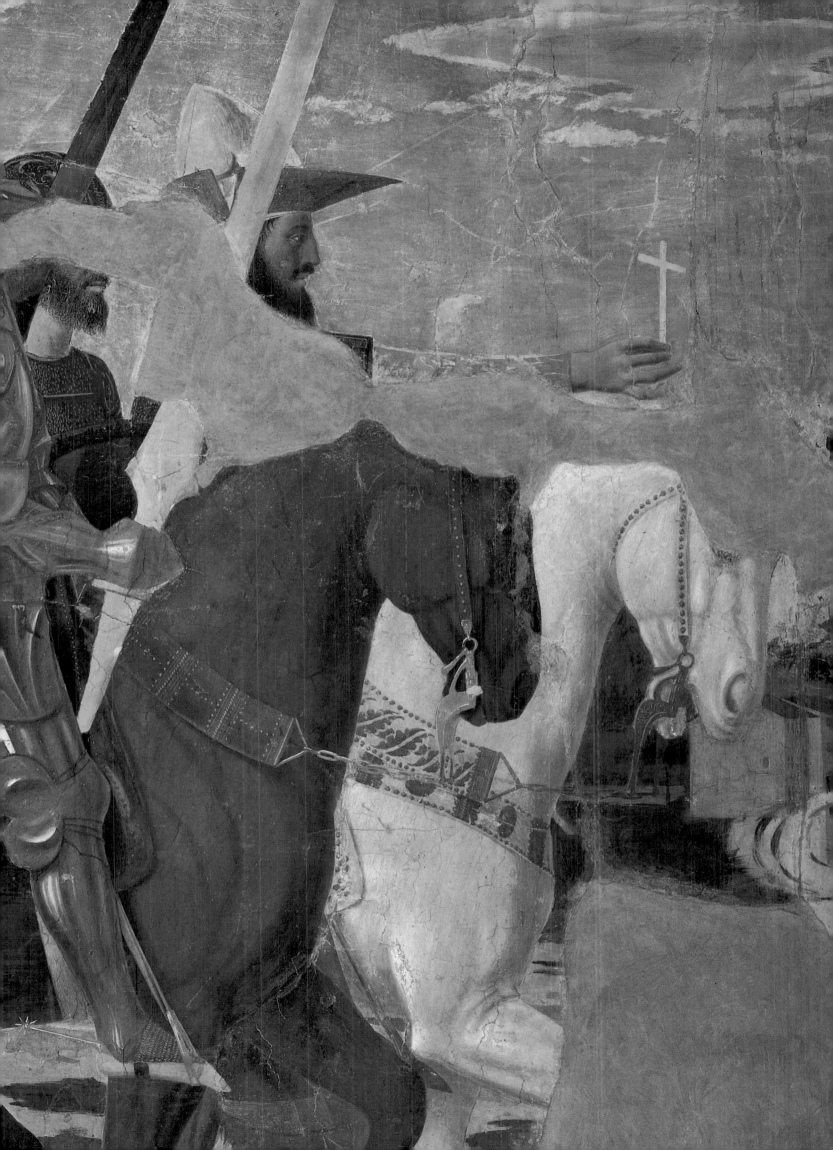

THE LEGEND OF THE TRUE CROSS
The Finding of the Cross

1452–66
fresco, 356 × 373.5 cm
Arezzo, San Francesco, chancel, left wall, second tier left

The events represented on the second tier of the left wall are those commemorated by the liturgical feast of 3 May, known as the Invention of the Holy Cross: St. Helena's finding of the three crosses from Mount Calvary and the distinguishing of Christ's from those of the two thieves. While Piero's composition, combining two episodes, follows quite closely traditional representations found in both liturgical manuscripts and monumental painting, he makes a number of innovations. To the left, the bishop of Jerusalem (area of the head is destroyed) and members of the imperial court, including a fat but elegant dwarf, listen as Judas indicates the location of the crosses. As a figure, the empress is again constructed of ideal parts, the stereometry of her cranium visible beneath her conical crown. The same structure is even more evident in the turbaned head of other nearby figures. A workman half-submerged in the pit he is digging, seen like a Renaissance bust from behind, has discovered a cross and is helped in lifting it. Three other laborers observe the work, one holding the first cross found. The proceedings are carried out with immense dignity, the figures formed into a semicircle around the central workman. The concentration expressed in the heads unifies the members of the group and cuts across the differences in their social status.

The formal arrangement places the newly found cross in the center of the figure group, and juxtaposes it directly with a saddle of hills in the background, above which is pictured the town of Arezzo (fig. 3). In this way, the background and foreground are graphically drawn together, and the efficacy of the holy site in Jerusalem is transferred to the cycle's real locale in Tuscany. This patriotic display has special meaning in the Franciscan context, since one of St. Francis's most famous miracles took place on a visit to Arezzo. Francis was traveling with a priest named Sylvester (named for the saint whom Constantine named pope), whose faith had come into doubt. Just outside the walls of Arezzo, Sylvester had a vision. He saw Francis, as he reports, "with a cross of gold coming from his mouth; the top of (the cross) reached up to heaven and its arms stretched far and wide and seemed to embrace the whole earth." Like Constantine after his vision, this Sylvester now converted, not just to renewed faith, but to the Franciscan order, thereafter becoming one of the most trusted of the friars minor. The miracle had a second episode, and we shall see in a moment its importance for the unusual cityscape as well as for the other episode in the right half of this tier (see next Colorplate).

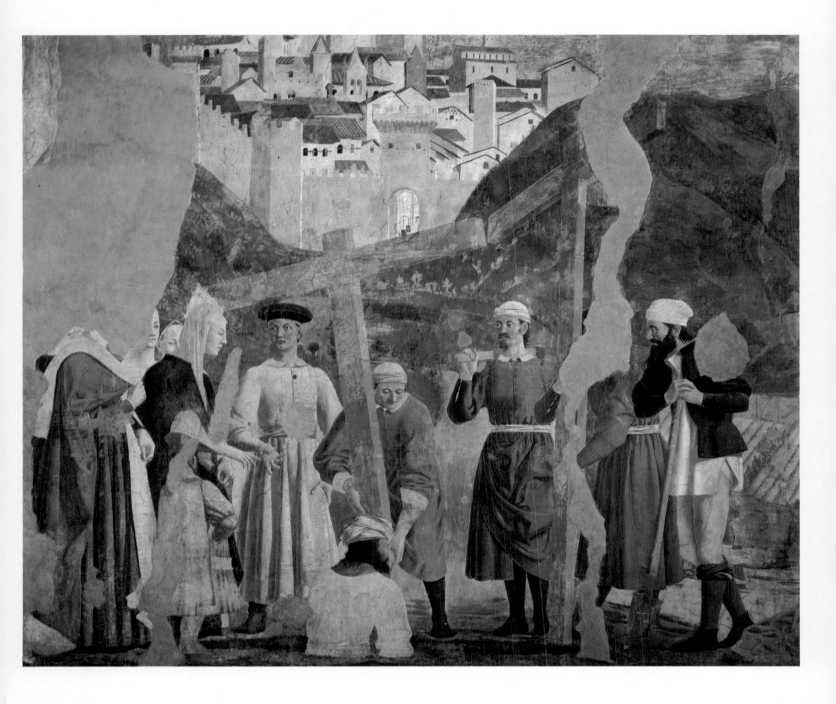

THE LEGEND OF THE TRUE CROSS
The Proving of the Cross

1452–66

fresco, 356 × 373.5 cm

Arezzo, San Francesco, chancel, left wall, second tier right

To prove which cross was "true," Helena had all three placed on the body of a young man whose funeral procession was in progress. At the touch of Christ's Cross, the corpse rose and gave thanks. It is this moment that Piero portrays: the empress and her ladies have fallen to their knees at the sight of the miracle. Again, it is a scene of intense concentration, with all the figures in a circle contemplating the Cross. In spite of the simplicity of the action, a number of literary allusions enrich the image.

In the version of the story in the *Golden Legend,* when the True Cross is revealed, the devil is vanquished and is heard to cry out in a loud voice. In the story of Francis's Arezzo miracle, the city is said to have been for some time racked by internecine warfare, and as Francis and Sylvester approached, they saw demons exulting at this chaos. Following Sylvester's vision, Francis called upon him to go to a gate of the town (the one pictured in the vista), and "in the name of almighty God (to) command the devils in virtue of obedience to go away immediately." Sylvester did his master's bidding, and the devils fled, "screaming and crying out." Again the worshipers in this church would identify the civic cleansing with the retrieval of the Cross (often called the "devil's trap"), which Helena afterwards presented as a gift to the citizens of Jerusalem.

Helena's vanquishing of the devil, moreover, adds another level of meaning to the Annunciation scene, near this one, on the altar wall. St. Ambrose, who in the fourth century was the first to report on Helena's find, wrote that as "... Mary (who trapped the devil with her virginity) was visited to liberate Eve ... Helena was visited that Emperors might be redeemed." Ambrose then quotes Helena: "As the holy one bore the Lord, I shall search for his cross ... she showed God to be seen among men; I shall raise from the ruins the divine standard as a remedy for our sins ..."

The *Golden Legend* goes on to tell that the crosses were found near a temple to Venus erected by the Emperor Hadrian so that the Christians who came to worship Christ would also be venerating Venus. Afterward, the temple was destroyed, and Helena built a new basilica to mark the spot. The urban setting Piero gives the scene makes reference to both the Early Christian past and the Renaissance future. The painted façade behind Helena and her group looks backward to Hadrian's temple, with its classically pedimented superstructure, and forward, with its three-part arched façade with circles and colored marble veneer. The design, in fact, is a premonition of buildings soon to be built for Pope Pius II in his new city center at Pienza. Moreover, the right-hand street view, representing Jerusalem but lined with contemporary Italian palaces, is crowned by a ghostly white dome and lantern, evocative of both ancient Roman hegemony and the future of the Italian Christian state.

But despite the fascinating architecture, it is the human drama that commands our attention. Perhaps the most striking is the reciprocity of physiognomy between Helena and her maidens and the entourage of Sheba across the way. These broad-browed women, gently tilting their perfected heads in a subtle variety of angles, show an identity of physical type that expresses the identity of spirit in those who experience miracles. The looping façade arcades in the backdrop seem to hold their placid ecstasy in place.

Meanwhile the men grouped at the right are onlookers whose notice has been caught unexpectedly. They should be understood as citizens of Jerusalem, all wearing the identifying costumes Piero used for this purpose. Most characteristic are the exotic hats worn over white turbans: the high, flaring stovepipe; the stiff, conical turban with contrasting brow band; and the mushroom-shaped shaggy fur model. As in the *Baptism* and the *Flagellation,* they are culled from the repertory of contemporary Byzantium, seen by Piero in the 1430s and used here to verify the scene's Near Eastern locale.

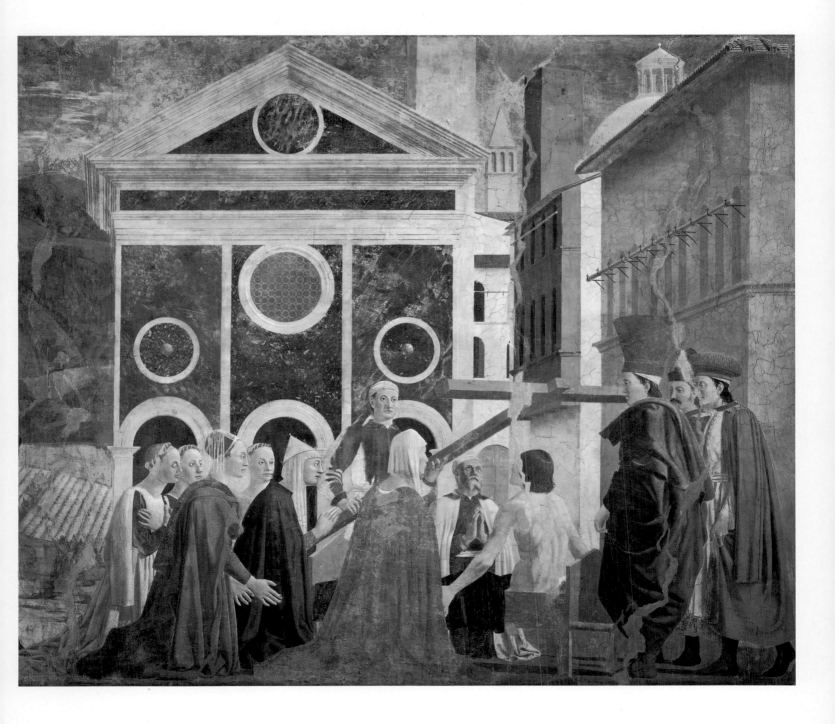

THE LEGEND OF THE TRUE CROSS
The Battle of Heraclius (detail, soldiers fighting)

1452–66

fresco

Arezzo, San Francesco, chancel, left wall, bottom tier left

The battle between the Byzantine Emperor Heraclius and Chosroes, king of the Sassanian Persians, took place in the summer of A.D. 628. It is one of the few relatively modern historical events that is fully described in the liturgy of the Western Church. The description is read on the Feast of the Exaltation of the Cross, 14 September, the day on which Heraclius returned a portion of the stolen relic to its place in Jerusalem.

Piero pairs Heraclius's battle on the lowest tier left (fig. 49) with Constantine's on the opposite wall. In order to contrast the two military events, he changed traditional iconography in several ways. Never before was the Battle of Heraclius shown as a mass conflict. Rather than two knights clashing on a bridge (the legend tells of hand-to-hand combat between the leaders' sons), Piero all but fills the long rectangular field with a clangorous melee between cavalry, foot soldiers, officers, mercenaries, slaves—all armed both in classical leather and the laminated trappings of contemporary manufacture. Compressed on the frontal plane, the battleground is a tightly woven fabric of impenetrable masses. Piero here invents a kind of shorthand space in which forms are neither complete nor fully readable. Parts of figures are delineated in fulsome detail, as for example the trumpeter's face: distended cheeks and veined under eyes, gloriously shadowed neck with reflected light modeling the chin. It is impossible, though, to locate the rest of his body. This trumpeter is on the same level as the adjacent horseman, yet there is no room for another horse. There are, moreover, many such disjecta membra: single eyeballs, severed heads, too many legs and arms and horse's hooves, in themselves represented fully rounded, reflecting light, and radiant in splendid garments, but existing only as parts. This abbreviating technique is enhanced by the criss-crossing weapon shafts that fly in the air and lie across the forms, binding them into place. The result is a composition that lends itself magnificently to excerpting. An arbitrarily cut-out group of figures, like our detail, makes a strong impact; it takes power from the sheer physical force and frighteningly anonymous quality of the armored knights. At the same time, the image has the aspect of a modern, finished abstract design.

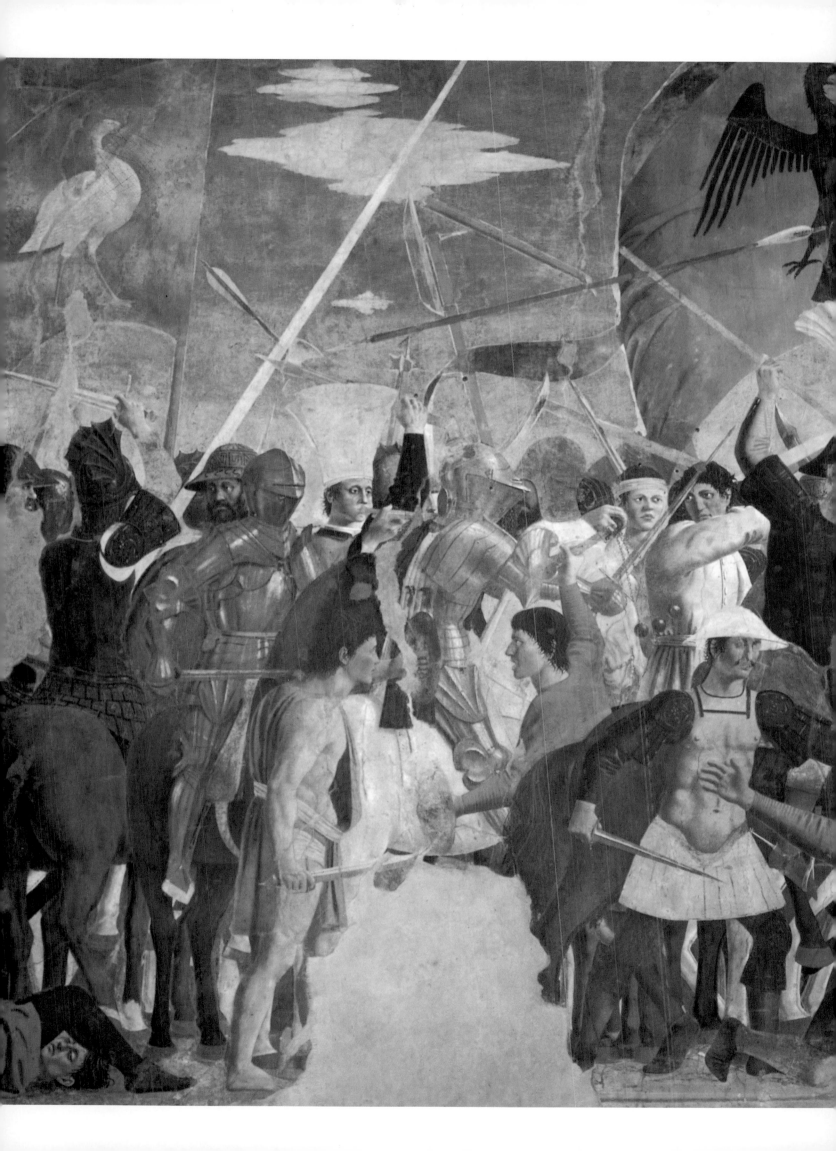

THE LEGEND OF THE TRUE CROSS
The Battle of Heraclius (detail, general and soldiers)

1452–66

fresco

Arezzo, San Francesco, chancel, left wall, bottom tier center

The white-plumed horseman riding a chestnut stallion under the flag of the imperial eagle has the air of a commanding general. In his position at the center of the skirmish and together with a partner on a white horse, he parallels Constantine and his mate on the opposite wall. The two pairs characterize active and passive heroes. Constantine raises the Cross in a static pose and meditative mood. This rider reins in his steed as he prepares to throw his lance. Constantine spilled no Roman blood; Heraclius, who fought not brother Romans but a hated Persian foe, brings his enemies down by the sword.

Yet, despite all the action, the battle is not in motion. Poses are hieratic; figures do not express emotion. Even as they give their battle cries, the men are the same contemplative, vaguely anguished creatures who always populate Piero's world. Their actions allude neither to an orderly chivalric encounter nor to contemporary rough-and-tumble clashes. The famous Battle of Anghiari had taken place in 1440 just outside Piero's native town, and so he probably had first-hand views of soldiers massing.

From his detailed rendering of arms and armor, he clearly knew their construction well. But, in truth, what we are supposed to see is not contemporary warfare. Rather, the reference is to ancient monumental representations of these historical events. The spear-throwing rider with a fallen enemy below the horse's hooves and a foot soldier seen from the back depend specifically on a classical relief (fig. 50) on the triumphal arch erected by Constantine himself (which Piero would have seen when he was in Rome). The pose and costume of the rider, and most particularly his plumed headgear, follow a drawing of an equestrian statue with lance and feathered headpiece that still existed in fifteenth-century Constantinople and may have represented Heraclius himself (fig. 51). The drawing was made by a fellow artist (Ciriacus of Ancona) who traveled to the East and on whose information Piero relied on other occasions. Thus along with citations from contemporary life, these classical quotations give his scene an authenticity that once more places it squarely in the official realm, in the early centuries of Christendom.

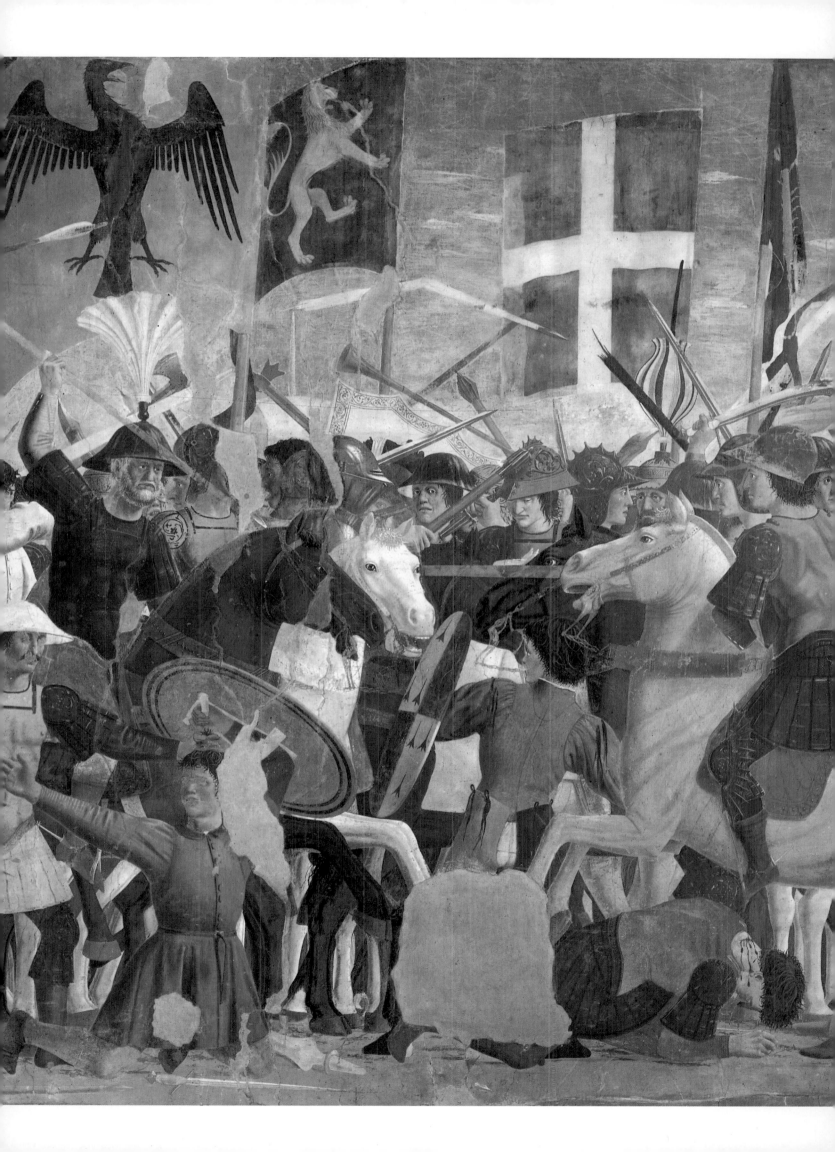

THE LEGEND OF THE TRUE CROSS
The Battle of Heraclius (detail, execution of Chosroes)

1452–66

fresco

Arezzo, San Francesco, chancel, left wall, bottom tier right

The cycle omits some major episodes from the last chapter of the True Cross story. Implied in the *Battle of Heraclius* but not represented is the fact that three centuries after its recovery by St. Helena, the Cross was stolen and had to be retrieved. Although the battle rages on, Piero has combined the crime, the judgment of the perpetrator, and the outcome of his trial into one image. Chosroes (who was something of a necromancer) stole the Cross because of its reported magical properties. He set it up in his silver tower from where he tried to rule the forces of the universe. There he made an unholy trinity, with the Cross representing Christ, a rooster as the Holy Ghost, and himself, indeed, as God Almighty. Piero encapsulates the sequence at the right end of the tier. The star-studded canopy covering the throne alludes to the king's celestial pretensions. Even more penetrating is the visualization of the substance of his blasphemy. Piero makes a physiognomical identification of Chosroes, as he awaits decapitation, with the lofty face of God the Father as he appears in the Annunciation scene just around the corner on the altar wall. The evil king is judged, moreover, not only by his seventh-century captors, but by all the ages to come. Representing witnesses at his execution, three men in fifteenth-century costumes, one with a grizzled head, one in a flaring turban, and one wearing the hat of a burgher, are surely members of the Bacci family, the Aretine patrons of the cycle. As the executioner raises his sword and a horse kicks up its hooves, the Bacci, by their own participation, make a pledge to keep the Infidel at bay.

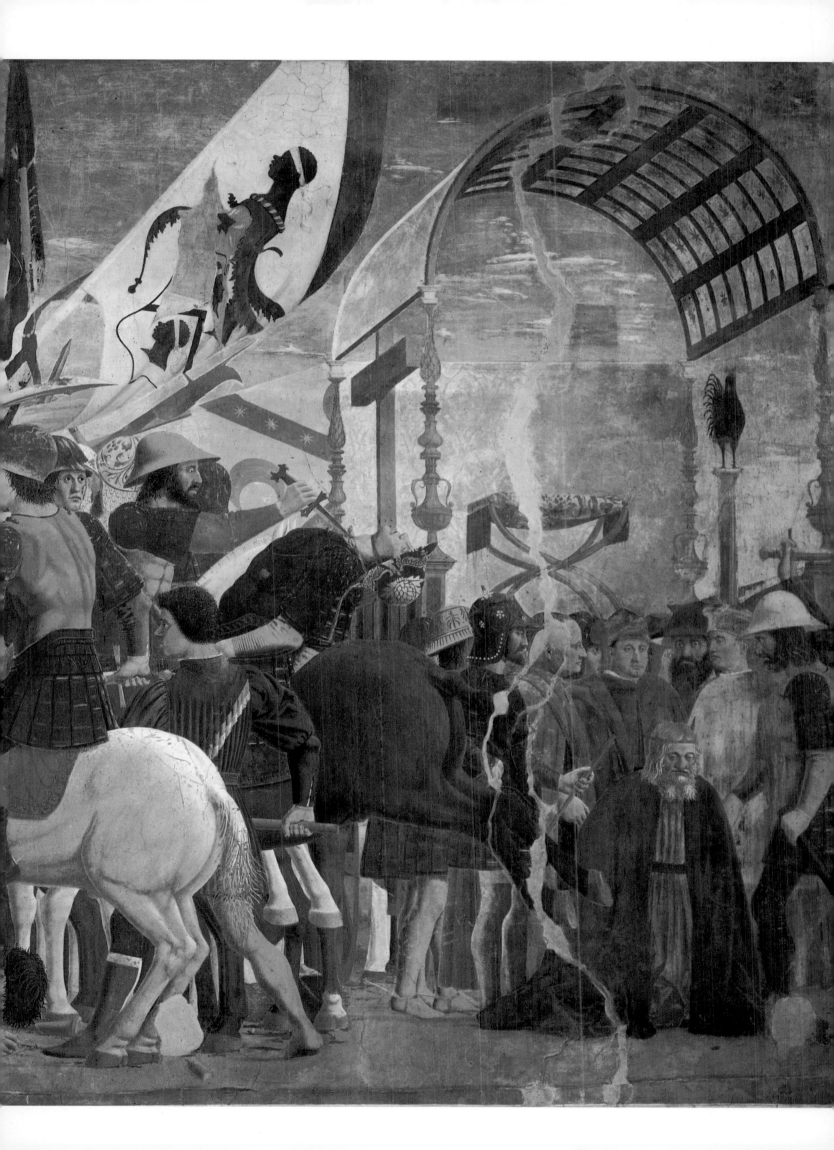

THE LEGEND OF THE TRUE CROSS
The Exaltation of the Cross

1452–66

fresco, 390 × 747 cm

Arezzo, San Francesco, chancel, left wall, lunette

In the final scene of the cycle, high in the left lunette, several events are again telescoped into one composition. The legend describes a proud and haughty Heraclius who tries to bring the relic of the Cross into Jerusalem in a procession with full military regalia. Arriving at the city, however, he finds the gate walled up and closed; an angel seated at its summit tells him that in this condition he may not enter. He is further admonished by Bishop Zacharia for not imitating Christ more closely.

Then Heraclius, taking off his ceremonial robes and his shoes and putting on a poor man's garment, easily went the rest of the way and placed the Cross on the same spot on Calvary from which it had been taken by the Persians. (Lesson VI, in the Breviary, reading for 14 September)

In contrast to the many manuscript illustrations of this passage in which Jerusalem's gate is the major focus, Piero set his scene far outside the town with no gate visible. Heraclius, who is represented only once, is already walking barefoot with the Cross (the upper part of the figure is mostly destroyed), accompanied by the bishop. The action of the scene is his confrontation with a group of kneeling Jerusalemites who, once more dressed in the costumes of Byzantium, concentrate their gaze on the Cross. One member doffs his hat as a sign of respect; another older gentleman still rushes along the road. The distance they have traveled from the city is suggested by the great fortress walls that rise behind them, casting shadows on the ground.

By representing this episode as an isolated scene, Piero achieves several aims. First he refers to the ancient protocol of *adventus,* or the formal ceremony of greeting and recognition to regal visitors, wherein the greater the distance from the city gate the visitor is greeted, the greater respect he is being shown. Here, the recognition is proffered not to the emperor himself but to his burden, the Holy Cross. Moreover, in representing the emperor of holy Rome simply dressed and barefoot, Piero emphasizes his penitential act as a premonition of discalced poverty, chief among the virtues of the Franciscan order. And lastly, by matching the final scene of the cycle with that in the opening lunette, he performs the ultimate exorcism. In the words of the Preface of the Cross:

we should . . . give thanks unto Thee, O holy Lord . . . who didst establish the salvation of mankind on the tree of the Cross; that whence death came, thence also life might arise again, and that he, who overcame by the tree also might be overcome.

By simplifying the episode and placing the scene of the Exaltation high in the lunette, Piero placed the offering made in the Adoration of the Cross in the privileged position, closest to heaven.

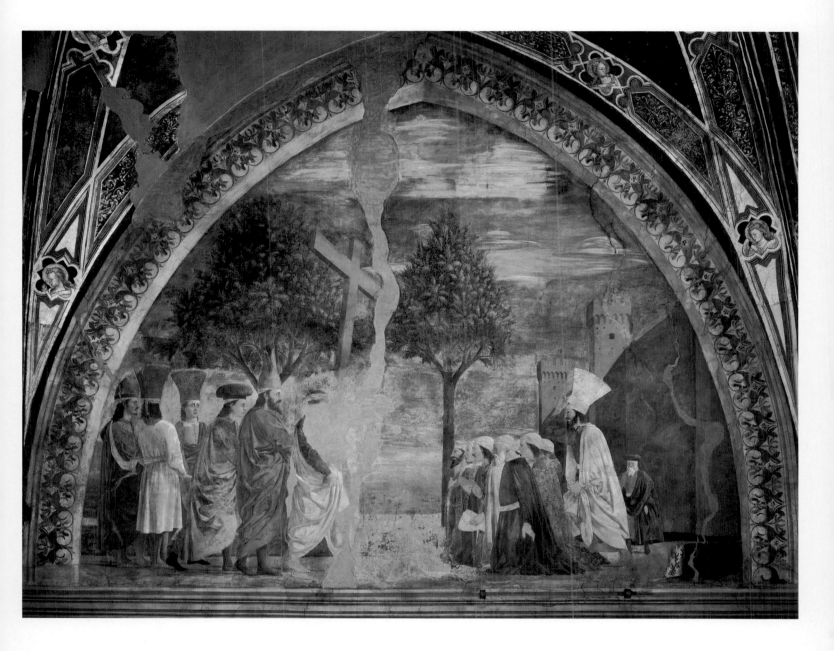

THE MADONNA DEL PARTO

1460–65
fresco, 260 × 203 cm
Monterchi, cemetery chapel

Soon after the fresco called *The Madonna del Parto* was discovered by a journalist walking in the countryside in 1889, it was detached from the wall and taken to Florence. Along with losses in surface quality resulting from this transportation, the original rounded shape of the sheltering pavilion was disfigured. But even before these reworkings, the fresco's physical locale had been drastically transformed. Documents discovered in 1977 show that the painting had once been housed in the altar niche of a small church called Santa Maria a Momentana (or Santa Maria della Selva) built in the thirteenth century some distance outside Monterchi, a provincial town about equidistant from Città di Castello and Sansepolcro. In the nineteenth century the ruined nave of the church was demolished and the apse was made into the little chapel surrounded by the cemetery we see today. Stories of connections between the painting's subject and the burial place of Piero's mother, after whom he was supposedly named, are thus pure fabrication. His mother was called not Francesca but Romana di Perino, and although born in Monterchi, she probably was buried in Sansepolcro with the rest of Piero's family.

In spite of these vicissitudes, the fresco retains its power: the figure of the pregnant Virgin, alluding to her own fecundity by touching her womb, is a deeply moving image. The gesture itself is centuries old, as seen, for example, in the crypt of Santa Prassede in Rome in a ninth-century fresco (fig. 57). The difference is that Piero has unlaced the prenatal gown and made a long opening down the front of Mary's body. While her supreme femininity is emphasized in the vaginal shape of the opening, more telling is the reference to another configuration. Because of her willingness to share Christ's fate in the Passion, Mary became known not only as the coredemptress but also as cosacrificant. Thus, the opening that stabs the front of her body also alludes to Christ's side wound, often represented as an isolated entity worthy of devotion

in contemporary manuscript illuminations (fig. 56).

Standing in the center of a damask-covered tent, Mary once again is given massive stature. The configuration of two angels opening the drapes from inside the tent also has a long history in the visual arts. For centuries it was used in both painting and sculpture to signify revelation. The angels in identical poses, one arm raised and one crossing the body, are again paradigmatic twins from the same cartoon. They vary only subtly in skin tone and expression. Their abstract color schemes alternate draperies of green and red with red and green, showing they are truly part of the ritual they perform. In the Litany of the Blessed Virgin Mary, she is called the "Queen of Angels" and the "Queen of Heaven." The angels here make up her court, and although she wears no crown but only a simple head veil, the velvet with which the tent is covered is a cloth of royalty. The inside of the tent, by contrast, is a quasigeometric construction of dull brown rectangles. The visible seams between the rectangles are magnified where the figures' halos of transparent gold cross over. They appear slightly tilted in the angels' halos, and diagonal in Mary's, as a result of her rotation. The two materials of the tent carry meaning. When God commanded Moses to make his tabernacle, he designated "fine twined linen, blue and purple and scarlet, with eleven curtains of goats' hair for a tent." To emulate this tabernacle, Piero indicated contrasting stuff, with the dull brown goatskin pelts arranged in precisely eleven tiers. The figure of Mary within the tent thus fulfills another Marian epithet: the Foederis Arca, that is, Mary as the Arc, guarded by cherubim, bearing the precious treasure of Christ, representative of the New Covenant.

The allusion to Mary as the covering for Christ, herself covered by heavenly protection, is an ancient conceit, visual as well as verbal. But again, while accepting the tradition, Piero carries it to a new realm, both more specific and more ideal.

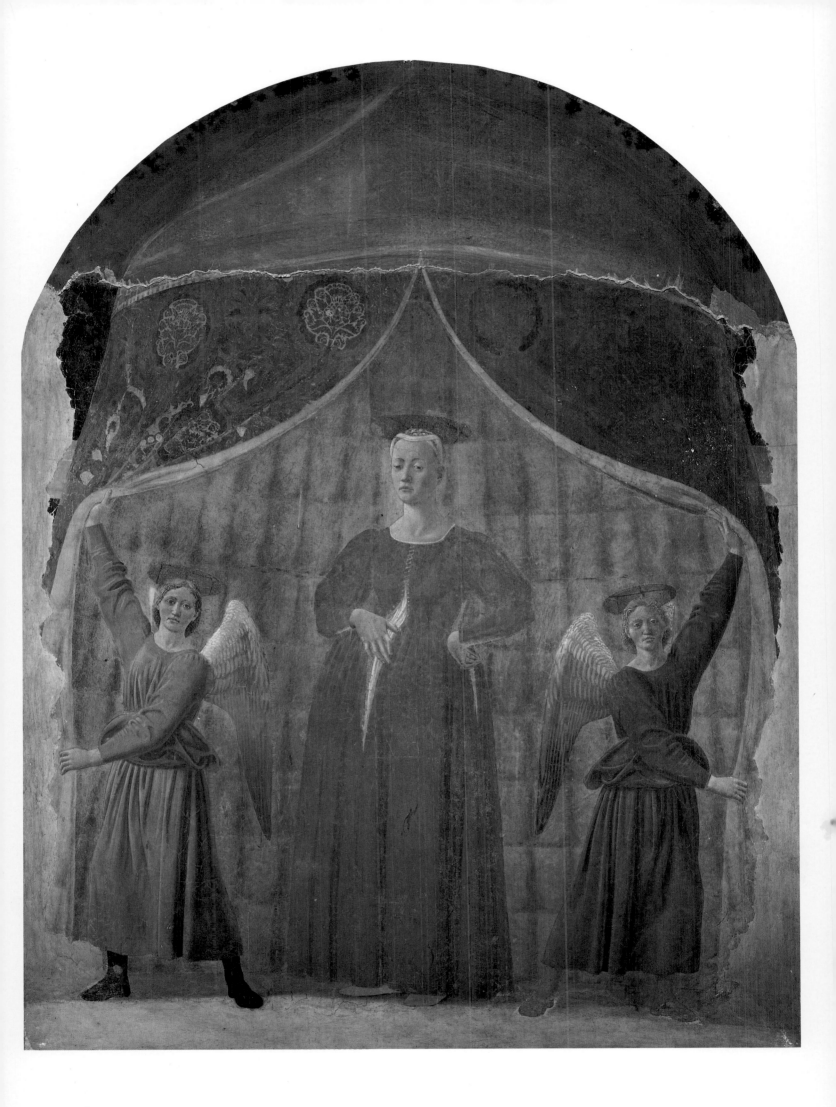

THE ST. ANTHONY ALTARPIECE

1460–70

tempera, 312 × 194 cm

Perugia, Galleria Nazionale dell' Umbria

None of Piero's works shows his method of turning rather standard assignments into new, experimental ventures more than does the *St. Anthony Altarpiece.* Vasari described this painting while it was still in the Franciscan nunnery of St. Anthony in Perugia, mentioning the beauty of the *Annunciation* but saying not a word about its peculiar shape. It is much taller and thinner than most polyptychs and has a superstructure like no other in the history of art. The main section starts off looking quite traditional, with the *Madonna and Child Enthroned* flanked by pairs of saints: St. Anthony of Padua and St. John the Baptist on our left, and St. Francis and St. Elizabeth of Hungary on the right. By eliminating the colonnettes between the paired saints, however, Piero unifies the space. Traditional gold is employed for the background, but it is applied in a novel way. Rather than leaving the backdrop flat and unworked, he tools the surface to imitate the damask pineapple pattern. The extreme richness of the heavenly ambient makes an ironic contrast with the simplicity and poverty of the discalced saints. Only the Madonna is equal to the regal setting in her matching, gold-shot crimson dress. She is enthroned on a weighty structure surmounted by a coffered semidome, decorated with rosettes and guilloche patterns. The perspective of the platform beneath her feet spreads out into the space of the flanking saints, giving some notion of how the lost centerpiece of the *Augustinian Altarpiece* (Colorplate 13) might have looked. Before this decorative background, all the figures stand out in ponderous physicality, proportioned with bulk and solidity. The Infant Christ is particularly muscular; his heavy nudity leaves no question of the human form that God has taken. As he raises his hand in blessing, he holds a bunch of cherries over Mary's womb to signal her fecundity. The sense of real presence in the gathering is epitomized in the halos, treated here as polished disks of gold on which are reflected the top of each figure's head.

Separated from the main tier by an extra friezelike podium, the predella is made up of three narrative scenes that match the three-part division above. In a stripped-down style, the scenes represent miracles of the modern saints: *St. Anthony Resurrects a Child,* the *Stigmatization of St. Francis,* and *St. Elizabeth Saves a Child from a Well.* The three compositions work together—rhymed motifs of architecture and figural poses repeated and mirrored—to focus on the central scene, an astonishing nocturnal vision of immense power in spite of its diminutive size. Embedded in a matrix of neutral tones, the apparition of the seraph burns with an iridescent blood-red color, emitting enough light to illuminate the night.

The most astonishing part of the ensemble is the strange shape of its superstructure, at first glance ill fitting with the rest. Gothic foliate arches and twisted colonnettes are replaced by a pinnacle of right-angle steps, in which Mary and the angel Gabriel face each other in a scene of the *Annunciation.* Traditionally, these two figures often interact across an empty space between parts of altarpieces, such as the tops of wings or separate rondels set within the frame. The spatial lapsus in such cases represents the domain of the Holy Spirit. Piero draws on this tradition, placing Mary and the angel on either side of an empty space; but he expands the conceit by creating the space himself with his own mathematically guided style. The figures flank a deep and perspectivized colonnaded corridor that ends at a panel of variegated marble. His innovation continues as the dove of the Holy Spirit descends across its entrance and a cluster of golden rays transforms the color of the architecture: where the rays touch the spandrels, the stone turns from black to red, the color of Charity. The red of this magical transformation is then repeated not only in the color of Mary's dress but also in the wings of the seraph appearing to St. Francis in the predella below. Mary's charity in taking the Lord into her body is thereby equated with St. Francis's sharing the pain of Christ's Passion. Thus, in spite of the unorthodox forms he introduces, Piero weaves a fine unity between the parts of the altarpiece.

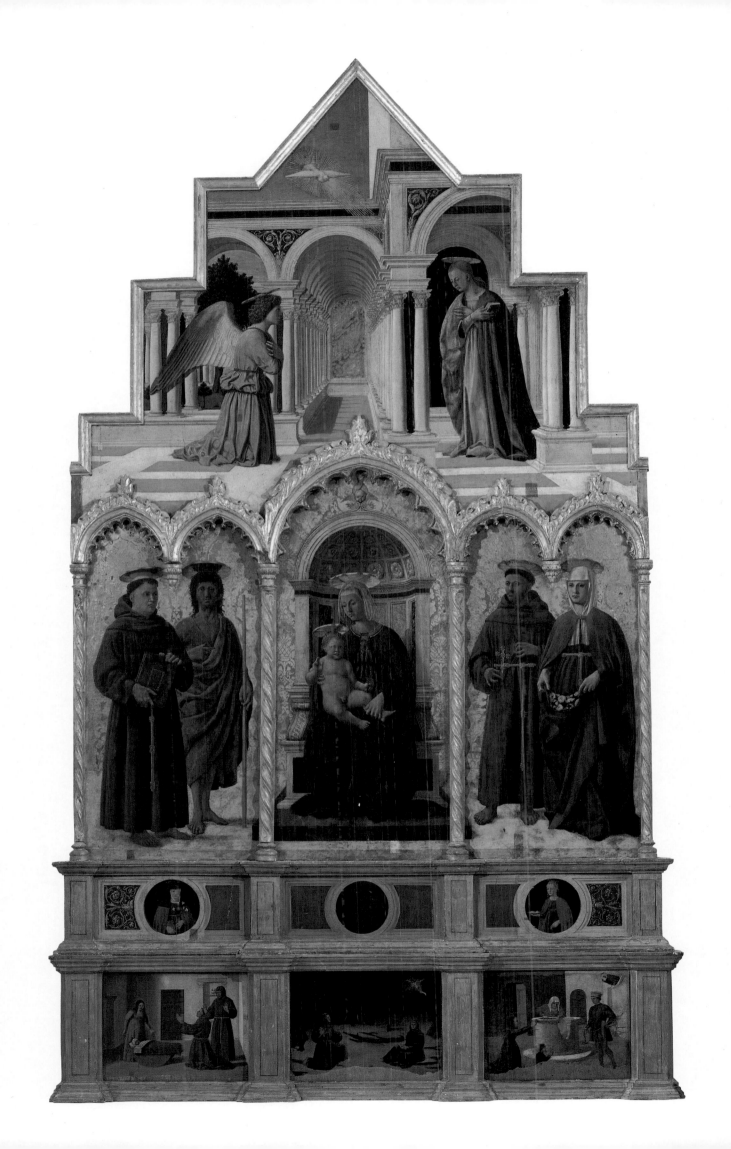

THE RESURRECTION OF CHRIST

1463–65
fresco, 225 × 200 cm
Sansepolcro, Pinacoteca, Palazzo dei Priori

Although parts of the painted architectural framework around the *Resurrection* are destroyed, enough remains to show that we are looking up at the underside of the lintel. The perspective construction, therefore, places the vanishing point quite low, below the painted plinth that held an inscription (now destroyed). This viewing station has the effect of making the immobilized soldiers seem to loom above us. With the figure of Christ, however, the point of view changes. Although he is high above us, he is seen straight on in emphatic confrontation. This shift of viewpoint does not come easily. To take this pose, Christ, in actual fact, would have to be standing on an imaginary step up above the bottom of the sarcophagus. His overwhelming quality is only one of the effects of the shift of viewpoint.

What is perhaps even more important is the resolution it brings to a theological problem implicit in this subject. In spite of the biblical description as rock cut, more often than not in visual art, Christ's tomb takes the form of a Roman sarcophagus. In almost all cases, it is shown with the lid blown off, tipped away, or lying to one side in oblique perspective (fig. 55). The main issue of the miracle, namely Christ's bodily passage through the sealed tomb, therefore, is generally not alluded to. In Piero's composition no such lid appears. Moreover, having

lowered the perspective of the sarcophagus to the point where we are looking up at the rim, Piero eliminates a view of the upper surface of the tomb. We literally cannot see the area of the lid, which, while not represented, is still implied. In this way, he suggests that the massive, palpable figure of Christ steps forth miraculously from a sarcophagus that remains hermetically sealed.

In representing four soldiers, Piero was following tradition. Many Late Gothic sculptured altarpieces show just this number, and many show them tumbling in agitated fear. Piero adds to this pattern a fanlike arrangement, reinforcing Christ's appearance of rising from a V-shaped vortex beneath his foot. The arms of the V then continue up and out along the placement of the trees. The colors of the uniforms again revolve in a paradigmatic exchange, this time of autumnal hues, while the composition employs the spatial shorthand seen before in the *Battle of Heraclius* (Colorplates 26–28). One is hard put, for example, to find the body of the guard who leans against his spear. The audacious pose of the boy falling on the relic—his strongly tilted head covered with a scrollwork helmet—seems to mirror the pose of the soldier with a dagger at his throat in the battle scene. It is often said that the features of the bare-headed soldier, who faces forward with his eyes closed, are those of Piero himself.

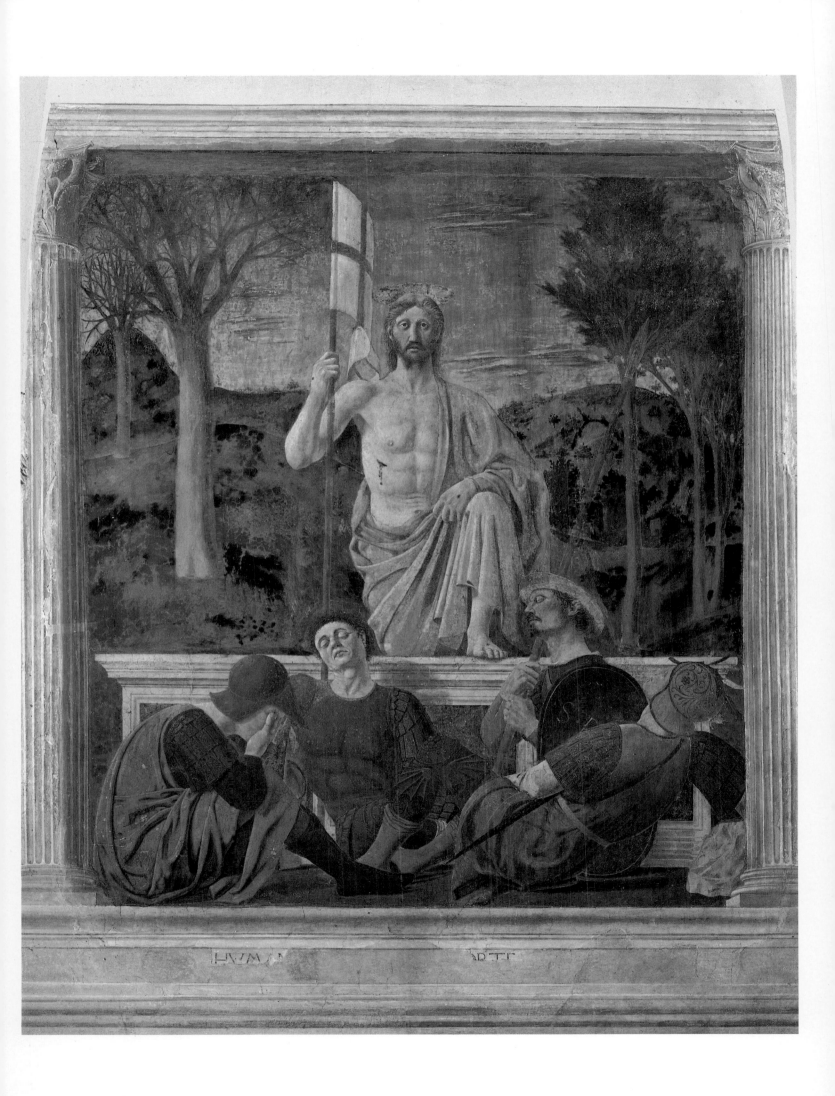

THE RESURRECTION OF CHRIST
(detail, head of Christ)

The face of Christ is awe inspiring, what the Italians call *brutto-bello,* a superb visualization of "beautiful ugliness." The visage has the abstract strength of its stereometric construction, the roughness of a peasant, the power of a herculean athlete, and the mystery of the eternal. Piero has created this effect by various means: he flattened the long nose with a shadow and bent it with an irregular highlight. He drew the thick lips asymmetrically and curved them almost into a sneer. He pointed the coarse beard downward to the sturdy juncture of the clavicle, stretching the neck into an immobile tower. He drew the eyebrows in outline and then displaced their coloring, effecting a shadowy form that moves but has no motion. He made the eye sockets deep and darkened, thus bespeaking sleeplessness and torment. He lifted the pupils and lowered the heavy lids to match wakefulness with unbending concentration. It is to this devouring and absorbing gaze that we respond. Piero made, in fact, a modern Pantocrator, the man-god who died to save man's soul and lived to tell man how to live his days.

Following the Battle of Anghiari in 1440, Sansepolcro was sold by Pope Eugenius IV to Florence, which held it as a fief for more than a decade. On 1 February 1459, the Palazzo dei Priori was officially returned to the citizens of Sansepolcro as a sign of their renewed civic autonomy. It is probable that the restoration of the building was begun soon afterward. Piero's commission was surely occasioned by these events, with the designated subject matter motivated by the town's foundation myth. On this simplest level, *The Resurrection* was an allegory for the divine source of the political governance.

But Piero's image is no simple Easter morning scene. Never before had the Risen Christ been given such a judgmental role. Normally in Resurrection scenes, he appears as the fulfillment of prophetic statements, as the bringer of new life, as the promise of life eternal in both the personal and in the cosmic sense. He had never before been shown proleptically, as the judge at the end of time. This new level of meaning, I suggest, was Piero's contribution to the prominent placement of the fresco. In an ecclesiastical setting, the allusion might not have been surprising. In fact, half a century later in this room, an altar was installed. But in a purely civic ambient the content had another tone. Piero took literally the medieval proposition that organized society, that is, the consciously planned city-state, was the institutional remedy for Original Sin. Man's civic crimes are but reflections, so many city statutes read, of that sin. Man's ability to judge and punish is likewise a gift reflecting God's own judgment in the heavenly sphere. The state is, therefore, not a secular entity, but an extension of the domain of heaven. Piero's "Christ in the council hall" is Christ the judge, who, in his own resurgence, protects the judge and purifies the judged. High on the wall of the entrance chamber, this image reminded both the judge and the advocate, the guilty and the innocent, of eternal responsibilities as they entered the courtroom and took up their duties.

A note on the fresco's condition: Whitewashing in the eighteenth century had a devastating effect on the surface of the *Resurrection*. As always, removal of the lime-based covering also removed surface refinements. Besides this direct assault, the greens of the landscape have oxidized and turned an almost uniform brown. Miraculously, the great psychological power of the image remains undiminished.

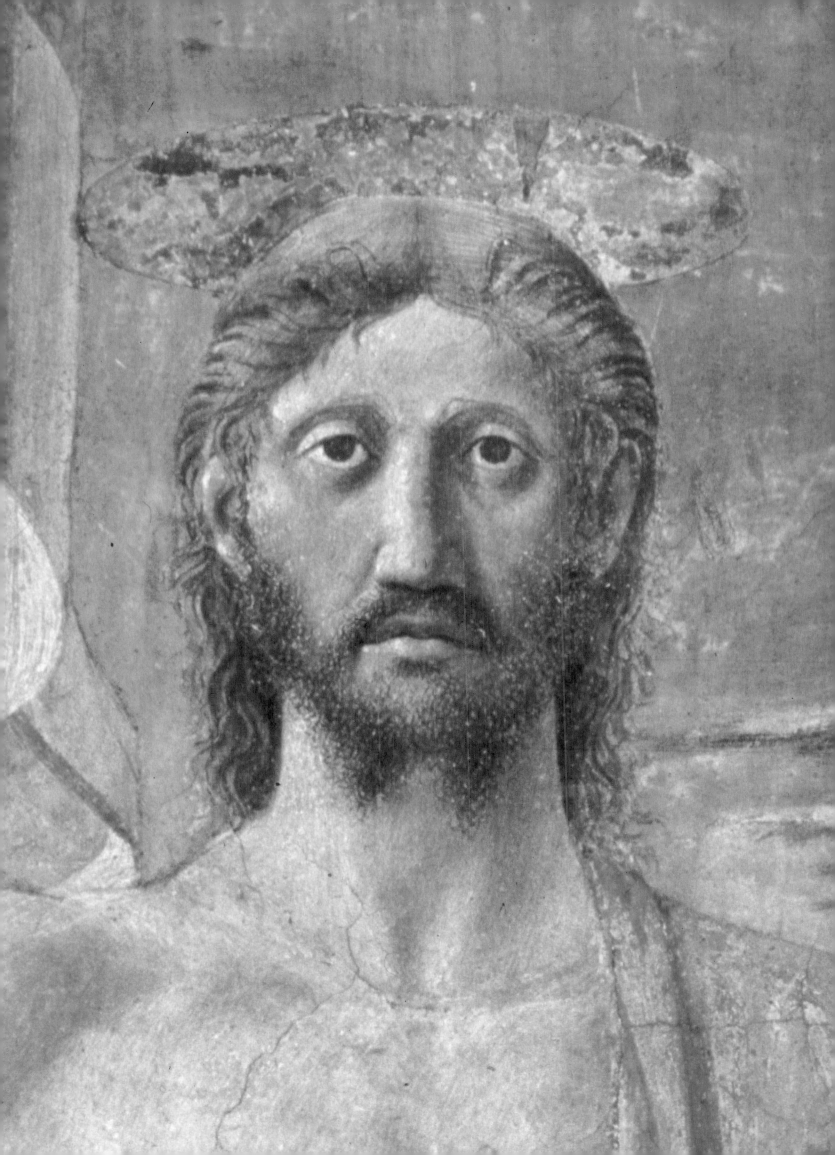

BATTISTA SFORZA and FEDERICO DA MONTEFELTRO

c. 1472–74
tempera, 47 × 33 cm each
Florence, Uffizi

Following the murder of his younger half-brother in 1444, Federico da Montefeltro was declared count of Urbino. Although there is suspicion that Federico had a hand in the murder, under his brilliant leadership over the next thirty years Urbino became one of the most powerful and cultured states in Italy.

As a professional soldier (*condottiere*) who fought for several popes, as well as for the rulers of Naples and Milan, Federico was enormously effective. In establishing the bloodline for his own family, however, he was less successful. His first wife was barren and died early. His cherished natural son, Buonasone, died of the plague in 1458. Hoping for better fortune, in 1460 he carefully selected a second wife. She was Battista Sforza, a princess from Milan, who was rich, well educated, healthy, and fourteen years of age. After the first eleven years of their marriage produced eight daughters, Battista secluded herself in the provincial palace at Gubbio and prayed for a son. In a vow to St. Guidobaldo, she offered her life in return for divine assistance, and on 24 January 1472, a prince was born and named Guidobaldo after the helpful saint. The entire province rejoiced with the couple. But Battista soon was called to fulfill her vow: six months later, on 6 July, she died of pneumonia while her husband was away at battle. Federico was devastated by her death and almost immediately went into retirement. For the next two years, he stayed in Urbino, expanding his already famous library, attending to his palace—then in construction— and commissioning visible records of his son's auspicious birth, the death of his beloved wife, and his own devoted mourning. The astonishing paired, double-sided portraits of Federico and Battista are among these works.

Piero's portraits of Federico and Battista have always been framed together, and their landscapes, the first such background in Italian portraiture, continue from one panel to the other. Both sitters are shown in absolute profile: without the slightest hint of rotation, their bodies are cut by the frame at mid-chest. In this format, they are identical to the newly invented three-dimensional sculptured bust portrait, cut off between the shoulder and the elbow and modeled fully in the round. The difference is obviously that the painted version isolates the profile in the manner of a medal or a plaque in low relief. Thus clinging to the picture plane, the undulating surfaces are silhouetted against the open sky, suspended high above the distant landscape. The countryside is more placid and earthy than the stony territory around Urbino, and it looks as if it had been tamed by the benevolent rulers who float above it. Recently cleaned, these panels glow with an atmospheric magic that picks out the highlights on every detail and takes the eye to the furthest reaches of the mist-covered hills.

The pair is clothed in court dress: Montefeltro in a red surcoat and hat of state, Battista in a damask-sleeved gown bedecked with enamels and pearls. Her hair is dressed with ribbons and a veil, topped with a band that holds a golden brooch in place, all secured with a tie around her neck. But in spite of such exquisite touches of reality, the forms are perfected and ideal. Changes that Piero made in outlines, now visible under the final application of paint, show how carefully he controlled the shapes. No curve, no tone, no wisp of hair could change without upsetting the balance he achieved. Yet, for all this elegance, there is an air of sadness. No sparkle of life lights the eyes. Battista stares straight before her; Federico's eye is half covered by one heavy lid. Piero had the warrior's real face before him: the determined thin-lipped mouth and wen-flecked cheek, the owlish eye, the huge nose earlier notched by a jousting lance that also destroyed his other eye. As for the countess, there was only the death mask (fig. 60), slack-jawed, lifeless, and heartbreakingly young. Yet both faces have the same eternal air. We will not soon forget them. The images Piero has constructed do not reflect how the couple was, but how they will be, together, for eternity.

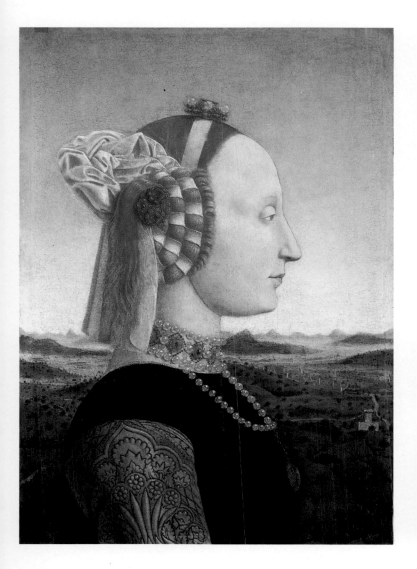
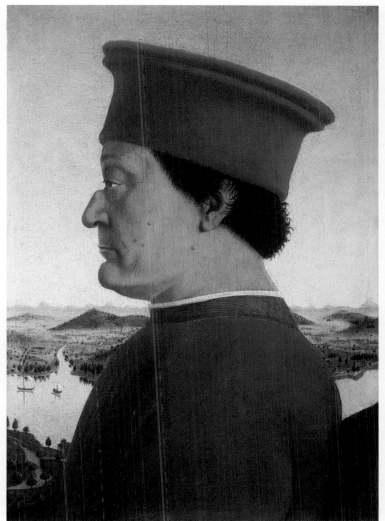

BATTISTA SFORZA and FEDERICO DA MONTEFELTRO
(panel backs)

Following once more the conventions of Renaissance medals, the reverse of each panel is adorned with an emblematic image. The sitters reappear now as full-length figures, each enthroned on a wheeled platform accompanied by several allegorical figures. The carts are driven by winged cupids and drawn by splendid steeds—white horses for Federico and unicorns, symbols of chastity, for Battista. They are stationed on a flat ledge of rock, high above the surface of the earth, appearing before another contiguous vista of idealized Marchegiana countryside. The view looks out over fields and dwellings, winding roads, a lake with sailboats floating on the glassy surface. The front face of the ledge is cut by jagged folds of stone that join but do not touch a marble parapet, which is carved with classical moldings and handsomely inscribed with Latin verses. Federico's inscription speaks of his fame as a military ruler, equal to the greatest men in ancient Rome. Indeed, he is shown on his cart in full armor, wielding a scepter and crowned by a winged figure of Fame. The four women seated on his cart are allegories of the cardinal virtues: Justice with a scale, Prudence with a mirror, Fortitude with a broken column, and Temperance, whose back is turned. Battista's verse says she is admired for her modesty in accepting praise for her husband's deeds. She is reading what is probably a prayer book. Her companions are the theological virtues: Faith with a chalice and Cross, Charity with a pelican that feeds her young, and Hope with a band around her head. The woman dressed in gray is probably a Clarissan nun, Battista's spiritual companion. The young countess, in fact, was a member of the Third Order of Franciscans and was buried in the simple garment of the confraternity.

Because Piero has presented these images with such logic, we do not immediately realize that three separate realms have been defined. The landscape is shown at a great distance and from above. The marble parapet, which carries in its very form sepulchral and memorial allusions, by comparison with the forms above, seems abnormally large. And the mountaintop plateau, where the procession takes place, is isolated from the spaces both before and aft. There the carts confront each another in a way that makes it impossible for either one to move. The meeting is thus defined as taking place in a realm beyond reality. We now may recognize the images as symbolic: they represent the spiritual and moral achievements of two human beings who have entered an ideal state. Remembered not for who they were but for what they were, Federico and Battista are shown triumphant, in static procession in the rarefied atmosphere of virtue consciously pursued and finally achieved. Seen from empyrean heights, the vista is not of what they leave behind but of what made their achievement possible.

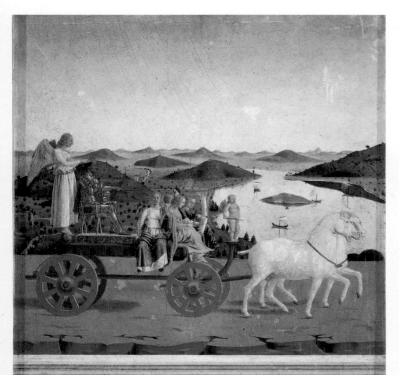

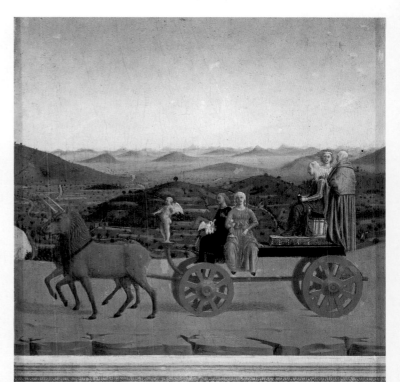

CLARVS INSIGNI VEHITVR TRIVMPHO ·
QVEM PAREM SVMMIS DVCIBVS PERHENNIS ·
FAMA VIRTVTVM CELEBRAT DECENTER ·
SCEPTRA TENENTEM ·

QVE MODVM REBVS TENVIT SECVNDIS ·
CONIVGIS MAGNI DECORATA RERVM ·
LAVDE GESTARVM VOLITAT PER ORA ·
CVNCTA VIRORVM ·

THE MONTEFELTRO ALTARPIECE

1472–74
tempera, 248 × 170 cm
Milan, Pinacoteca di Brera

The impression of an auspicious relationship between figures and setting in this painting is very strong. A tension results from the fact that a monumental edifice seems mysteriously dominated by figures. Spreading across the width of the picture plane, the figures make it difficult to read the building's structure. Yet, in the end, there are enough clues to follow the rationale for the apparently irrational leap of scale. Today the task is perhaps a bit more difficult than it should be. The panel has been slightly shaved on the right side. The disfigurement cuts off details that completed the symmetry and would have made the reconstruction somewhat easier.

The first thing to observe is that there are surprisingly few orthogonals (lines that project into the depth of the space, perpendicular to the picture plane). Those that occur are either broken, as with the arches of the transept, or partially masked, as at the right side of the Virgin's dais (fig. 58). Horizontally, except for the floor, no part of the architecture reaches the picture surface. At a considerable distance behind the figures, up a step and at about the level of St. John the Baptist's hip, the base of a crossing pier is visible. Running the eye up from there, one encounters the corner of the nave architrave, visible as a fragment toward the top of the vertical edge. These elements would have been matched on the right side. Astonishingly, it is from these meager details that we get our bearings: We are standing toward the front of a longitudinal nave; the Madonna and her entourage are well forward in the nave, in front of the space of the crossing of the transept, behind which the forechoir and apse area begins.

We can reconstruct the space mathematically only at this point. The forechoir, paneled with many colored marbles, has unbroken orthogonals that locate the vanishing point at just about the level of Mary's eyes. By taking the finite measurements of the full-face coffers in the transept, we can calculate the length of the gold-flecked coffers in the vault and thereby estimate the distance to the apse: it is approximately 45 feet, or 15 meters. The impression of recession in this area is intensified by the design of the architecture, with the side panels of colored marble in steep perspective and the swiftly moving horizontal frieze emphasized by its deep porphyry red. The effect of the perspective diminution is redoubled, moreover, by the abnormally large and heavy proportions of the coffers, which make the wall pilasters seem even slimmer and more delicate than they are. Thus, although Piero encourages the eye to associate the figures directly with the setting, he has removed the apse to a great distance and used devices of design to make it appear to be too small. The result is that the apse seems to frame the Madonna as a backdrop, on a scale hardly bigger than the tabernacle of the traditional Maria Ecclesia theme.

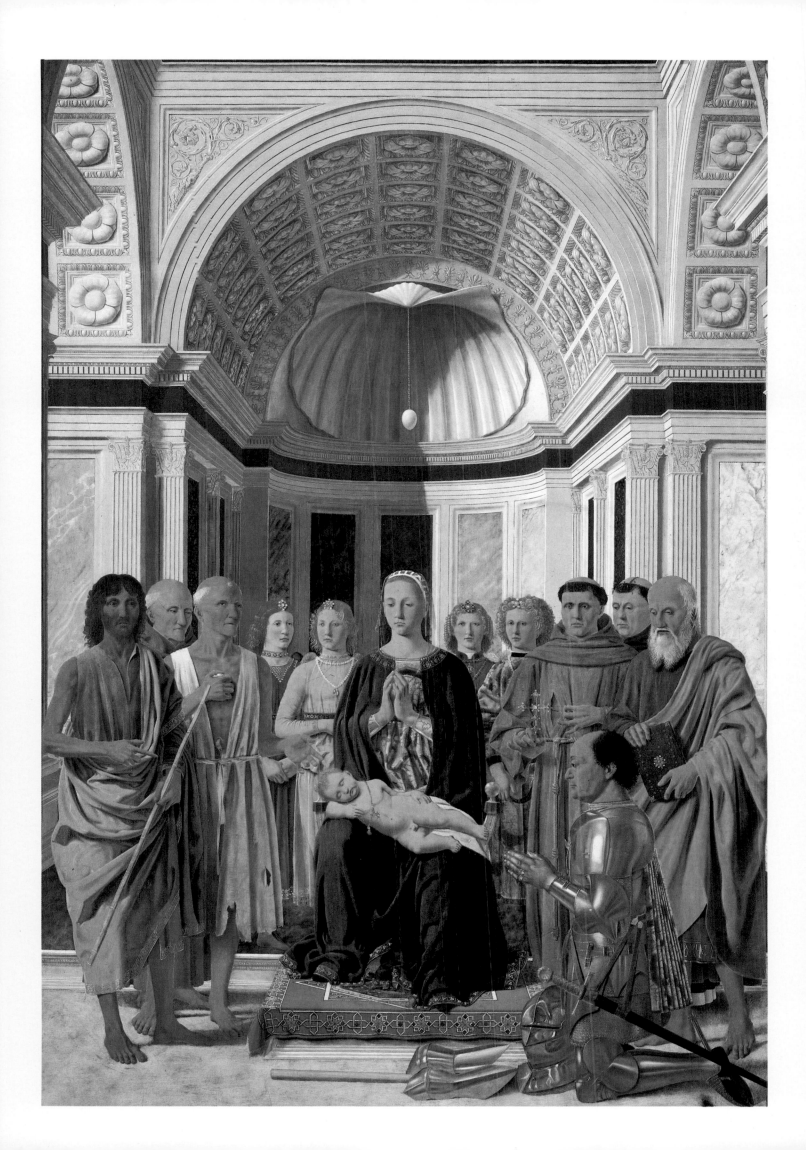

THE MONTEFELTRO ALTARPIECE
(detail, Federico da Montefeltro)

The profile head of Federico da Montefeltro is identical (although without the warts) in view and size to that of the Uffizi bust portrait (Colorplate 34) and may have been taken from the same cartoon. Most probably, therefore, the two paintings date from about the same time. In contrast to the peaceful nature of the bust, here it is the fame of the sitter as one of the most effective military leaders of his time that is emphasized. Every portion of his suit of plate armor is set in place: from the armet and wrapper; breastplate with reinforcement bent forward and held in place by bolt and screw; cuisse; pauldron made up of four lames extending around behind the shoulder blade; vambraces, Milanese-style butterfly-shaped elbow guards; wings at the knee (poleyns); leg cannons; and mail fringe at knee and foot. Even included are such realistic touches as external hinges and velvet-covered straps and buckles at the wrist and, at the ankles, bolts that hold internal hinges. Federico's sword in its red-velvet scabbard is strapped at his waist; his red and gold damask cape hangs down behind; and his spurs of steel and gold are fastened to his feet. In every sense it can be said that Piero painted two portraits, of Federico and of his armor.

Unlike many votive donors, Federico kneels by himself. He stares straight before him, taking cognizance of no one in the company of saints. Yet despite this emotional isolation, a mystical bond unites them. On the ground before him are his battle helmet, mitten-shaped gauntlets, and baton. These objects are arranged in front of the Madonna's dais with great formality, like votive offerings. Moreover, like a badge upon his sleeve, a light-filled window is reflected on the shoulder guard. This tiny, semicircular-topped shape relates to the flow of light that illuminates the apse and describes the shape of unseen windows that make up the fenestration of the church. Touched by this reflection, Federico, too, is absorbed into the very body of the church.

The singular reinterpretation of the donor figure brings with it new levels of personal meaning. For several years before the death of Battista, Federico had had an ambiguous relationship with the papacy. A great ally and friend of Pope Sixtus IV, he was distrusted by the College of Cardinals to the point that a petition for marriage between one of his daughters and a papal nephew was denied. In August 1474, when he came out of retirement and saved Rome from the vicious tyrant Niccolò Vitelli, however, he regained the cardinals' favor. He was, in fact, greatly honored in a famous ceremony on the steps of St. Peter's in Rome. He was made captain general of the papal armies, elected to the orders of the Garter, Ermine, and Golden Fleece, and his title was raised from count to duke. A few months earlier, he was still bent on counteracting all suspicion. In this altarpiece, which shows none of the signs of the new dignities (and therefore dates from before August), Piero overlaid conventional religious subject matter with declarations of trustworthiness and fidelity. He displays Federico as official Defender of the Faith. Before the setting that represents the Church, Federico is presented in affirmation of his reliability and lasting devotion. Dressed as an armed warrior, he does not ask for protection but presents himself as a strong, self-sufficient agent who, in turn, offers protection. Piero shows him as the Christian knight who boldly pledges to the Church, along with his private piety, his entire physical force and military prowess.

THE SENIGALLIA MADONNA

1478–80
tempera and oil, 61 × 53.5 cm
Urbino, Galleria Nazionale delle Marche

Senigallia is a small town on the Adriatic coast that was taken over from Sigismondo Malatesta by Federico da Montefeltro in 1462. In 1822, a painting, the *Madonna and Child with Two Angels,* was recorded for the first time in the church of the Madonna delle Grazie just outside of the town, and it was attributed to Piero. Later in the century it was transferred to Urbino. It probably dates from the late 1470s.

From the elegance of the *Montefeltro Altarpiece*'s frontal view of an ecclesiastical interior, Piero here turns to an off-balance, asymmetrical domestic setting. From a space that can be rationalized and plotted, he turns to a genuinely ambiguous view partially cut off on all four sides. The Madonna and her angelic attendants are visible only down three-quarters of their bodies. A doorway to the left and a niche to the right in the middle ground are both seen as severed forms, cut at the sides and at the top. A vista through the doorway shows only the corner of a second chamber, and although this room is flooded with light, no window is represented. Nowhere in the lower portion of the composition is there contact between the vertical forms and the ground. As a result, the figures seem to hover in a no-man's-land of sacred space, where one cannot enter and where every mote is meaningful.

Returning from the courtly ambient of jewels and damask, this Madonna is again a country maid, sturdy, serious, and inward turning. She carries her blessing baby protectively and with pride. Jesus wears an infant toga and raises his hand in an almost papal benediction. His tightly knit features play between youth and age. Again his coral amulet presages his sacrifice. The white rose he carries pays tribute to Mary's purity. The angels, too, are simplified. Their hair is not dressed; their pearls and crystal modest. They venerate with crossed arms, protecting their charges and admonishing their devotees.

The architectural details are also ambiguous. The niche at first seems secular, with its classicizing details. But surely the burning flame atop the grotesque carvings carries paschal meaning. It is the candlestick of Easter, bearing messages of both tragedy and hope. Inside the niche, the shelves seem sparsely furnished. Again the objects are religious tools. The little box on the top shelf is a pyx, fashioned to hold the host. The basket down below carries cloth. We are reminded of Mary's duties in the temple, making veils. She also sewed the linen that would be Christ's grave clothes.

The doorway, too, relates to Mary. Though carved in the modern style, it refers to her epithet, the Porta Coeli, or "door to heaven." The light falling in the second room (full of drops of sparkling moisture when seen close up) is a recollection of the solemn essence that passed miraculously from the godhead to form the Holy Child.

All these visual effects Piero took from northern art. In no other of his paintings is he so close to his Flemish brethren. Yet no northern painting ever looked like this one, weighty in its weightlessness, somber in its brilliance, spacious in its interpenetrating spaces, and *brutto-bello*, divinely beautiful, in its earthly ugliness.

THE ADORATION OF THE CHILD

c. 1478–80
tempera and oil, 124.5 × 123 cm
London, National Gallery

The London *Adoration* is Piero's only large-scale altarpiece to take a rectangular shape wider than it is high. Across the surface, the figures make a series of independent groups held together by a thread of concentration with a common focus. Without external interaction, each person's thought is fixed on his own method of paying homage to the Child. Italian farms often have a promontory, called an *aia,* open to the sun and regularly used for threshing wheat. Piero has placed his *aia* close to the picture plane to give an unobstructed view of the infant who is called the "Bread of Angels." The ground is sparsely covered with mossy growth, plants and weeds of a rudimentary nature. Tiny birds have come to feed on their seeds. Unfortunately, it is precisely the ground cover and the surface of the promontory that are the least well-preserved parts of the painting, although an apron-shaped stage seems to have been what Piero had in mind. Such an arrangement is a new departure in his thinking,

since it is one of his few compositions to lack mathematical indications as to how to read the space. This move is all the more intriguing since it corresponds to his intense period of mathematical speculation.

The two distant vistas filling the sides of the composition are detailed with a clarity that is also new. The winding river beneath lofty palisades is sharply seen, without an atmospheric veil; the dark green trees that line the banks are reflected in the water and are clipped to perfect bulb-shape roundness; sunlight dances on their surfaces. The urban view is equally clear, with tranquil, well-organized streets and towers kept in good repair. Once more, Piero shows the sanctity of his native land in both countryside and city, depicting the terrain of Sansepolcro and its people as worthy of the saintly visit. While he draws his subject from homespun narrative, he gives it iconic power through both conceptual and visual sharpness.

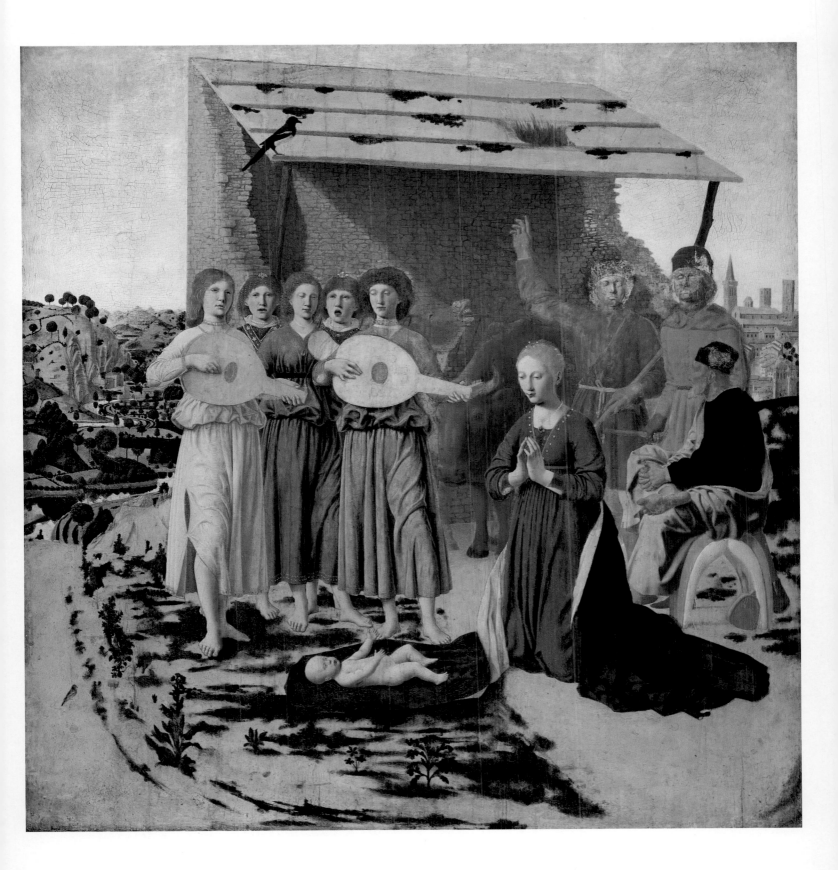

THE ADORATION OF THE CHILD
(detail, angels and animals)

The baby lying on the edge of his mother's robe is a real newborn, his snowy but well-formed body is dramatically silhouetted against the royal blue. Although he is so young he is still without hair, his are the only eyes in the composition that are really focused. As he lifts his arms with outstretched hands, he gazes directly at Mary with respect and gratitude.

The angels worship him with music, three playing stringed instruments and two singing. With skilled fingers the three forward figures fret and pluck their lutes and bow the viol. Their pastel dresses hang in columnar folds that mold their legs and leave their feet and ankles bare. The two singers in the back are more elegant. Wearing liturgical garb, the crossed dalmatic of deacons, they intone the Gloria with open mouths. The richness of these decorations, encrusted with pearls and other gems, give their song, and the action of the painting, the value of a heavenly ritual. Yet Piero makes the "miraculous sweetness" of the angelic concert visible in the guise of peasant boys, arrayed in finery, but without wings and standing in the grass.

These boys are not the only singers; they are joined by the ox and ass, the presence of which depends on ancient tradition. Even before the doctrine of the Virgin Birth was established, before the iconography of the Nativity had a narrative form, Christ's birth was represented on Early Christian sarcophaghi simply by a crib—a feeding crib—covered by the lean-to roof—the *tegurium*—and the two animals (fig. 66). The scene represented the fulfillment of Isaiah's prophesy, "The ox knoweth his owner, and the ass his master's crib" (1:3). In later centuries, when the narrative was fully developed, the animals remained. And so they do here, but with a novel meaning. The ox who "knows his owner" looks at the infant and lowers his head in a kind of prayer. No one before Piero had depicted this animal expressing such gentle understanding. But the ass, completing a kind of up-down down-up pattern that fills the space next to the angels, carries the conceit to an even higher level of devotional participation. The lowly animal lifts his head with open muzzle and brays with all his heart. Mimicking the angels as best he can, he joins in singing:

O all ye beasts and cattle, bless the lord: praise and exalt him above all for ever. (Ps Sunday at Lauds I, Roman Breviary)

No amount of overcleaning or rubbing could obscure these beautiful, touching ideas.

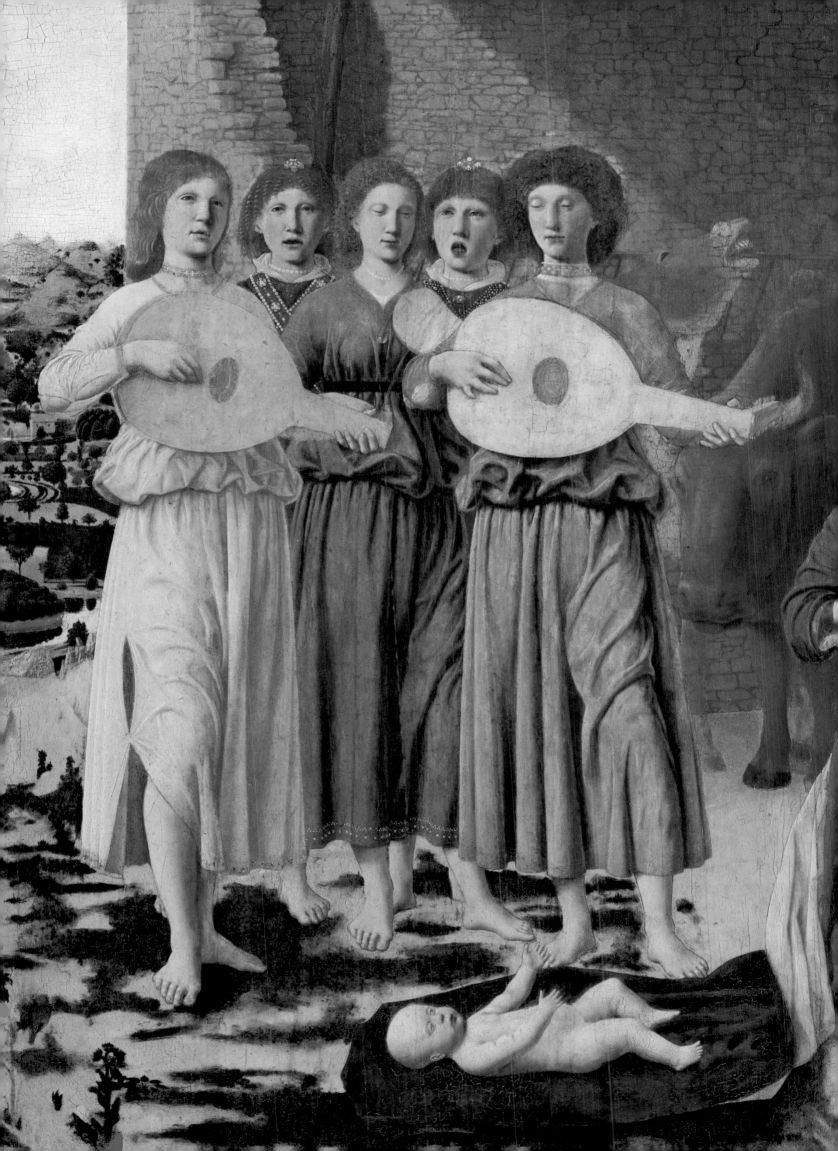

ALEXANDER, INGRID C. AND ANTONIETTA GALLONE GALASSI, "A study of Piero della Francesca's *Sacra Conversazione* and Its Relationship to Flemish Painting Techniques," *Icom Committee for Conservation; 8th Triennial Meeting, Sydney, Australia* (Getty Conservation Institute, Los Angeles, 1987) 1; short work on restoration findings

ALPATOV, MICHEL, "Les Fresques de Piero della Francecsa à Arezzo: Semantique et Stilistique," *Commentari* 1 (1963) pp. 17–38

ANGELINI, ALESSANDRO, *Piero della Francesca* (Florence, 1985); useful brief survey in many languages, including English

APA, MARIANO, *La "Resurrezione di Cristo": Itinerario sull'affresco di Piero della Francesca a Sansepolcro* (Biblioteca Comunale di Sansepolcro, 1980); contextual study

ASHTON, JOHN, *The Legendary History of the Cross* (London, 1887) pp. 113–76; classic nineteenth-century philological study

BANKER, JAMES R., "Piero della Francesca's *Sant'Agostino Altarpiece;* Some new documents," *Burlington Magazine* 129 (1987) pp. 645–51; the altarpiece and its architectural ambient

BATTISTI, EUGENIO, *Piero della Francesca* (Milan, 1971); monumental, heroic compendium of information and documents, but full of flights of fancy and mixed signals in the interpretive realm

BELTING-IHN, CHRISTA, *"Sub matris tutela"*: Unters. zur Vorgeschichte d. Schutzmantelmadonna (Heidelberg, 1976); iconography of the Madonna della Misericordia theme

BERENSON, BERNARD, *Piero della Francesca or the Ineloquent in Art* (1st Italian ed., 1950; New York, 1954)

BOIME, ALBERT, "Seurat and Piero della Francesca," *Art Bulletin* 47 (1965) pp. 265–71; documents Piero in nineteenth-century French academic circles

BORRI-CRISTELLI, LUCIANA, "Palazzo Residenza e la *Resurrezione;* Documenti. Recerche su Piero" Paolini, ed. (1989) pp. 7–33

BORSOOK, EVE, *The Mural Painters of Tuscany, from Cimabue to Andrea del Sarto* (1st ed., 1960; Oxford, 1980); basic work on Italian Renaissance fresco painting

CALABRESE, OMAR, *La macchina della pittura* (Rome, 1985) pp. 241–63; Piero and semiology

CALVESI, MAURIZIO, "Sistema degli equivalenti ed equivalenze del sistema in Piero della Francesca," *Storia dell'arte* 24/25 (1975) pp. 83–110; historical analysis of structural and thematic balance in Piero

——— "Nel Grembo dell'Arca," *Art e Dossier* 33 (1989) pp. 16–20; iconography of the *Madonna del Parto*

CANEVA, CATERINA, "Il dittico di Urbino; Capolavori e restauri," exhibition, Florence, 1986

CARLI, ENZO, *Piero della Francesca, the Frescoes in the Church of San Francesco at Arezzo* (Milan, 1965)

CARRIER, DAVID, "Piero della Francesca and His Interpreters: Is There Progress in Art History?" *History and Theory, Studies in the Philosophy of History* 26 (1987) pp. 150–65

CHELES, LUCIANO, *The Studiolo of Urbino: An Iconographic Investigation* (Wiesbaden, 1986) pp. 72–6

CLAGETT, MARSHALL, *Archimedes in the Middle Ages* (Philadelphia, 1978) vol. 3, pt. 3 ("The Medieval Archimedes in the Renaissance 1450–1565"), pp. 383ff., esp. 399–400 and 415–16

CLARK, KENNETH, *Piero della Francesca* (1st ed. 1951; London, 1969); brings positivist clarity and historicism to deep appreciation of the artist

DABELL, FRANK, "Antonio d'Anghiari e gli inizi di Piero della Francesca," *Paragone* 417 (1984) pp. 73–94

——— "Domenico Veneziano in Arezzo and the Problem of Vasari's Painter Ancestor," *The Burlington Magazine* 127 (1985) pp. 29–32

DEL BUONO, O., *L'opera completa di Piero della Francesco,* catalogue by P. De Vecchi (Classici dell'arte, 9) (Milan, 1967); in Italian, compendium of basic information, documents, and color plates

DON, SIDNEY, "Piero and the Franciscans," undergraduate term paper, graduate seminar, Yale University, 1978; observed the liturgical reference of the donkey in *Adoration of the Child*

FRANCASTEL, PIERRE, *Peinture et société: naissance et destruction d'un espace plastique: de la Renaissance au cubisme* (1st ed. 1957; Paris 1977)

FRANKLIN, DAVID, "An unrecorded commission for Piero della Francesca in Arezzo," *The Burlington Magazine* 133 (1991) pp. 193–94

GILBERT, CREIGHTON, *Change in Piero della Francesca* (Locust Valley, N.Y, 1968); attempts to make a new chronology of Piero's works

GINZBURG, CARLO, *Indagini su Piero* (Turin, 1981); English edition, *The Enigma of Piero: Piero della Francesca: "The Baptism," "The Arezzo Cycle," "The Flagellation"* (London, 1985); historian's view of Piero in context; cf. review by Eve Borsook, *The Burlington Magazine* 125 (1983) pp. 163–64

GOLDBERG, JONATHAN, "Quattrocento Dematerialization; Some Paradoxes in a Conceptual Art," *Journal of Aesthetics and Art Criticism* 35 (1976) pp. 162ff

Golden Legend of Jacobus de Voragine, translated by Granger Ryan and Helmut Ripperger (1941; 2nd ed. New York, 1969);

original 1262–64 text of many lives of the saints, arrangement according to the Church calendar; used as source book by artists

GUSTON, PHILIP, "Piero della Francesca: the Impossibility of Painting," *Art News* 64 (1965) pp. 38–39; a great painter's tribute to Piero

HENDY, PHILIP, *Piero della Francesca and the Early Renaissance* (New York, 1968); standard monograph

HUXLEY, ALDOUS, *Along the Road* (New York, 1925) p. 189

KENNEDY, RUTH WEDGEWOOD, *Four Portrait Busts by Francesco Laurana* (Northampton, Mass. 1963); publication of Battista Sforza's death mask

LAVIN, MARILYN ARONBERG, *Piero della Francesca's "Baptism of Christ"* with appendix by B. A. R. Carter (New Haven, 1981)

———— *Piero della Francesca: The Flagellation* (cloth, London/New York, 1972; in Japanese, Tokyo, 1979; paper, Chicago, 1990)

———— "Piero della Francesca's *Montefeltro Altarpiece:* A Pledge of Fidelity," *Art Bulletin* 51 (1969) pp. 367–71

———— *The Place of Narrative: Mural Decoration in Italian Churches, 431–1600 AD* (Chicago, 1990) pp. 167–94

LHOTE, ANDRÉ, "Piero della Francesca," *La Nouvelle Revue Française* (1930)

LINDEKENS, RENÉ, "Analyse sémiotique d'une fresque de Piero della Francesca: *La Légende de la vraie Croix*," *Canadian Journal of Research in Semiotics* 4:3 (1979) pp. 3–19

LOLLINI, FABRIZIO, "Una possibile connotazione antiebraica della 'Flagellazione' di Piero della Francesca," *Bollettino d'arte* 65 (1991) pp. 1–28

LONDEI, ENRICO FERDINANDO, "La scena della 'Flagellazione' di Piero della Francesca. La sua identificazione con un luogo di Urbino del Quattrocento," *Bollettino d'arte* 65 (1991) pp. 29–66

LONGHI, ROBERTO, *Piero della Francesca* (1st ed. 1927; 2nd ed. 1945; Milan, 1963); in Italian, a brilliant, personal reading, filled with poetic insight that has never been surpassed

MARTONE, THOMAS, "L'affresco di Piero della Francesca in Monterchi," *Atti del Convengo Internazionale sulla "Madonna del Parto"* (Monterchi, 1980); eccentric, overblown study; observes goatskin tent

MEISS, MILLARD, "*Ovum Struthionis*, Symbol and Allusion in Piero della Francesca's Montefeltro Altarpiece," *Studies in Art and Literature for Belle da Costa Green*, ed. Dorothy Miner (Princeton, 1954) pp. 92–101; essential early understanding of "meaning" and "structure" in Piero's work; caused much debate

————WITH T. G. JONES, "Once Again Piero della Francesca's *Montefeltro Altarpiece*," *Art Bulletin* 48 (1966) pp. 203–06

———— *La Sacra Conversazione di Piero della Francesca* (Quaderni di Brera, 1; Florence, 1971)

Piero: Teorice dell'arte, ed. Omar Calabrese (Symiosis, Collana di Studi Semiotici, 1) (Rome, 1985); papers from a colloquium of structuralists, theoreticians, and observers of Piero [French and Italian]

PODRO, MICHAEL, *Piero della Francesca's "Legend of the True Cross,"* 55th Charleton Lecture, University of Newcastle upon Tyne (Edinburgh, 1974)

Un progetto per Piero della Francesca: Indagini diagnostico-conoscitive per la conservazione della "Leggenda della Vera Croce" e della "Madonna del Parto" (Florence, 1989); restoration prognosis and reports

REUTERSWÄRD, PATRIK, review of Paul Barolsky's *Infinite Jest: Wit and Humor in Italian Renaissance Art,* 1978, in *Konsthistorisk Tidskrift* 49:2 (1980) pp. 77–79; Barolsky's response, "Piero's Native Wit," *Source* 2 (1982) pp. 21–22

RICHARDSON, JOHN, *Cézanne at Aix-en-Provence* (New York, 1956)

SALMI, MARIO, *La Pittura di Piero della Francesca* (Novara, 1979); last monograph by great master of art history who lived in Arezzo

SCHNEIDER, LAURIE, "The Iconography of Piero della Francesca's Frescoes Illustrating the Legend of the True Cross in the Church of San Francesco in Arezzo," *Art Quarterly* 32 (1969) pp. 22–48; first work to associate Arezzo cycle with liturgical feasts

———— "Shadow Metaphors and Piero della Francesca's Arezzo Annunciation," *Source* 5 (1985) pp. 18–22; cites ideas of Howard McP. Davis

TANNER, MARIE, "Concordia in Piero della Francesca's *Baptism of Christ,* *Art Quarterly* 35 (1972) pp. 1–21

TOLNAY, CHARLES DE, "Conceptions religieuses dans la peinture de Piero della Francesca," *Arte Antica e Moderna* 23 (1963) pp. 205–41; splendid, perceptive early penetration of Piero's spiritual content

UGOLINO, GUIDO, *La Pala dei Montefeltro: Una Porta per il mausoleo dinastico di Federico* (Pesaro, 1985)

VENTURI, LIONELLO, *Piero della Francesca* (Geneva, 1954) pp. 52–92; small monograph; first color reproductions

VICKERS, MICHAEL, "Theodosius, Justinian, or Heraclius?" *Art Bulletin* 58 (1976) pp. 281–82

WITTKOWER, RUDOLPH, AND B. A. R. CARTER, "The Perspective of Piero della Francesca's *Flagellation*," *Journal of the Warburg and Courtauld Institutes* 16 (1953) pp. 292–302; first to demonstrate architectural "reconstructibility" of Piero's spatial representations

PHOTOGRAPH
CREDITS

Numbers refer to pages: Alessandro Angelini, *Piero della Francesca*, Scala, 1985: 32; Archivi Alinari, Florence: 9 (bottom), 10 (bottom left), 13 (top), 13 (bottom), 16 (top), 17 (top), 22 (bottom left), 22 (right), 26 (top), 27 (top), 28 (bottom), 31, 34, 35 (top left), 36 (top), 36 (bottom), 41, 42 (bottom), 43, 45 (top), 45 (bottom), 46 (top right), 46 (bottom right); Archivi Vaticani, Vatican City: 16 (bottom), 26 (bottom); Bildarchiv Foto Marburg/Art Resource, New York: 27 (bottom); Bildarchiv Preussischer Kulturbesitz, Berlin: 22 (top left); Eötvös Lorand University Library, Budapest: 37 (left); Gabinetto Fotografico, Florence: 11, 12, 14, 18 (top), 36 (top), 38; Gabinetto Fotografico, Roma: 15 (bottom); Istituto Centrale del Restauro, Archivio Fotografico: 20 (right); Landesbildstelle Rheinland, Düsseldorf: 35 (bottom); Marilyn Aronberg Lavin, Princeton: 7 (bottom), 15 (top), 19 (top), 19 (bottom), 20 (top left), 20 (bottom left), 21 (top), 21 (bottom), 24, 28 (top), 29 (top), 29 (bottom), 33, 39 (top), 40 (right); Österreichische Nationalbibliothek, Vienna: 39 (bottom); Mario Quattrone, Florence: 113 (left), 113 (right); R.M.N., Paris: 35 (top right), 42 (top), 53; Scala/Art Resource, New York: 8 (bottom), 49, 51, 55, 57, 59, 61, 69, 71, 75, 77, 79, 81 (left), 81 (right), 83, 85, 87, 89, 91, 93, 95, 97, 99, 101, 103, 105, 107, 109, 111, 115 (left), 115 (right), 117, 119, 121; Pierluigi de Vecchi, *The Complete Paintings of Piero della Francesca*, Harry N. Abrams, Inc., 1967: frontispiece, 7 (top)